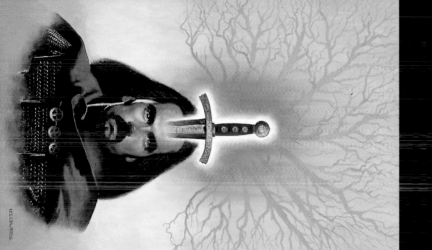

Les Edwards, Silver on the Tree

THE ENCYCLOPEDIA OF FANTASY AND SCIENCE FICTION ART TECHNIQUES

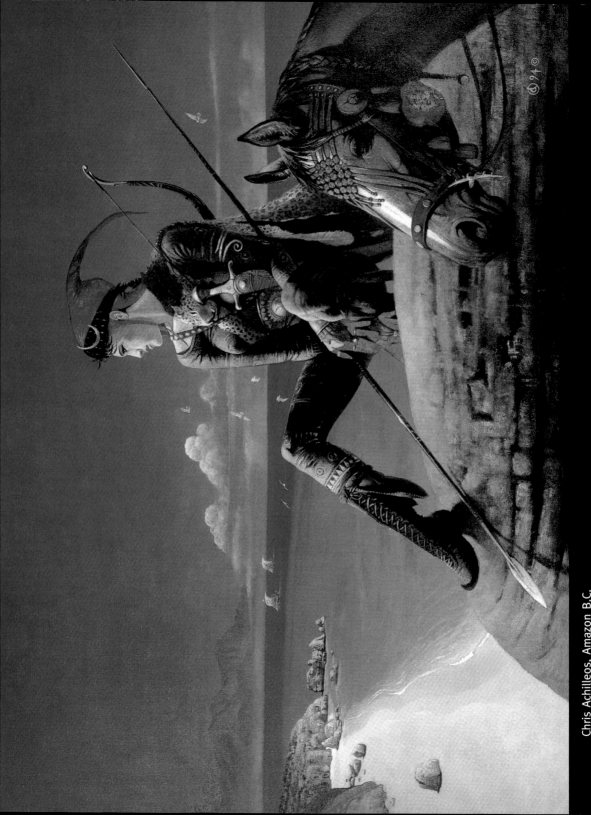

Chris Achilleos, Amazon B.C.

THE ENCYCLOPEDIA OF FANTASY AND SCIENCE FICTION ART TECHNIQUES

JOHN GRANT/RON TINER

RUNNING PRESS
PHILADELPHIA · LONDON

9 8 7 6

Digit on the right indicates the number of this printing.

Library of Congress Cataloging-in-Publication Number 95-70148

ISBN 1-56138-534-4

The book was designed by:
Quarto Inc.
The Old Brewery
6 Blundell Street
London N7 9BH

Designer Graham Davis
Senior editor Kate Kirby
Copy editor Hazel Harrison
Senior art editor Penny Cobb
Picture researcher Giulia Hetherington
Art director Moira Clinch
Publishing Director Mark Dartford

Typeset in Great Britain by Central Southern Typesetters, Eastbourne
Manufactured in Singapore by Eray Scane Pte Ltd
Printed in China by Leefung Asco Printers Ltd

This book owes a considerable debt – notably in terms of the terminology used to describe the various fields of the fantasy genre – to the pioneering work done by the editorial team of *The Encyclopedia of Fantasy* (1995), chief editors John Clute and John Grant. Thanks also to all the artists who have contributed to this book, whether with original art or with kind permission to reproduce previously existing artworks. At a more personal level, thanks are due for their tolerance to Rikki Horn, Catherine Barnett, Jane Barnett and Fionna O'Sullivan.

This book may be ordered by mail from the publisher.
Please include $2.50 for postage and handling.
But try your bookstore first!

Running Press Book Publishers
125 South Twenty-second Street
Philadelphia, Pennsylvania 19103-4399

Conan the Barbarian
from Marvel Comics

Graham Bleathman,
Thunderbirds 1 and 2

Jim Burns, Triad

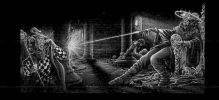

Paul Davies, The Demon Crown

Contents

Introduction 6

Conceptualization 12

24 Tools and Materials

Pencil/Ballpoint Pen 26

Ink 28

Felt-Tipped Pens / Pastels 30

Airbrush/Acrylics 32

Oil Paints / Gouache 34

Watercolors / Mixed Media 36

Substrates 38

40 Techniques

Alternate Realities 42

Anthropomorphism 46

Body Language 50

Characterization 52

Comic Strips 56

Computer Enhancement 62

Creatures 66

Displacement 70

Distortion of Form 72

Erotica and Exotica 74

Exaggeration 76

False Perspective 78

Hardware 82

Human and Humanoid 88

Illusion of Space and Depth 92

Implausible and Impossible Structures 94

Juxtaposition 98

Lighting 100

Sword and Sorcery 104

Through the Looking Glass 108

112 Themes

High Fantasy 114

Alien Landscapes 122

Fantasia 130

Space Opera 140

Splatter 148

The Strange 156

Getting Published 170

Index 172

Credits 176

INTRODUCTION

Fantasy art is the art of the imagination. It knows no boundaries. As a fantasy artist, you have unlimited scope to express yourself. No one can stop you.

The Garden of Earthly Delights, a triptych by Hieronymus Bosch currently in the Prado, Madrid, can be regarded as an ancestor of much modern fantasy art.

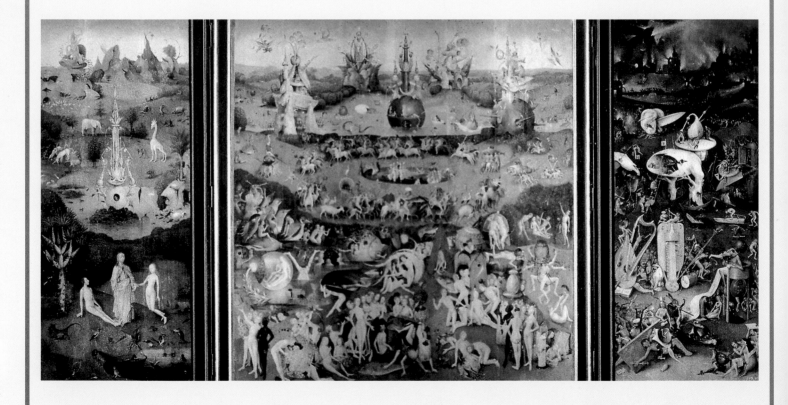

RIGHT: *Fairies on a Gourd* by Alan Baker, done using watercolor, pen and ink, crayon, bleach, pencil, and airbrush. Subject matter aside, this image could almost have come from Bosch's infernal garden.

BELOW: The White Knight from Lewis Carroll's *Through the Looking Glass*, drawn by John Tenniel. Tenniel was briefed as thoroughly as any illustrator might be today to make sure that the images exactly matched Carroll's own visualization.

This is the joy of the best fantasy, whether you are a creator or a "consumer": fantasy, in all its forms, offers you a boundless imaginative playground in which to revel. This is not to say that working in the field of fantasy art can be an exercise in self-indulgence–discipline is important as well, if you are to become successful–but fantasy offers you a freer rein than any other form of art: indeed, it is based on the fact that the artist allows her or his imagination to roam.

THE SPECTRUM OF FANTASY Fantasy appears in four main forms: art, the written word, comics, and movies. Unlike the case in almost any other genre of creativity, the underpinning of these four forms is identical: the means of communication may differ, but there is no firm boundary, in terms of creativity, between the different aspects of fantasy. All of them depend for their success on the flow of ideas–the development of an initial, original idea into something fully realized.

It might seem there was a big gap between, say, written

Illustration by Chiodo of Conan the Barbarian for the cover of Marvel Comics' *Havoc* #6.

fantasy and fantasy art–between, as it were, a book and its cover. Yet the guiding thrust is much the same. Both are exercises of the imagination, the expression of creative ideas. Both explore the conceptual freedom that fantasy allows. Ideas are freely exchanged between the two modes of expression. A fantasy artist setting out to create a new artwork must go through the same thought-processes–must enter the same mind-set–as a fantasy writer embarking on a new novel. Where will my original idea lead to? Do I want to think it out now, or do I want my imagination to lead me on a journey whose destination I will discover only when I get there? Through what and how many conceptual realms will the audience be prepared to follow me? How far can I stray from the orthodox?

Of course, not all fantasy artists think this way–there is plenty of mediocre, unimaginative fantasy art around, just as there is plenty of mediocre, unimaginative fantasy fiction–but the best of them are working to discover new areas of the great fantasy playground. This parallel holds good also for the creators of comics and movies.

Another point to remember is that many of the best fantasy paintings are narrative. They may present you with only a single event, but that depiction challenges you to imagine for yourself two different stories: what has happened before, and what will happen afterward.

WHERE IT ALL CAME FROM Fantasy art is not a new genre: prehistoric cave paintings seem to depict mythical creatures like the unicorn. As with some of the earliest pictures produced by civilization–such as those of the Assyrian half-fish, half-man Oannes–these may have had some sort of religious origin, and almost certainly a mystical one.

If one had to choose a single ancestor of modern fantasy art, one could do worse than single out *The Garden of Earthly Delights* by Hieronymus Bosch (*c*1460–1516). Here we see deployed in almost full maturity many of the themes that still permeate late-20th-century fantasy art. There are monsters and impossible structures and a bizarre landscape, and overall a sense of unreality that would, centuries afterward, be picked up and refined by the Surrealist painters, such as Salvador Dali (1904–1989), Max Ernst (1891–1976), René Magritte (1898–1967) and, yet later, H.R. Giger (b. 1940).

This influence still exerts itself over fantasy art, but there are others. Perhaps the greatest springs from the Victorian era, when a great blossoming of imaginative fiction–coupled with advances in printing techniques–gave rise to the publication of illustrated books with increasingly imaginative and sophisticated art. The earliest artist of note in this context was probably "Mad" John Martin (1789–1854), whose enormous,

spectacularly melodramatic canvases tackled Armageddon-like subjects–such as *The Great Day of His Wrath* (1833). He brought this broad sweep of imagination to book illustration with an edition of Milton's *Paradise Lost*. His pictures–crowded with hosts of tiny figures backdropped by fantastic architectures and apocalyptic conflagrations–have visibly influenced such contemporary artists as Bruce Pennington, Chris Foss, John Berkey, Jim Burns, David A. Hardy, John Harris, and Geoff Taylor.

The rise of imaginative fiction–by Lewis Carroll, J.M. Barrie, George MacDonald, Andrew Lang, and countless others–spurred the creative abilities of artists like Gustave Doré (1832–1883). The work of Sir John Tenniel (1820–1914) on *Alice*–for which he was extensively briefed by Carroll–presaged that of the great fairytale illustrators like Arthur Rackham (1867–1939), Charles Robinson (1870–1937) and his brother William Heath Robinson (1872–1944), Edmund Dulac (1882–1953), and Winnie the Pooh's illustrator E.H. Shepard (1879–1976).

Through the same period the French artist Albert Tobida (1848–1926) was illustrating rather different books–his own satirical speculations about mankind's future; of the artists just cited, his work was closest to the comic art of Heath Robinson. The detailed bizarreness of the Dutch graphic designer M.C. Escher (1902–1972) has a modern outlet in the work of artists like Ian Miller.

American artists were slower to leap into fantasy. On one hand, there were paintings like those of Grant Wood (1892–1942) and Andrew Wyeth (b. 1917), whose subjects were sternly realistic but whose styles were clearly fantasticated (Michael Whelan might be thought of as one of their spiritual descendants), but the "Father of American Illustration"–because of the enormous influence of both his work and his teaching–was Howard Pyle (1853–1911). In his art, as in Wood's and Wyeth's, the human figure dominates, and this is a persistent feature of much American fantasy art–as by Frank Frazetta (b. 1928) and Frazetta's own disciples, like Boris Vallejo. The separate "arcadian" tradition of Maxfield Parrish (1870–1976) still has an overt influence on much fantasy cover art, where typically a small figure is dwarfed by a vast background; Tim White is one practitioner. The "arcadian" tradition can be seen to intersect with the inheritance from Martin–and even from Bosch–in this modern trend of depicting tiny figures amid seemingly infinite landscapes.

Of course, dozens of other past masters still exert an influence on fantasy art–people like Henry Fuseli (1741–1825), Richard Doyle (1824–1883), and Richard Dadd (1819–1887). The list could be continued interminably. Even if the fantasy

Tom Centola's *Unicorns*, in oils and airbrush, captures admirably and imaginatively the moody nostalgia of traditional romantic fantasy.

BELOW: Ami Blackshear's watercolor, *Diamonds and Toads No. 3*, epitomizes the gentler tradition of fantasy illustration that continues alongside the more dynamic styles derived from comics.

art you wish to create is high-tech contemporary or futuristic, you would be wise to acquaint yourself, through books or otherwise, with the paintings and illustrations of as many as possible of these artists of the past. They have much to teach you, even though the details of their subject matter may be quite different.

In the last decade or two, Western fantasy art has become much more diverse as fantasy artists have been exposed to a far greater range of cultural influences. Japanese *manga* has made its presence felt. Surrealism has had something of a comeback. The psychedelia of the '60s and '70s may be dead, but something of its spirit lives on. The airbrush–a new tool–had a powerfully influential period of ascendancy. As in the Victorian era, the increasing sophistication of printing techniques has led fantasy artists to experiment more widely in different media, such as collage and mixed media to gain subtle color and texture effects. Moreoever, fantasy art is no longer seen as fit solely for the covers of fantasy books, pulp magazines, and record covers: mainstream novels, calendars, advertisements (notably including TV advertisements), theater posters, packaging, T-shirts–any and all of these, and more, are likely to be graced by fantasticated art.

WHERE DO YOU GET ALL THOSE CRAZY IDEAS FROM?
This is the question that, traditionally, all fantasy creators must face from time to time. The equally traditional response is that some of them are already there in the real world, some are part of the common stockpot shared by all fantasists, and some of them just . . . arrived. The last category is the interesting one.

No one can teach imagination. At the same time, the old cliché–that you either have it or you don't–is not really true. All human beings have imagination; to take a simple example, we all think about our own futures, which is an imaginative act. Children often live in a world that is more fantastical than mundane. As we grow older, however, most of us determinedly inhibit our imaginations–we have to cope with the real world, in which fantasy is too often seen as having no part to play.

But imagination is not something that, once curbed, is lost forever. The trick of all fantasy creation is to rediscover the imaginativeness of childhood and then probably to add the disciplines of adulthood to give the fantastication form. It is no coincidence at all that some of the finest fantasy has been produced for children: through the re-exploration of childhood, adults can often regain that "magical land" they once inhabited. Equally it should come as no surprise that several of the artists we mentioned above are remembered best for their children's illustrations.

Childhood is only one of the playgrounds you can enter.

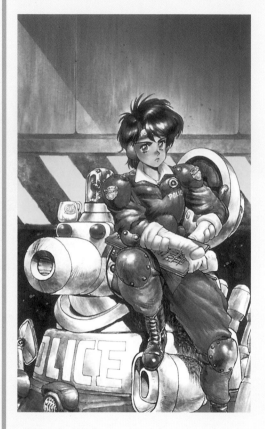

Manga painting by Masamune Shirow for *New Dominion Tank Police*, which he both writes and illustrates.

Anyone, no matter how imaginative they consider themselves already to be, can increase the range of their fantasy conceptualization by deliberately walking into and exploring such playgrounds. The world of dreams is another. Allowing your mind to follow an initial idea as it runs its course–no matter how silly that course might seem to be–is yet another. Or you might read Gibbon's *Decline and Fall of the Roman Empire*, a popular book on quantum physics, or your local newspaper, or go to an art gallery, a photographic exhibition, the movies, or the beach. Maybe you could try just playing around with a new artistic medium, watching what happens as you doodle. Any of these may offer open gateways into a playground of the imagination, or be the playground themselves.

The point is that you can discover or rediscover your imagination through consciously opening yourself to all sorts of influences. You should not expect those influences directly to affect your creative work–indeed, parroting them is something you need to guard against. What you *are* wanting them to do is to spark off new trains of ideas in your mind: you're wanting them to help you discover your own imagination.

Someone once said, "The trouble with having an open mind is that people come along and put things in it." As a fantasy creator, this is something you want to encourage people to do. Let the disparate notions clash or interconnect in your head–you can always sift out the junk later. In the meantime, allow yourself to wander at will through the playground of ideas that you have ingested.

CONCEPTUALIZATION IS THE NAME OF THE GAME From the above, it must be clear that the first and fundamental technique of fantasy art–and of all fantasy creation–is the effective deployment of the imagination. This is why we have chosen to organize the bulk of this book along conceptual rather than straightforward "method" lines. Some of our section headings may at first seem strange to you– "Displacement," "Through the Looking Glass," etc.–but you will soon find, as you explore the world of fantasy art further, that these topics become obvious reference points for you. On one hand, they represent effects that you wish to achieve; on the other, they are ways of thinking that you want to encourage in yourself in order to enhance your innate perception of the fantastical that lies all around you–and which you can pluck from the air and put to use in your art.

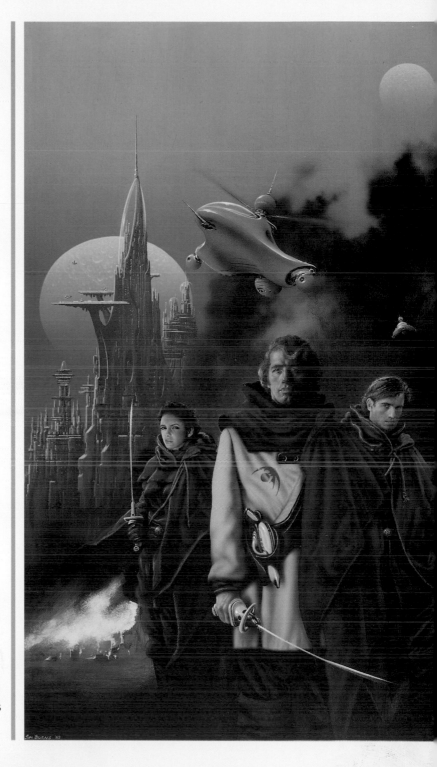

RIGHT: In *A Quiet of Stone*, Jim Burns blends fantasy and science fiction hardware ingredients to produce a work of what is called science fantasy. Burns has adroitly taken advantage of the effects this subgenre offers through its odd juxtapositions.

Conceptualization

The popularity of fantasy art stems from its ability to create a sense of wonder. It intrigues audiences with visual ideas and concepts that seem new and out of the ordinary—different in some way from the mundane, everyday world.

The fantasy artist is concerned with creating new worlds—these could be described as alternative realities. We show our audience strange landscapes, weird creatures, fantastic vessels and buildings, supernatural phenomena . . . and portray them in ways that set fire to the imagination.

Every fantasy artist and fantasy writer is from time to time asked where they get their ideas from. It is difficult to give a practical response, because the most truthful answer is "From inside my head." This does not offer much help to the novice, who might then counter with a further question: "How do you arrange matters inside your head so that such ideas become available to you?" This is less easy to answer, but in fact the process is not all that complicated. In this chapter we investigate some of the ways in which imaginative artists develop new concepts and hope that they will set an example through which you can begin to discover your own creativity.

THE PAST IS NOT A DIFFERENT COUNTRY It is a common misconception that ideas for imaginative paintings spring up in the artist's mind complete and perfectly formed; that artists have their heads full of strange images of nightmare creatures, and have to paint them in order to "get them out of their system." This may be true of some rare individuals, but if you are one of them, you would not need to be reading this chapter.

Almost all fantasy art grows in the fertile soil of what has gone before. Successful imaginative artists are able to bring together many different aspects of their own experience and play with them to generate novel combinations and new concepts. Everything we have taken on board from the world around us—including other people's paintings, the books we have read, and the movies we have seen—are grist to the mill of our creativity. We take this raw material and juxtapose, combine, and develop it in various ways to create original images and ideas for use in our artwork.

DRAW CONSTANTLY To become adept at this kind of creativity, you must treat it in the same way as the acquisition of skills in any area—you must practice. You cannot express ideas unless you have the wherewithall, so to develop your practical skills in delineating form and structure, light and shade, perspective, picture composition, and all the rest you will need to use your sketchbook, drawing from observation. This does not mean you should not also sharpen your inventiveness by drawing and doodling the kinds of fantasy subjects that interest you from imagination – but you need to root your fantastication in experience of the real world. Anything you see in the everyday world around you is worth a sketch—street scenes, vehicles, people on trains or in cafes, and so on—so carry your sketchbook everywhere, and don't be shy of using it.

With practice, you will develop the firm link between eye, mind, and hand that is the key to fantasy drawing, and once

Two of the preliminary sketches for the picture that appears on pages 106–107.

the link has been forged, you will have begun to access your own creativity. As you draw, ideas will flow, because drawing and imagining will have become two parts of the same activity.

The sketchbooks of imaginative artists are full of drawings from life—along with memory sketches, bits of invention, and flights of fancy, plus odd notes and jottings made when ideas have occurred to them.

Opposite are some examples of sketchbook pages by two very different fantasy artists. They were chosen to show how the artists work to create new ideas. On the following six pages, we take an in-depth look at this creative process in action, showing the steps in the development of several projects from first concept to finished picture.

CASE STUDY I: SKETCHBOOK JOTTINGS These pages from Ron Tiner's sketchbook show character designs for a sword-and-sorcery tale, roughs for a graphic novel, a practice sheet of Amerindians for a fantasy-paper advertisement, sketches of sunbathers on a Mediterranean beach, a model drawn from life, and stages in the development of two other projects.

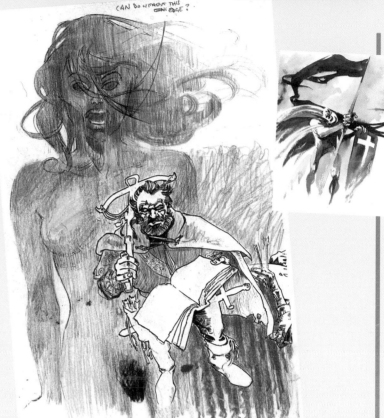

ABOVE, LEFT AND BELOW: Three sketches from observation.

ABOVE: Preliminary color sketch for the artwork whose final form is shown on page 104.

TOP RIGHT: Character sketch for a fantasy set during the time of the Third Crusade.

BELOW LEFT: Decorative drawing of a tree from imagination.

BELOW: Sketches for an illustration of the story "The Machine Stops" by E. M. Forster.

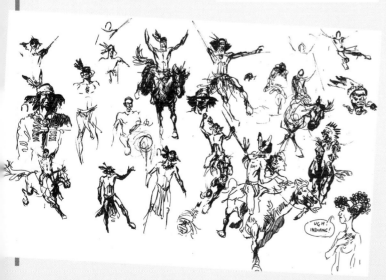

LEFT: A page of drawings of North American Indians done in preparation for an advertisement.

CASE STUDY II: MIXING DRAWINGS FROM OBSERVATION AND IMAGINATION The illustrations on this page are notebook and sketchbook pages by Paul Bartlett for various projects. Bartlett works up his ideas along several different lines at once, mixing drawing from observation and imagination with extensive notes.

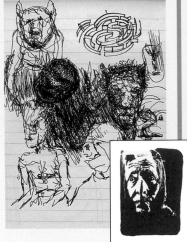

LEFT: "Early study for 'The Game of Life,' done in pen and smudge." From Bartlett's private sketchbook.

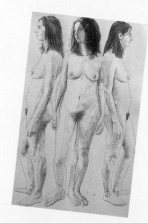

ABOVE: Notebook studies, and (inset) image for a poster: "Must Children Die and Mothers Plead in Vain?"

BELOW RIGHT: Notes and working drawings "thinking about the need to transform fantasy into fact."

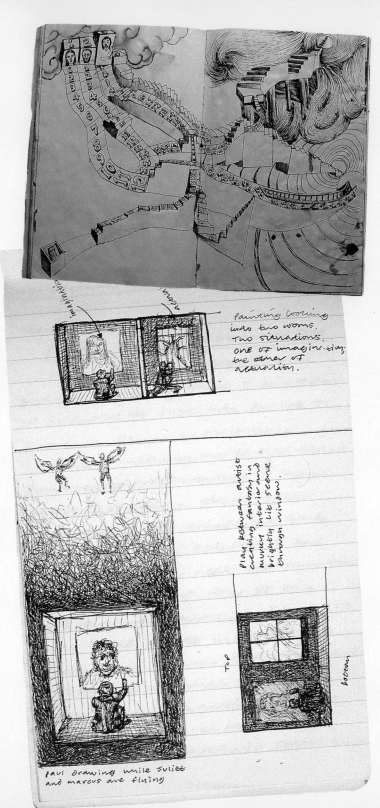

paul drawing while Juliet and marcus are flying

ABOVE: "Confusion of direction –which language to use to react to looking?" A working drawing/study in the artist's private notebook.

ABOVE: Colored pencil drawings from life of a standing nude, related to a Janus theme.

CASE STUDY III: WORKING FROM IMAGINATION Henry Flint rarely draws from life. His sketchbooks contain a pot-pourri of ideas for fantasy characters and space hardware, interspersed with notes for story ideas and oddball flights of fancy. As a drawing progresses, the lines and shapes are continually developed using a pencil and eraser.

RIGHT: A typical Flint page of miscellaneous notes and drawings as the artist lets his imagination run wild.

ABOVE: Strange creatures and caricature fill a page of Flint's private sketchbook.

BELOW: Hardware bits and pieces plus Flint's contribution to the debate on the nature of time.

LEFT: Working sketches developing a character called Chainsaw Biker (see page 22).

RIGHT: Another piece of idiosyncratic hardware from Flint.

COVER PAINTING "The Scholar," by Ron Tiner, was commissioned for the cover of a publisher's catalog.

The brief was simply "books." The first idea was to show a wizard with a book of spells. In one of the character sketches for his face, he had a fantastically long beard, and this led to the introduction of the long-legged stool– otherwise, his beard would trail on the ground–and from this developed the character of the scholar with a candle. Sketches of the background followed, then the large detailed drawing as the final stage before starting on the finished artwork. All these drawings were done in ballpoint pen. The first color version was done in brown ink and colored with watercolor. For the second version, a wash of warm ocher was laid over the whole picture area. The scholar and the floor area were masked out with masking film, and deep brown was sprayed on with a spraygun, followed by a further sprayed layer of Prussian blue over the upper half. The scholar himself was then painted in detail in gouache. Oil pastels were used for the candlelit stack of books, and finally other details were painted in gouache.

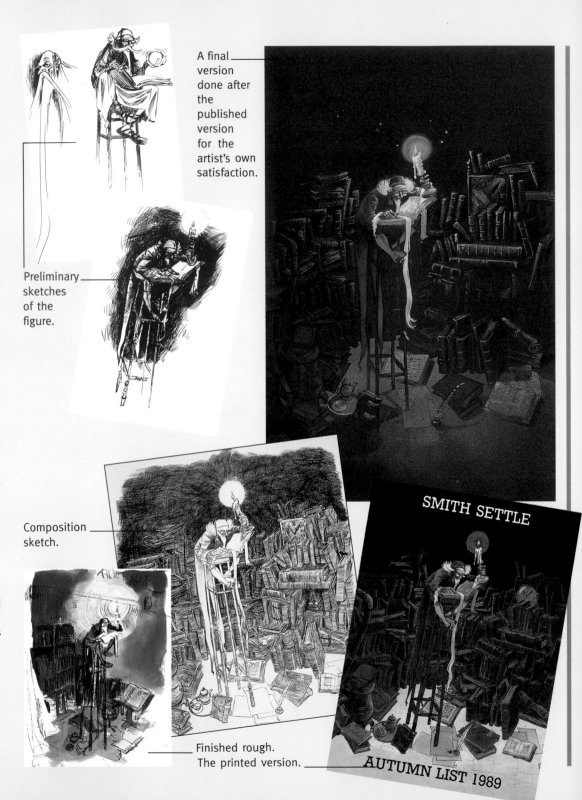

A final version done after the published version for the artist's own satisfaction.

Preliminary sketches of the figure.

Composition sketch.

Finished rough. The printed version.

SMITH SETTLE

AUTUMN LIST 1989

BOOK ILLUSTRATION Ron Tiner's "Procession" began as a page of a graphic novel which required someone to be sitting on an elephant.

The first sketch was inadvertently started too close to the bottom of the page, so the artist lopped off the legs and the end of the trunk to make it look as though the animal were wading through a pool of milk. This seemed to work rather well, so the idea was developed further in later drawings with floating flowers and drapery. The elephant itself was made more flamboyant by giving it first ears like the wings of an exotic butterfly, and then horns, headgear and other regalia. The figures on the elephant's back were worked on separately. The finished artwork was in pen-and-ink line with watercolor.

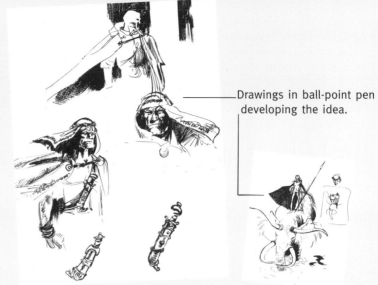

Drawings in ball-point pen developing the idea.

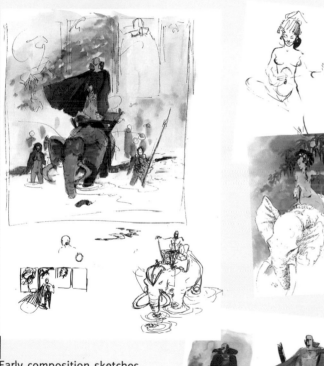

Early composition sketches.

Experimental sketches of the two figures.

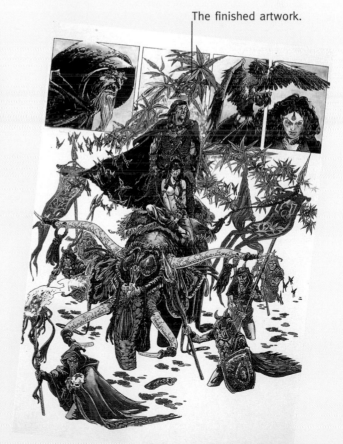

The finished artwork.

A VISUAL STORY These two pages show how Ron Tiner has developed a simple story idea into a complete scenario. All the sketchbook work was done in ballpoint pen. Finished artwork was in black ink line and watercolor.

The story began with a "dark man" who could "spit lightning from his eyes." These sketches show how the image was created. When the dark man was killed, his blood fell on the ground and caused great trees to grow upwards of a mile in height, which eventually covered all Britain. The artist was given a free rein to develop this scenario.

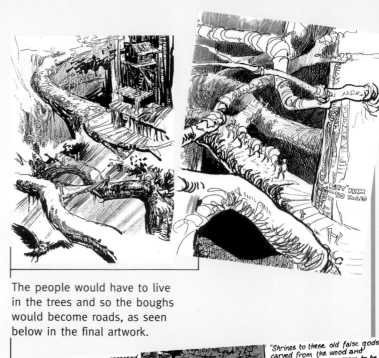

The people would have to live in the trees and so the boughs would become roads, as seen below in the final artwork.

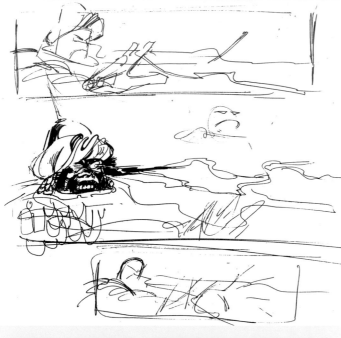

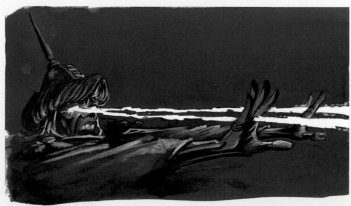

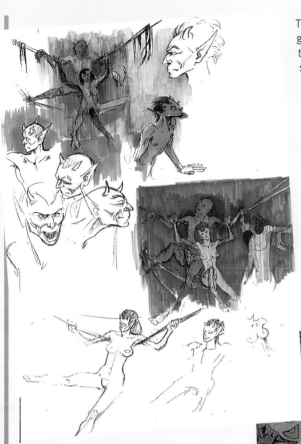

The upper classes would gravitate (or antigravitate) to the upper boughs for sunlight and fresh air.

The lower classes would need to build platforms on which they could construct dwellings.

At ground-level there would be little or no natural light. Here the lowest forms of life live, along with woodsprites and other creatures.

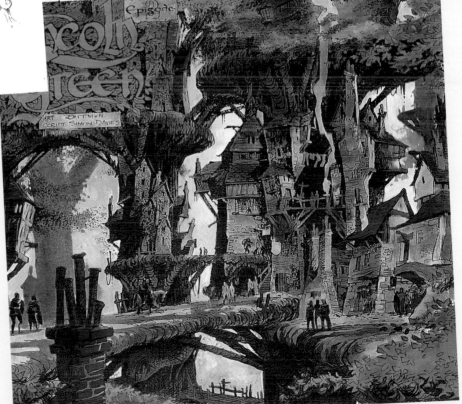

DEVELOPING EXTRATERRESTRIAL LIFEFORMS

Paul Bartlett was asked to produce a set of illustrations of the types of extraterrestrials that might exist on some of the other planets of the solar system. Here are the sketches and artworks involved in his creation of lifeforms dwelling in the atmosphere of Jupiter.

RIGHT: "The need to be constantly 'airborne' is answered by the creatures having thin-skinned gas-sacs that expand into balloons filled with carefully regulated gases. Crucial for propulsion and nutrition is the multipurpose valve/mouth in the creatures' base."

A page of fairly detailed sketches exploring the notion of such creatures.

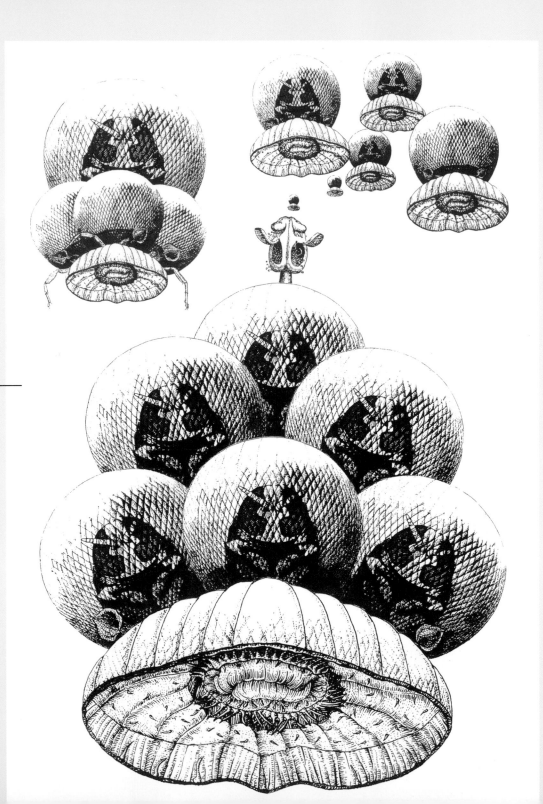

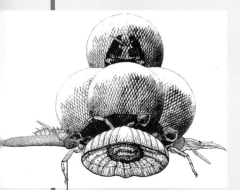

As Bartlett clarifies his ideas he is able to consider other aspects of his Jovians, notably their appendages.

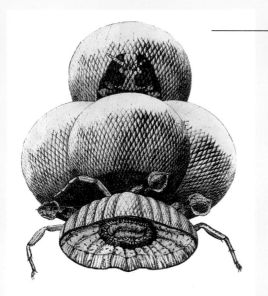

Artwork is taken on to a more advanced stage, adding color and further detail.

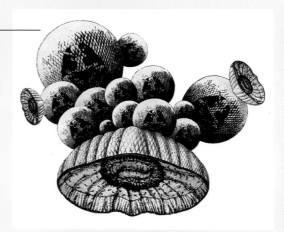

In the end he opted for simplicity in the creatures' structure, deciding to depict a flock of them.

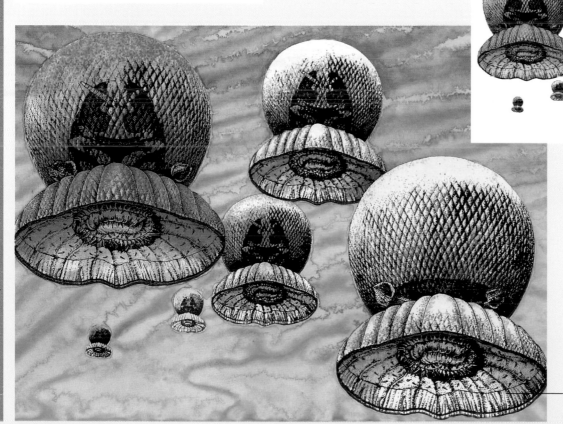

Last to be inserted was the background showing the turbulent atmosphere of Jupiter.

CHARACTER DEVELOPMENT

This character, "Metal Dreadlocks," was developed by Henry Flint for a comic-book series which was ultimately abandoned. The line drawings show the artist playing with the character's appearance and clothing. The more polished color work continues the development process, giving the character a more distinct personality.

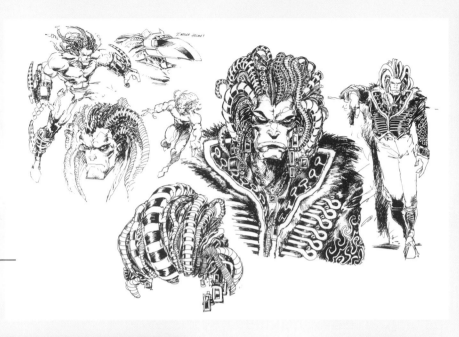

A sheet of character studies ————————— showing early concepts and the development of the character's personality through playing with clothing and facial expression.

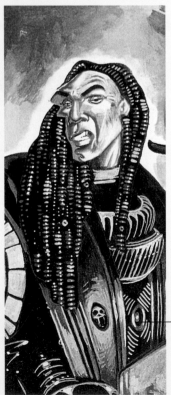

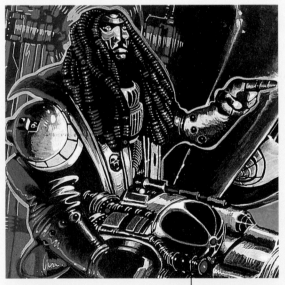

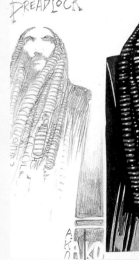

By the time first color sketches appeared, the character–and his dreadlocks–had evolved considerably, so that he now seems much more of a space-warrior type.

He has also become encumbered by items of hi-tech weaponry.

Further developmental sketches in both pencil and color concentrate on the personality rather than the hardware.

Fooling around with lighting effects, colors, and distortion of the face helped to give Flint greater insight into the character he was creating.

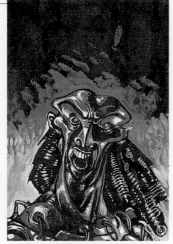

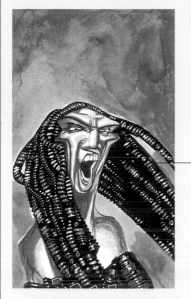

Sometimes the distortion could be highly exaggerated. The time had come to try out the character in an actual scene.

The original crude swash of color in which interesting shapes developed serendipitously.

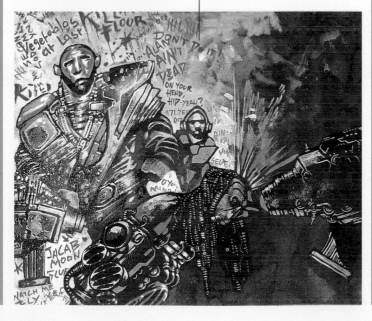

RANDOM EFFECTS In Henry Flint's "Offworld Cityscape," the foreground was drawn first, then the basic shapes of the midground and background. These latter were next roughly painted in a narrow range of colors, allowing irregularities to form randomly within each color area. The resulting faint shapes and edges were worked on with pen and brush to form architectural and machine-like shapes which were, in their turn, enhanced with further applications of color, as demonstrated in the swatches at the right.

Most artists gravitate toward a comparatively small selection of tools and materials: some will be happiest using gouache on canvas, with perhaps a touch of airbrush; others will prefer line and wash on cartridge paper, or oils on textured board, or . . . It is through such specializations, either deliberate or intuitive, that artists develop their own particular styles.

But you shouldn't let your preferred media inhibit you. Exploring different media can spark off new ideas–and ideas are what fantasy art is all about. In this book we have assumed that you have at least a nodding acquaintanceship with most of the commoner media–that you do not need to be told how to hold a paintbrush–yet we strongly advise you to examine the examples depicted in the following pages. You may be overlooking something very obvious–the humble ballpoint pen, for example–in your quest to achieve a particular effect.

Take some time, every now and then, to play with media–or combinations of media–that you would not normally use. You may find that working with these unaccustomed tools and materials starts your ideas flowing.

LEFT: Untitled piece by John Holmes.

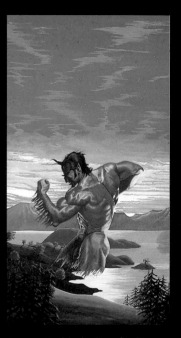

ABOVE: Untitled piece by Terry Oakes.

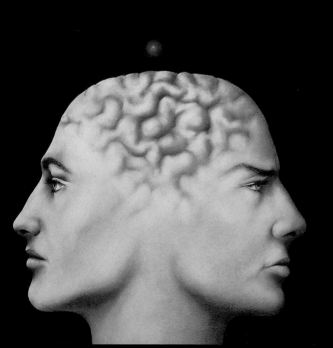

Untitled piece by John Ottinger.

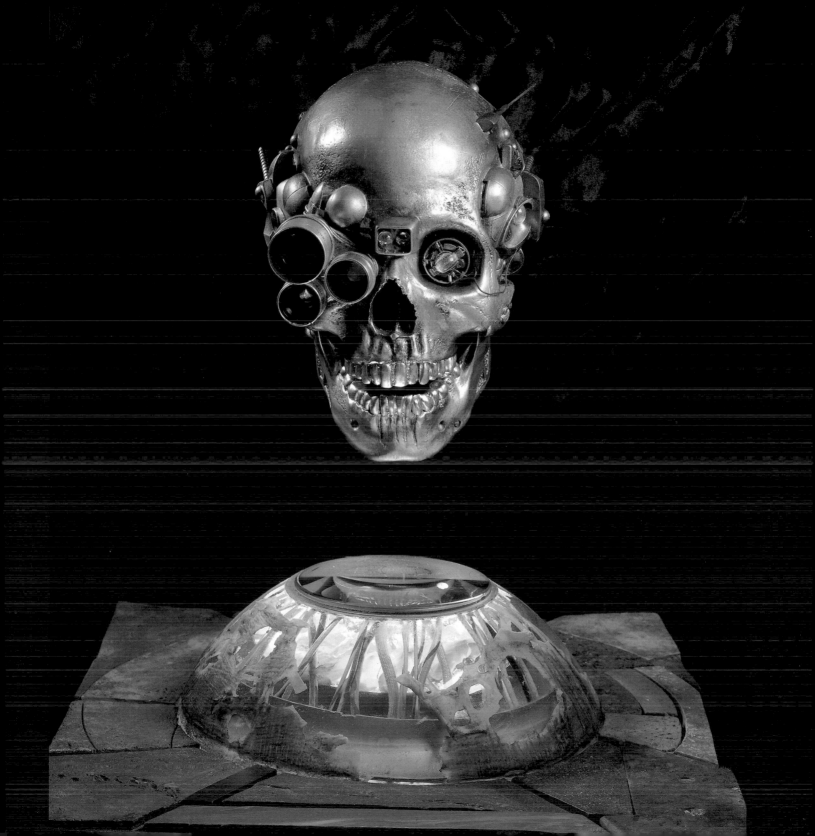

PENCIL

Pencils offer a very wide tonal range, with the added advantage that you can modify the drawing as you go. Pencil drawings should be protected with a fixative against smudging, particularly when the softer grades are used.

Texturing using varying hand pressure.

Overlaid hatched colors.

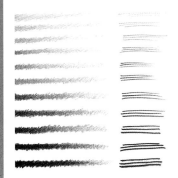

Graphite pencil grades.

Gradation using progressively harder pencils.

Texturing with soft pencil on rough-surfaced paper.

Watercolor pencil and wet brush.

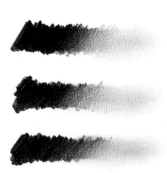

Blending using a 6B pencil softened by rubbing with a dry finger.

Texturing using a putty eraser.

Colored pencils, varying strength of color by hand pressure.

BALLPOINT PEN

A ballpoint pen is simple to use and can produce a precise, flexible line varying in intensity from pale gray to a good black. This versatility allows for a surprisingly delicate range of crosshatched tonal effects.

Crosshatching with lines of various strengths.

Informal curling line-hatching.

Range of line density.

Range of marks showing how depth can be created using different crosshatching and stippling combinations.

Range of tonal density using varying hand pressure.

TIP

- Ballpoints work best on smooth, fairly soft-surfaced papers. The ink is greasy, so keep a piece of soft paper towel nearby so that you can clean the point periodically.
- If you use ballpoint over a preliminary pencil drawing, leave the finished drawing for a couple of hours before erasing the pencil work or the ink will smear.
- Don't use ballpoints for artwork that is subsequently to be painted as the inked lines will in time "bleed" through the paint.
- Even black ballpoints are rarely lightfast. Drawings will fade if left in bright sunlight.

Curvilinear patterning.

Subtle effects can be achieved by stippling.

Linear patterning using circle template.

INK

India ink offers a good, solid black, though it can be diluted with water to offer a brownish-gray halftone. Colored inks can be mixed to achieve subtle colors, or laid one over the other in transparent glazes.

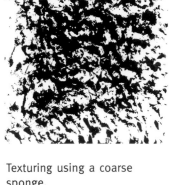

Texturing using a coarse sponge.

Dry brush.

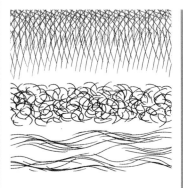

Linear texturing and hatching.

White lines scratched in dried ink surface.

Ink over masking fluid.

Wax resist.

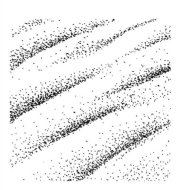

Point stipple.

Ink lines drawn with various pens and, at bottom, with a flat piece of wood.

Ink lines painted with brushes and Japanese calligraphy brushes.

TIP

Halftones, textures, and patterns can be obtained by crosshatching, stippling, spraying, spattering, or by dabbing the ink onto the paper surface with a sponge or textured cloth. If you use a hard paper, you can also scratch lines into black areas.

Two colored inks merging while still wet.

Orange ink brushed over dried yellow ink.

Blue ink dropped onto area of wet yellow ink.

Colored texture achieved using a sponge.

Acrylic inks on both sides of gel-coated acetate.

Acrylic ink painted wet-into-wet on gel-coated acetate.

Leaf print brushed over with green ink.

Spatter using toothbrush.

TIP

The great advantage of colored inks is their transparency; you can get clear, delicate effects by overlaying successive glazes of color. But remember that artwork done in colored inks is not lightfast. There is no way a picture in this medium can be preserved.

FELT-TIPPED PENS

Many line artists use fine fiber-tipped pens in preference to traditional pen and ink. Some felt-tips are lightfast and waterproof when dry; but not all, so check the pen contains waterproof ink.

Spatter and spray effects using compressed-air attachment.

Water-based felt-tips on wet paper.

Ruled-line quality–broad, medium, and fine.

Flexibility of free-style line.

Crosshatch technique using broad alcohol-based pen.

Merging water-based colors with wet brush.

Felt-tips used on back of paper to give a background, then hatched over on artwork side.

Overlaid transparent colors.

Crosshatching with small strokes of fine tip.

TIP

Two basic kinds of ink are used in felt-tipped pens: alcohol-based, which are waterproof, and water-based, which are soluble. Alcohol-based ink will mark almost anything indelibly. In general, felt-tip pens are not compatible with other media.

PASTELS

The main types are soft, or chalk pastels and oil pastels. Soft pastels need a textured surface to hold the pigment, and should be sprayed with fixative to prevent smudging.

The rough paper texture breaks up the strokes of soft pastel.

A putty eraser used to lift out soft pastel.

Soft pastel rubbed with a finger.

Oil pastel brushed over with mineral spirits.

Oil pastel used with colored ink for wax resist.

Watercolor on top of oil pastel.

Flat area using side of soft pastel stick on gray paper.

The same color on a pale blue-gray paper.

Overlaid crosshatching strokes in soft pastel.

TIP

Oil pastels have a greasy texture, allowing some interesting wax-resist effects. On the minus side, oil-pastel drawings always have a rather sticky surface.

Soft pastels are nearly always done on tinted paper. A wide choice of colors is available.

AIRBRUSH

The airbrush delivers color in a controllable spray. The nozzle can be adjusted to give a very narrow spray for fine detail or a broad one for larger areas, and the coarseness of the spray can also be varied.

Masking film in position over bottom left-hand corner.

Result after mask has been peeled away.

Gradation achieved by applying paint more thickly at top, using sweeping movements.

Blending two colors.

Effect when using cut-paper mask.

Effect when using torn-paper mask.

A fine airbrushed white glaze over lower half.

Use of spatter cup to provide a coarse spray.

TIP

The airbrush is particularly effective for rendering machined metal surfaces, the subtle gradations of flesh color, and broad areas of flat or finely blended color. Your airbrush must always be cleaned after use.

Effect when using fabric mask.

ACRYLICS

Acrylics can be thinned with water or used straight from the tube. Their consistency can be further altered by using acrylic mediums, and interesting textures can be achieved by adding materials such as sand.

Transparent glazes of bright color laid over one another.

Opaque layers painted directly on top of dried color.

Color scoured out using sandpaper and a knife blade.

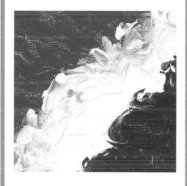

Paint mixed with an impasto medium can be used very thickly.

Dry-brush overpainting.

Gradated textured area applied with a sponge.

TIP
When dry, acrylic paints are completely waterproof. Their drying time is short, and the surface is tough and resilient. Because of their versatility and speed of drying, these paints are very popular with illustrators.

Glaze over a texture.

Scumble over a textured area.

OIL PAINTS

Oils are versatile, permanent, and durable. They have a fairly long drying time, although now substances are available which, when mixed with the paints before application, speed up the drying process.

Overpainting with opaque paint.

Color thinned with turpentine.

Glaze over sepia underpainting.

TIP

The traditional way of working in oils is to build up the colors in stages, beginning with a drawing and then an underpainting in monochrome, using paint well thinned with turpentine. The full range of color is then applied in the form of transparent glazes and light scumbles of opaque color.

The alternative method is to apply the colors direct, without an underpainting, known as working *alla prima*. The paint is usually applied in a sequence called "lean to fat," which means beginning with thinned paint and building up to thicker (fatter) color.

Underpainting in sepia.

Color brushed on straight from tube.

GOUACHE

These bright, permanent, opaque watercolors are probably the most popular paints among illustrators. They can be diluted with water for transparent applications or applied in opaque overlays.

Dried surface scratched with blade.

Airbrushed area graded using subsequent airbrushed white.

Transparent wash and glaze.

Blending wet-into-wet.

Wet semi-opaque overlayer dabbed with sponge.

Opaque color.

Opaque color over dried layer.

Softening an area using semi-opaque white.

WATERCOLORS

These offer a broad choice of transparent, lightfast paints. Watercolors come in tubes or as small solid blocks. The blocks can be bought in boxed sets, but most artists prefer to assemble their own palette by purchasing their colors separately.

Watercolor over masking fluid.

Damp color blotted with paper towel.

Watercolor used wet into wet.

Transparent wash.

Blending damp colors into one another.

Dry brush.

TIP

Watercolors have the slight disadvantage of needing constant attention during use to make sure they remain clean and unpolluted by other colors—which can occur when mixing.

With tube watercolors, a small amount of each color is usually squeezed onto a plate or plastic palette in roughly spectrum order before the painting is begun. A small drop of clean water can be put on each periodically to keep them moist for easy use.

Paper should always be stretched before use, as otherwise it can buckle when wet paint is applied.

MIXED MEDIA

This term applies to a wide variety of interesting combinations of painting and drawing media. Most fantasy artists occasionally use a combination of different materials in one piece of artwork, and a great many routinely do so.

Pastel on dry gouache.

Wax resist using watercolor over oil pastel.

Gouache flicked over wet watercolor.

Ink line in wet watercolor.

Gouache on top of dry watercolor.

Water-based marker over wet watercolor.

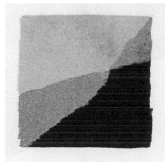

Semitransparent paper overlay/montage.

TIP

If you want your artwork to survive more than a very short time, you need to know which materials are and are not compatible with one another.

Avoid using two media which have very different drying times, such as oils and acrylics, because cracks and fissures are likely to occur very soon after completion.

Felt-tipped pens–particularly spirit-based ones–are incompatible with most other painting media; their colors may creep and spread out. Colored drawing inks, too, have a high incompatibility factor. In general, though, art materials get along surprisingly well together.

SUBSTRATES

If you want to produce artwork on an unconventional surface such as metal or leather, give consideration to the type of paint and the method of application. An unexpected reaction could cause decay.

Acrylic on unprimed millboard.

Acrylic primer dabbed onto smooth board for texture – suitable for oils or acrylics.

Primed cotton material (can be pasted onto board using primer) suitable for oils or acrylics.

Primed fine-weave cotton – suitable for oils or acrylics.

Acrylic on unprimed masonite.

Fabric paint on muslin.

Primed or unprimed burlap–for oils or acrylics.

Fabric paint on felt.

Primed sandpaper—suitable for oils or acrylics.

Acrylic ink on gel-coated acetate.

Airbrushed acrylic ink on enameled metal.

Acrylic-primed watercolor paper—for oils or acrylics.

TIP

Never make rash assumptions when preparing to paint on an unfamiliar material. The best way to avoid problems is to experiment thoroughly before you begin to paint. On a spare piece of the same material, apply some test colors, thickly and thinly, exactly as you plan to do for the final artwork. Allow your test to dry thoroughly, then scuff, scratch, and otherwise maltreat the base material. In this way, you can avoid having to return your fee or having to deal with difficult confrontations with aggrieved ex-clients.

Always make sure the surface is clean and not too smooth for the paint to adhere properly; check it has not been polished, oiled, or treated with any cleaning substance that may leave a residue.

The swatches on these pages show the effects which can be achieved with certain materials on a variety of unusual surfaces. Do not assume these are durable combinations. They are shown merely to give some idea of the possible visual effects.

Fantasy art is, at its best, an art of ideas. However technically proficient an artist might be, without the inspiring genius of imagination the results will almost invariably be unsatisfactory. Conversely, on occasion a quite poorly executed bit of artwork can represent an exciting piece of fantasy. Of course, we want to aim for the ideal: a highly imaginative picture done to the highest possible standards using the exactly appropriate materials. The starting point must always be the idea. Accordingly, although this alphabetical section of the book contains countless tips on materials, approaches, and physical techniques, most of its sections are determined according to conceptual considerations.

At the start of each section is a pair of paintings that stand as "visual definitions" of the particular facet of conceptualization we are trying to convey: they are exemplars of the type of effect you should aim to achieve.

At the end of most sections is an "exercise" box. All professional artists are likely to find themselves working to commission, usually for the printed media. In these boxes we present an example of a commission you might receive, and offer some suggestions as to the sort(s) of approach you might take. We don't expect you to follow the suggestions; we do hope they help spark off your own ideas.

One further major theme runs throughout this part of the book: experiment. Play with ideas and methods until you find something you like–then follow it through.

Jaran by Jim Burns.

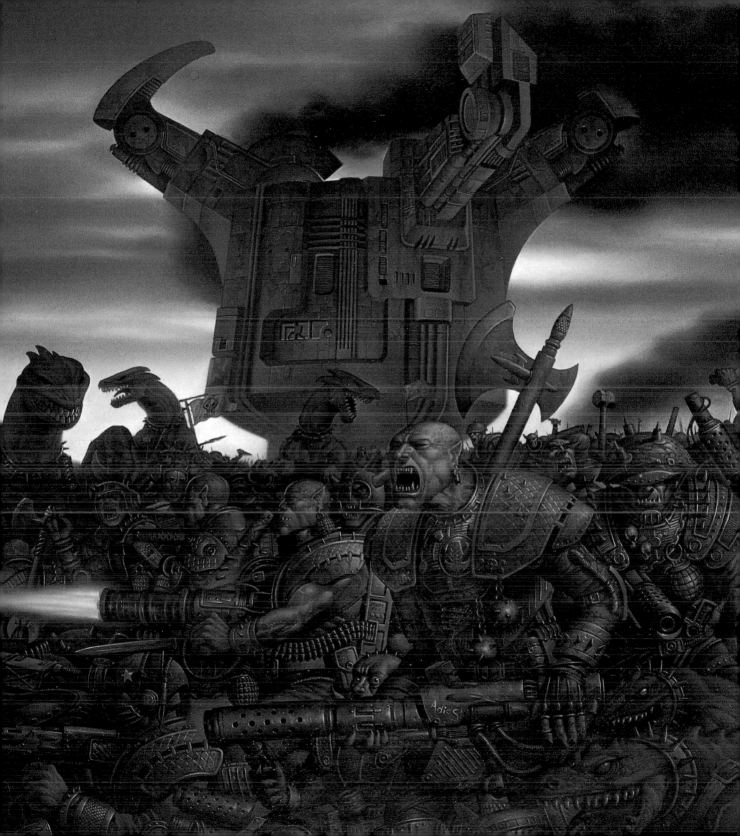

ALTERNATE REALITIES

Written fantasies often call the precise nature of reality into question, seeing the reality in which we live as no more than the superficial manifestation of what existence really is.

Behind the manifestation of reality, there may be a whole welter of other realities lying parallel to ours—perhaps the reality that lies on the other side of the mirror.

An obvious example of an alternate reality is fairyland, which since the earliest legends has been regarded as a world that co-exists with ours, to which we can hope to gain access through magic or special techniques. More recently, science-fiction writers have adapted this idea to that of parallel universes, resembling ours but separated from it by some change caused by past events. The artist can recreate—and extend—the feel of such stories to *show* what it would be like if we could see through the surface of our reality to the more exotic territories behind it. You can also overlay incidents that, although belonging to a single reality, are widely separated in time and/or space, thus creating a juxtaposition that is physically impossible but conceptually quite natural.

COLLAGING REALITIES At the most basic level, you can create such juxtapositions using a collage-type arrangement, which is what movie posters often do.

The idea is to integrate the various "shots" in pictorial terms, while making sure that they are perceived by the viewer as being separate. There are various devices you can use, such as employing wide diversities of scale, and lighting each of the shots differently. As a general rule, use bright front lighting for the shot that you want the viewer to regard as the base reality.

You can either keep the different lightings rigorously separate or grade them into each other. You can also try giving each of the shots a different theme color, which directly conveys to the

Further Information
☞
Juxtaposition; page 98
Lighting; page 100

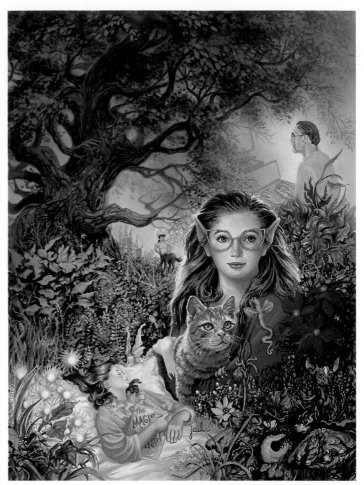

ABOVE: In *Letters to Jenny,* by Jael, the alternate realities are collaged together in such a way as to produce a nicely unified composition.

RIGHT: This piece by Alan Baker uses a different approach to alternate realities, with a "transparent" face superimposed on the rural-idyll vignette, so that both images can be viewed interchangeably.

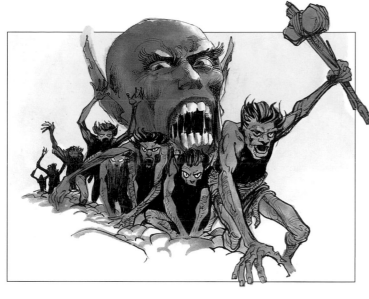

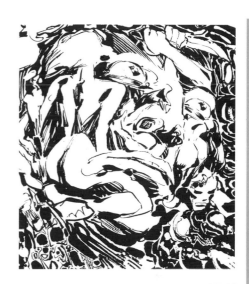

DUAL IMAGE It is possible to view this illustration by Henry Flint as a jumbled mixture of bodies and parts of bodies, but the arrangement of shapes can also be read as a human face. Interestingly, you can view the face only when you make a conscious effort to ignore the figures, and vice versa.

JUXTAPOSITION Realities can be separated out within a single image by giving them different scales and different theme colors, as demonstrated in this color sketch by Ron Tiner.

BELOW: Looking into someone's mind? Well, here's a crude way of doing so—an engineer's cutaway drawing of the person's thought as if it were a house. What goes on in this house's rooms varies radically depending on the type of person you're depicting. A painter's "rooms" will probably be quite different from those of a soldier.

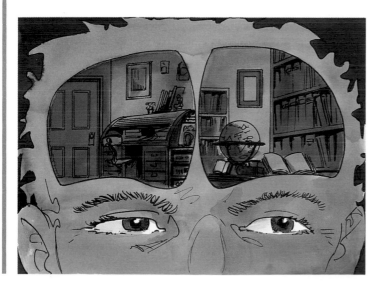

EXERCISES
You have been asked to paint the cover illustration for Thomas Palmer's novel *Dream Science* (1990). The underlying idea is that reality is an infinitely more complicated structure than we normally think. It is not one single existence, but fragmented, with all sorts of other shards spiraling around the main focus of reality, which is the part we live in. By various means, people can move from one shard to another, often changing form as they do so.

Here are some options you might consider:
● The image of a cloud of lesser realities orbiting a central one, like the clouds of stars being swirled around the hub of a galaxy, is a very powerful and attractive one. So you could think of showing the situation from the outside, as it were, with radically differing panoramas—some extremely fantasticated—showing within a selection of shards.
● Or you could decide to move in for a close-up. One of the ways in which people can be transferred from one shard to the next is through dying (in this respect, the shards resemble afterlives). So a dramatic effect might be to show the crumpled body of a murdered man with—both rising from it and passing outward through some invisible screen—his "spirit," transmogrifying (perhaps becoming female in form?) as it passes through the screen.
● Or you could go in even closer, perhaps showing a face partially torn away to reveal other incompletely rendered images, giving the impression that we are viewing the face through a not-quite-transparent screen.

AN ALTERNATE REALITY IS A WHOLE OTHER CAN O' BEANS One way to kick off an alternate-reality painting is to begin as Ron Tiner has here, with something so prosaic that it's hard to imagine any kind of "ethereal presence" behind it. A can of beans, for example...

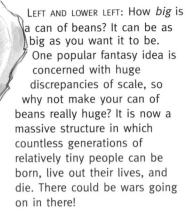

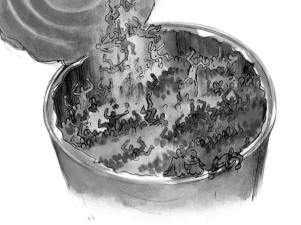

LEFT AND LOWER LEFT: How *big* is a can of beans? It can be as big as you want it to be. One popular fantasy idea is concerned with huge discrepancies of scale, so why not make your can of beans really huge? It is now a massive structure in which countless generations of relatively tiny people can be born, live out their lives, and die. There could be wars going on in there!

BELOW: If you look into a real can of beans, you see ... beans. But here lighting is used to convey that there is something quite *other* in the can.

viewer that the shots are set in different realities.

VISUAL PUNS Many of the expressions we use in everyday speech can be used as bases on which to build pictures that overlay conceptual realities. We talk of people having butterfly minds–so what would it look like if someone's mind really were a butterfly? Or we say someone is hagridden–which you could literally interpret to show them with a witch riding on their shoulders. Or we talk about someone's flesh crawling ...

In all such instances, the visual realization of the verbal expression forces the viewer to do a double-take–to "solve" an initially confusing visual image.

DEPLOYING ALTERNATE REALITIES IN GENRE FANTASY AND SCIENCE FICTION This can add a degree of interest and excitement to your treatment of subjects that might otherwise seem hackneyed and stale.

RIGHT: Tom Abba has used vast differences in scale to separate out the realities.

BELOW RIGHT: Phil Gascoigne has overlaid different realities on each other, reading from front to back.

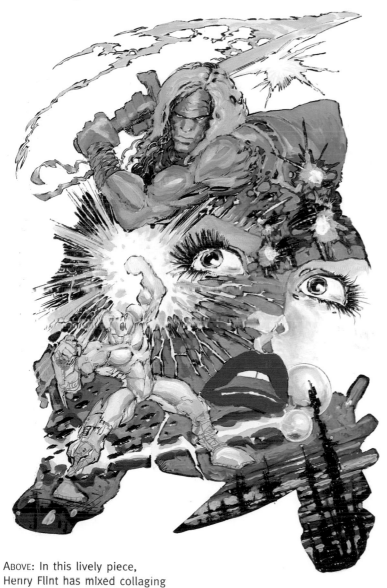

ABOVE: In this lively piece, Henry Flint has mixed collaging with scale differences.

ANTHROPOMORPHISM

The word "anthropomorphism" means the perceptual endowment of something nonhuman–whether living or dead– with human attributes.

In written fantasy and science fiction, it is something most often done (usually because of a failure of imagination) with creatures that are certainly nonhuman: if, in the racist conceptual vocabulary of too many fantasy and science fiction writers, the beings from Tau Ceti II, for example, are squat, greasy, and smelly, that's a sure clue they're treacherous bad guys because these are attributes we associate, in (fictional) human terms, with villainy.

To the fantasy artist, the term means something more: it refers to the grafting onto things that are dead (or at least immobile) of the characteristics of things that are living and mobile. A house, even when depicted as a collection of bricks and mortar, may also be portrayed as sentient–as having a will of its own. By extension, non-sentient living things may be regarded as fully conscious–like the Ents in Tolkien's *The Lord of the Rings* (1954–55), who are walking trees and have personalities.

The idea of the quasi-human tree goes back much further than that. Everyone has looked at the crenellations on a tree's bark and seen faces there. This was taken further by late 19th- and early 20th-century fairytale illustrators like Arthur Rackham, who rejoiced in showing trees with human faces. The Druids seem to have regarded trees as having souls and faces (an archetypal belief is that the possession of a face implies possession of a soul). Trees aren't the only ones given the illusion of (human) life by the projection onto them of faces: to choose among many examples, a rocky crag in the 1984 movie *The Neverending Story* is given the qualities of humanity because it has a face whose indentations can, just, be interpreted as delineations of a human face.

Anthropomorphizing a tree in order to unsettle a viewer is a fairly obvious gambit. Roots crawling above the surface can represent crooked legs, and branches and "groping" twigs made to appear like arms and hands.

ABOVE: *The Tree-Dwellers* by Alan Baker is a charming piece of anthropomorphism.

BELOW: *Nuclear Blast* by Dan Seagrave displays a nice dichotomy between what is obviously architectural on the one hand and just as obviously organic on the other.

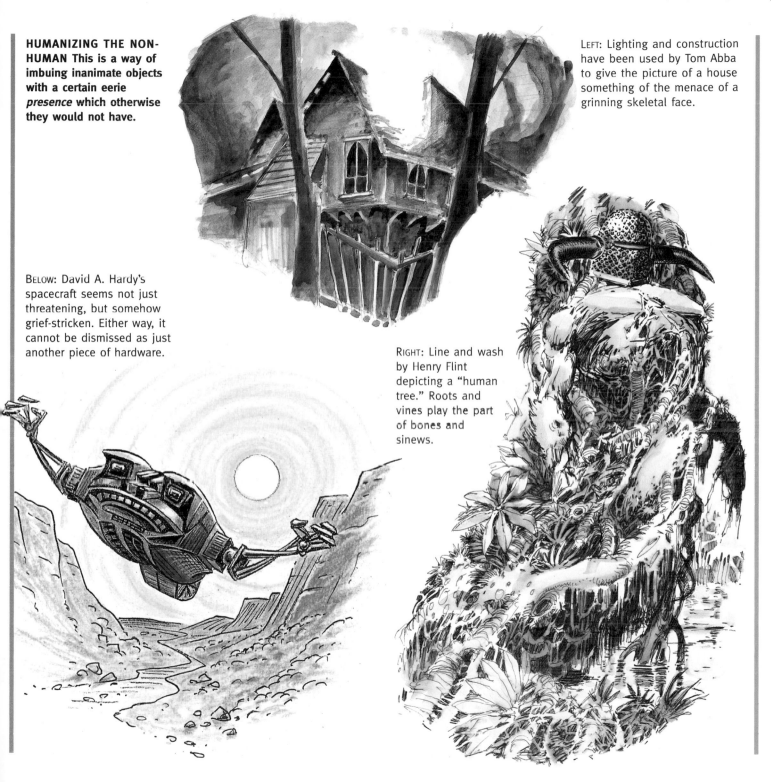

HUMANIZING THE NON-HUMAN This is a way of imbuing inanimate objects with a certain eerie *presence* which otherwise they would not have.

LEFT: Lighting and construction have been used by Tom Abba to give the picture of a house something of the menace of a grinning skeletal face.

BELOW: David A. Hardy's spacecraft seems not just threatening, but somehow grief-stricken. Either way, it cannot be dismissed as just another piece of hardware.

RIGHT: Line and wash by Henry Flint depicting a "human tree." Roots and vines play the part of bones and sinews.

Another way to give inanimate objects the semblance of life is to imbue them with a host of eyes; for example, the lens-shaped interstices between the branches of a group of forest trees might be (subtly) given pupils, so that the forest as a whole would seem to adopt a personality.

GETTING BEYOND THE OBVIOUS A more interesting option than merely grafting living features onto inanimate objects is to give them presence. One way you can do this is to give them not features, but overall shapes that call to the viewer's mind the idea of something living–that hint at sentience rather than show anything specific that might be thought of as sentient. If you show a person running away from a huge chunk of rock that looks as if it is top-heavy and about to topple forward, the viewer will interpret the rock-formation not only as threatening, but as crouching, about to spring. There may be no direct visual cue suggesting to the viewer that the cliff is sentient, yet that is nevertheless the idea that–through subtle visual allusion–is conveyed.

FRIENDLY (OR DISTINCTLY UNFRIENDLY) HARDWARE Don't forget that you can give machinery the appearance of having personality. The grin on a robot's face may make the machine either friendly or terrifying. A similar line put subliminally into the depiction of a spaceship can mean that it stops being a machine and becomes a "person"–with character.

ANTHROPOMORPHIZED HARDWARE Although the spaceship in this picture by Ron Tiner is certainly not a living organism, its insectile form gives it a "personality."

CAVES AND CAVERNS With their stalactites and stalagmites, rock formations and reflections in oddly shaped pools of water, caves, and caverns present an ideal collection of shapes into which to imbue hidden life.

These three anthropomorphized cave mouths, painted by Paul Campion, convey very different moods to the viewer.

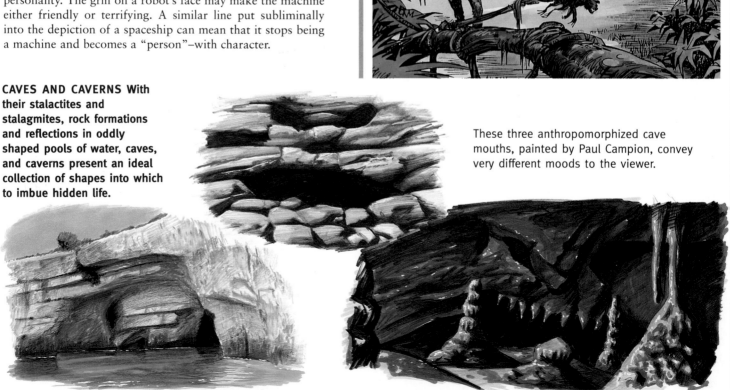

GRAPHIC GEOMORPHOLOGY
The artist can play with the viewer's emotions by using landscape shapes that are reminiscent of the human form in some way.

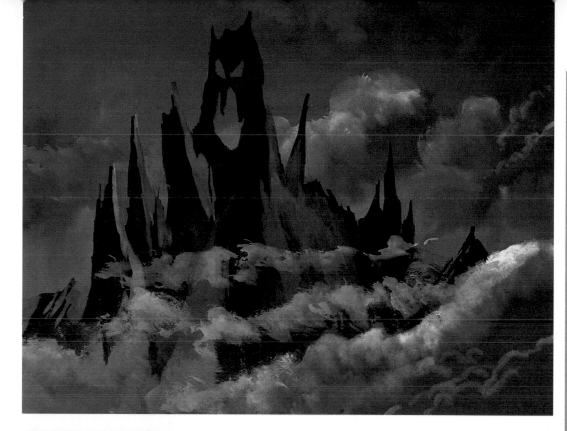

RIGHT: There is something demonic about this range of mountains painted by Ron Tiner. The animator Vladimir (Bill) Tytla used this sort of approach when creating Cernabog for the *Night on Bald Mountain* section of the Disney movie *Fantasia*.

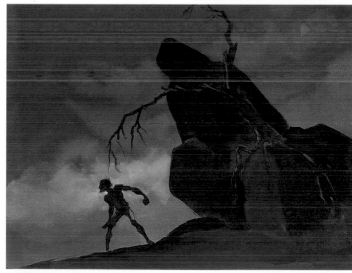

ABOVE: In this painting Ron Tiner merges the dark forms of the rock and the tree to make a threatening—and humanized—shape. But the main source of the humanization is actually the vulnerable-seeming figure in the foreground, without whom the landscape would be devoid of threat.

EXERCISES
You are asked to produce a poster for the David Cronenberg movie *Naked Lunch*, based on the William Burroughs novel. Throughout the movie, inanimate objects become animate; a recurring image is of an old-fashioned typewriter becoming a giant beetle.

● Imagine yourself looking straight ahead into the typewriter, with its rows of keys becoming a set of grins. Behind the keys is the platen, which you could envisage as a lengthened eye. Receding behind that are the bars which supported the paper in an old-fashioned typewriter; you could represent them as a beetle's antennae.

● Turn everything around. Instead of having the writer crouched over the beetle-like typewriter, you could have him working on a normal typewriter while, behind him, a huge beetle-typewriter shape crouches.

● If the keys of a typewriter resemble teeth, then the typewriter could be regarded as a huge insectile mouth, out of which the writer is fleeing. This is a great example of how you could use inversion of scale to produce that true fantasy feel.

BODY LANGUAGE

In real life we convey almost as much through our bodily posture as we do through the words we speak and the tone in which we speak them.

For example, the statement "Please wait your turn" can be a command, or a request, or a suggestion, or a supplication. Much of the meaning of the statement resides in the body language of the person who is making it. If they are standing with their chest puffed out, they are telling you to do something; if their shoulders are slumped and their face upturned toward yours, they are begging you to do it.

MOVEMENTS The ways in which people move give a key to their characters and even their occupations. The firmness of the line you use is one way of conveying this.

Imagine there's a panic on the deck of a starship. Someone reaches to flip a vital switch. The strong, firm lines of the arm and hand can show that this is the competent pilot, doing exactly what she has been trained to do; conversely, the same arm and hand can be fuzzily delineated (as can the switch itself) to show that this is someone who doesn't really know what they're doing. Or you could think of making the fingers long and delicate, their movements apparently superbly precise–like those of a musician on the strings of a musical instrument–to convey the notion that the individual performing the action is not a human being at all, but some elfin creature . . . perhaps even (bearing in mind the recruitment policies of 42nd-century starships) an elf!

TRICKS OF THE TRADE Don't be too frightened of making your characters perform exaggerated, actorish gestures. Remember you're giving the viewer visual cues, not accurate depictions of reality. If you came across someone in real life who used the body language of a stage Romeo, you'd just laugh, but that same body language, on stage, conveys powerful emotions. Remember: in a way, fantasy art is a performance art.

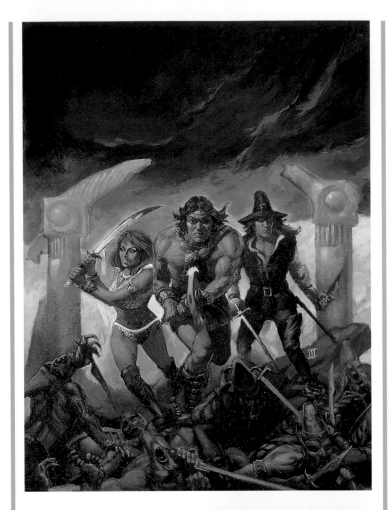

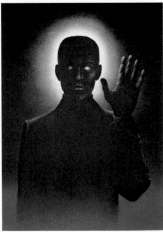

ABOVE: Even if we ignore the blood-smirched weaponry and the heaped corpses, aggression is written into the postures of the three stock sword and sorcery characters depicted here.

RIGHT: However unsettling the spectral figure in this painting by John Holmes might be, the fact that his hand is raised palm-forward conveys that he is not hostile, and indeed is trying to communicate peacefully.

SAYING IT ALL WITH POSES

In these sketches, Ron Tiner has used a combination of body language and physical character types to give very different meanings to the same few words.

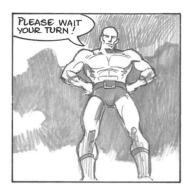 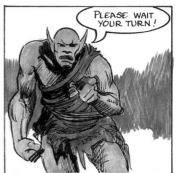

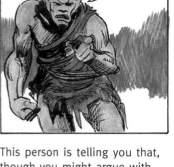

All the lines of this huge individual's body tell you you must wait your turn. There can be no arguments.

This person is telling you that, though you might argue with him, he would rip your head off if you did.

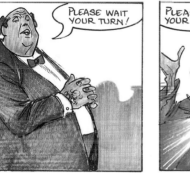 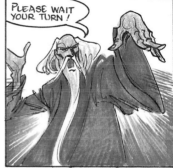

The floppy, lank hair enhances the idea of someone who is not demanding but humbly requesting.

This pompous person, hands clasped across an ample paunch, is *expecting* you to obey his command.

With a flamboyant gesture, a wizard tells you to wait your turn . . . and there is no question but that you will.

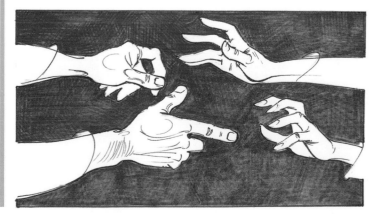

EXPRESSIVE HANDS In the "Please wait your turn" pictures above, the hands are usually playing an important part in the overall body language. Being able to draw expressive hands is an important weapon in the fantasy artist's armory, as demonstrated in Ron Tiner's illustration.

EXERCISES

You, rather than Michael Whelan, have been asked to produce the illustrations for the Meatloaf album *Bat Out of Hell II*. Jim Steinman's songs often focus on the difference between outward display and inner uncertainty. His typical "narrator" seems outwardly to be a complete knucklehead, but is actually deeply insecure, wanting romance but being inherently incapable of discovering it. There are various options:

● Stress the romantic aspects of the songs, displaying their female subjects as ethereal, almost fairy-like beings. (This is an option Whelan chose.)

● Focus on the dehumanization that many of the songs express, so that your pictures show weird scenes in which there are no human characters at all. (Whelan did this as well.)

● Concentrate only on the fantasticated images you can derive from titles like "Everything Louder than Everything Else," "Back Into Hell," and "Objects in the Rear View Mirror May Appear Closer than They Are"—not to mention the title of the album itself. (For the cover, Whelan showed a levitated motorcyclist assailing a gigantic bat-devil crouching atop a New York skyscraper.)

CHARACTERIZATION

Today we are so bombarded with visual images of different human types that it is hard to avoid making every character you draw a cliché.

At the same time, you want to use those clichés to give visual clues as to the type of character portrayed: if you don't make the barbarian mighty-thewed or the wizard scrawny and bearded, you may create a character the viewer can't interpret. To some extent, your characters have to conform to a perceived norm–however silly that norm might really be. It is up to you to superimpose touches of individuality on the clichés.

FACIAL TYPES Facial and cranial shapes can be categorized as brachycephalic, dolichocephalic, and mesocephalic.

In the brachycephalic look, all the facial features tend toward breadth rather than length. The profile is flattish–the nose doesn't jut much. The impression is that the person is physically strong and very "together." This is the kind of face you want to give to a character who is completely confident in his or her abilities. Brachycephalic faces communicate physicality. A brachycephalic face to which has been added excess fat looks self-indulgent and greedy. The same flat-facedness that in the male can evoke brutishness can be used to make a female seem totally in command of her body, and thus very sensual. If you want to emphasize this, contrast sensitive-seeming eyes with the flat facial features.

Associated with the narrow-headedness of the dolichocephalic look is protrusion of the features–the nose is likely to be jutting and beaky. We intuit that the person is ascetic and esthetic–they rely more on brain than on brawn, and can be vulnerable. At the same time they can be cruel. The dolichocephalic look was superbly exploited in the 1935 movie *She*, where Helen Gahagan, as She, could look in one moment vulnerable and in the next completely ruthless because of her exquisitely beaky face.

> **Further Information**
> ☞
> Body language; page 50

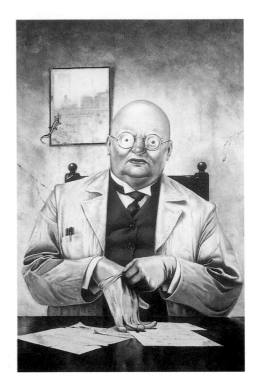

ABOVE: Les Edwards deploys various means of characterization in this painting –facial expression, body language, and a degree of exaggeration–to create a notably creepy effect.

BELOW: The clean-scrubbed face David Farren shows here typifies the "inoffensive" characterization you might use for an ad. Imagine the effect of swapping the faces in these two pictures!

FACIAL AND CRANIAL CLASSI-FICATIONS Anthropologists used to divide people into three categories: *brachycephalic* (broad-headed), *dolichocephalic* (narrow-headed), and *mesocephalic* (in between). These categories remain important to the artist because we all instinctively ascribe character attributes to different face shapes.

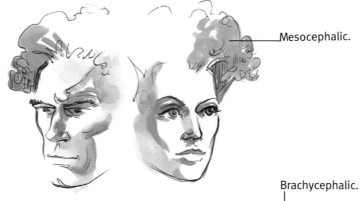

Mesocephalic.

Brachycephalic.

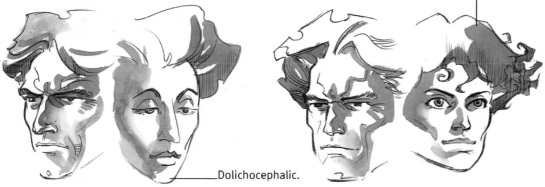

Dolichocephalic.

SOMATOTYPING This body-shape classifying system recognizes three types: *ectomorph* (rather fragile-seeming, bony, minimal flesh and muscle), *endomorph* (more softly rounded shape, large abdomen, small hands and feet, generally fleshy), and *mesomorph* (heavily boned, square, fairly well-muscled).

FACIAL FLESH Whatever the basic facial shape, you can alter a character's perceived personality by adding facial fat. The illustration above shows the five primary locations in which facial fat appears: from the side of the nose down to the corner of the mouth (1), around the jowls (2), on the chin (3), beneath the chin (4), and under eyes (5).

ABOVE AND BELOW: The same basic face with different distributions of facial fat, numbered 1–5 according to the drawing above left. In the final drawing (6), extra fat has been added in all five locations.

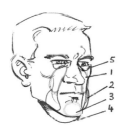

1

2

3

4

5

6

The mesocephalic look is what the ordinary person in the street has–it is neither broad nor narrow. As a fantasy artist, you can use this facial shape to portray exactly such a character: Mr. Everyman. This is the type of person whom you instinctively want to use as the mundane persona of a flamboyant superhero. In making this connection, you are pandering to the wish-fulfillment fantasies of your viewers, most of whom are likely to be average, mesocephalic people. Don't be afraid of making that connection!

HAIR The pattern of hair on a character's face and skull can be used to convey personality. Look at the thumbnail sketches here of a pair of "stock" faces given different types of cranial and facial foliage.

Curly hair can make someone look frivolous; straight hair tied tightly back makes them seem self-controlled, perhaps icy, or uncommunicative. Straight hair swept back off the forehead can be used to make a man seem arrogant or bombastic, but add glasses and he can seem severe or intellectual instead.

EXAGGERATING FACIAL CHARACTERISTICS The different locations of facial fat shown on page 53 can be exploited to give your characters exaggerated personalities, and so can the proportions of the face. In this group of thumbnail sketches by Ron Tiner, both techniques have been deployed to produce a very wide range of different perceived personalities.

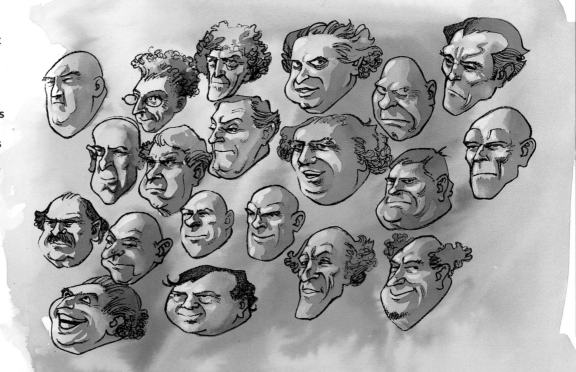

CLOTHING The way in which someone is dressed gives a strong clue as to what job they normally do.

RIGHT: A wizard traditionally wears flowing robes, and it would be ridiculous to garb him in a leather tunic and chain-mail loincloth, because that would be totally out of keeping with the actions he normally performs.

ABOVE: You should avoid ludicrous disparities, such as a female warrior clad in a gauzy dress that would be lethal in a battlefield, but to make the female counterpart of this warrior look good you could consider adornment–wristlets, armbands, etc.

EXERCISES
A publisher has asked you to draw a scene in a standard fantasy tavern with all sorts of characters jostling shoulder to shoulder.
● You want to convey the idea of a full range of stock fantasy characters. Someone stumbling into the tavern sees a sea of faces in which certain characteristics stand out, but not necessarily belonging to particular individuals. If you want to suggest, for example, that the assembled company is hostile to the newcomer, you could give one character an "unfriendly" physical attribute, like a fat chin; and then the next character some feature that you would normally incorporate into the face of the first, and so on.
● Or you could give all of the people in the inn a single characteristic in common, thereby unifying them even though all of their other facial appearances might be quite disparate.
● You could concentrate on a single face, making it as obsessively over-characterized as you like, then give lots of visual clues that the faces of the people behind this individual, although hidden from view, are equally horrendous. In this way you would be getting at that lovely fantasy feel whereby readers are performing the bulk of the invention for themselves.
● Alternatively, you could depict a somewhat hazy mass of faces as perceived in the reflection of a puddle of beer on the bar to convey the ambience generated by the different array of faces present in the bar.

COMIC STRIPS

All the best fantasy art has a sense of movement, of storytelling. Nowhere is this more so than in comic-strip illustration, where the artist has an overt storytelling function to perform.

Almost all forms of fantasy art are narrative art. Often, if you look at a good fantasy painting, you will see that, even though it depicts just a single scene, that scene implies two stories: the one preceding the scene and the one following it.

STORYTELLING A story isn't just the recounting of a series of events. Stories have structure–narrative form. They have a beginning (characters/scenarios are introduced), a middle (a number of interconnected events), and an end (satisfying resolution). Your strip succeeds if the reader identifies with one character or group and "lives" the story through them. Make sure s/he is carried along from one event to the next. Every frame should lead the eye on to the next frame.

There is certainly room in comic-strip art to do bits of fancy painting and drawing and to let your imagination take flight, but never at the expense of the basic job: storytelling.

DEFINITIONS Each picture in a sequence is called a frame; the narrow spaces between frames are called gutters. Dialogue is contained in speech balloons and thoughts in thought balloons. Narrative text is generally contained in panels and sound effects ("FX" or "fx") are usually lettered in a suitable style within a frame.

THE SCRIPT Some comic-strip artists do it all themselves, but most strips involve two people: a writer and an artist. (Various other people may also be involved.)

Your script will have a standard, frame-by-frame format. For each frame you will be told, first, what it is that the picture must show: this will be both a description of the scene and, possibly, a few words explaining how the picture advances the story–why this picture is necessary. Next you will be given the wording (if any) for the narrative panel and for the various

ABOVE: Page from *Dr. Who and the Cybermen* drawn by Michael McMahon. The flat black areas, juxtaposed with the clean linework, give a nice crisp effect.

BELOW: A page from a retelling of the *One Thousand and One Nights* adapted and illustrated by Ron Tiner. The densely hatched linework conveys the exoticism of the material.

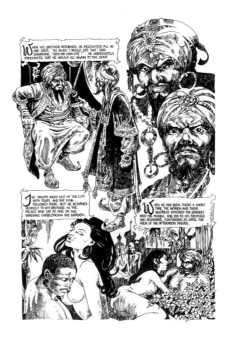

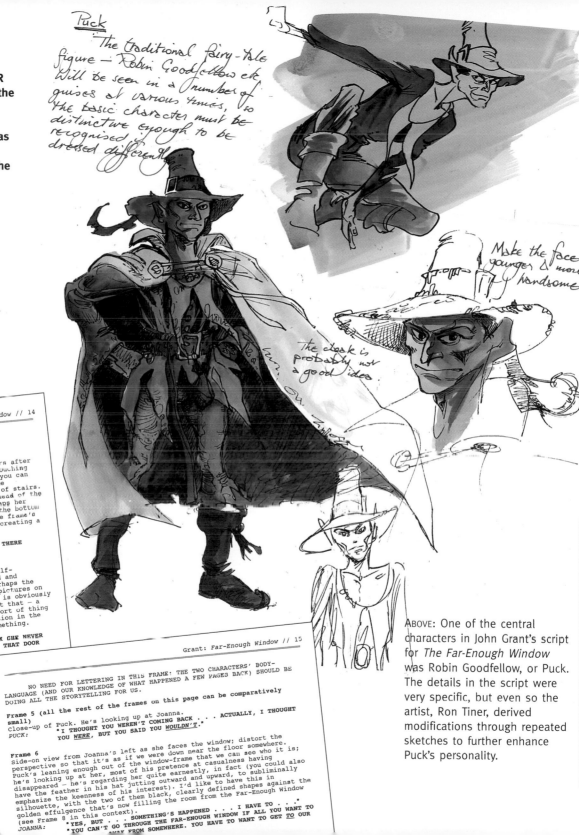

DEVELOPING A CHARACTER

When you first get a script, the writer's description and the personality that a character projects will give you ideas as to what that character looks like. Do lots of sketches of the character in different poses and performing different actions, bearing in mind the poses will also express personality.

BELOW: The script you receive gives a frame-by-frame description of how the writer conceives the story in visual terms. The amount of detail you are offered varies from writer to writer.

Puck
The traditional fairy-tale figure — Robin Goodfellow etc. Will be seen in a number of guises at various times, so the basic character must be distinctive enough to be recognised if dressed differently.

Make the face younger & more handsome.

The cloak is probably not a good idea.

Grant: *Far-Enough Window* // 14

...nd of tall, thin frame, looking up the stairs after ...s time near the top: her left hand is out, touching ...e a bit slumped, her head forward. I want the ...ht hand's by her side; even from this angle you can ...sant for her, this is a very l-o-n-g flight of stairs. ...ebby-feeling, too: clearly the room at the head of the ...n't quite reached, is fairly well lit, perhaps her ...ould be blocking out any direct view we, at the bottom ...of that light. Otherwise, it'd be nice if the frame's ...rt of percolating down from the top border, creating a ...t in the dark air.

...LTHOUGH SHE'D TOLD HERSELF SHE'D NEVER GO UP THERE

...om. Joanna's by the window, looking at it half-...expectantly. I think we can see just her head and ...one-quarter profile. Past her we can see perhaps the ...e of Aunt Hilda's grotty old age-blackened pictures on ...real focus of attention is the window, which is obviously ...try to capture a hint in the glass of the sort of thing ...source of illumination. At the moment it's just that — a ...know) lies beyond . . . maybe some imperfection in the ...iscent of Titania's flowing ringlets, or something.

...AST TIME SHE'D LEFT FAIRYLAND SHE'D TOLD PUCK SHE NEVER ...D TO SEE HIM — OR IT — AGAIN. HAD SHE CLOSED THAT DOOR ...ER?

...of the front of the house (don't forget ...windows lit (although maybe the lamp ov ...nough Window, which shines out like a be ...u can just see, very small, enough of a ...n of a silhouette) of Joanna to know tha ...Make the foreground as mundane as possi ...— so the contrast between it and what Jo ...Enough Window is as pronounced as possib

...AYS AFTERWARDS, SHE'D ASK HERSELF WHAT BR ...PROMISE . . .

...hould be the same shape as Frame 2) ...e as the Frame 2, except that Puck's now ...of the inner window-frame, but we can sense he' ...best to look casual, but we can sense he' ...ough pose to fool Joanna, who's beginning ...about the wisdom of what she's doing — she ...him: she's remembering only too well the ...though she knows full well his touch was ...ave the same taboos in Fairyland that her have ...make a sheltered young thing like her unease, and her ...He's aware of her . . . early as casual as

Grant: *Far-Enough Window* // 15

NO NEED FOR LETTERING IN THIS FRAME: THE TWO CHARACTERS' BODY-LANGUAGE (AND OUR KNOWLEDGE OF WHAT HAPPENED A FEW PAGES BACK) SHOULD BE DOING ALL THE STORYTELLING FOR US.

Frame 5 (all the rest of the frames on this page can be comparatively small)
Close-up of Puck. He's looking up at Joanna.
PUCK: "I THOUGHT YOU WEREN'T COMING BACK . . . ACTUALLY, I THOUGHT
 YOU *WERE*, BUT YOU SAID YOU *WOULDN'T*."

Frame 6
Side-on view from Joanna's left as she faces the window; distort the perspective so that it's as if we were down near the floor somewhere. Puck's leaning enough out of the window-frame that we can see who it is; he's looking up at her, most of his pretence at casualness having disappeared — he's regarding her quite earnestly, in fact (you could also have the feather in his hat jutting outward and upward, to subliminally emphasize the keenness of his interest). I'd like to have this in silhouette, with the two of them black, clearly defined shapes against the golden effulgence that's now filling the room from the Far-Enough Window (see Frame 8 in this context).
 SOMETHING'S HAPPENED . . . I HAVE TO . . .
JOANNA: "YES, BUT . . . YOU CAN'T GO THROUGH THE FAR-ENOUGH WINDOW IF ALL YOU WANT TO
 "YOU CAN'T GO THROUGH THE FAR-ENOUGH WINDOW. YOU HAVE TO WANT TO GET *TO* OUR
 ...Y FROM SOMEWHERE.

ABOVE: One of the central characters in John Grant's script for *The Far-Enough Window* was Robin Goodfellow, or Puck. The details in the script were very specific, but even so the artist, Ron Tiner, derived modifications through repeated sketches to further enhance Puck's personality.

SHOTS Like a movie director, be aware that the distance from which you view something—each "shot"—affects the reader's emotional reaction to that part of the story. Over the story as a whole, your choice of shots can entirely transform the reader's concept of the tale.

RIGHT: The long shot is often used as an establishing shot to orient the reader when there is a change of scene, or a shift in the viewpoint from which the tale is being told. It can also be a mood-setter rather than merely a scene-setter.

A general view conveys the relative positions of characters and surroundings.

The medium shot can be an action view or a mood-setter.

Use the closeup when you want readers to identify with one character.

Ultra-closeup is used to accentuate the emotion of a single character.

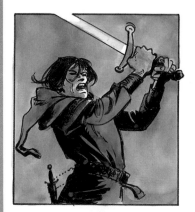

The up-shot makes the figure more impressive and can be used to add menace.

The down-shot renders the reader a voyeur—someone watching but not involved.

The angle-shot slightly disorients the reader and can add shock-value to a scene.

PAGE LAYOUT (right) The way you lay out a page gives that part of the story a mood. A formal layout simply relates a series of events. A splash panel adds force and excitement to one particular event. An informal layout encourages the reader's involvement.

characters' thought and/or speech balloons. You may also be given some FX to incorporate.

Read the script through carefully to see how best you can tell this story. Does it require delicate, decorative line drawing or dark dramatic shadows? You should think about how big and how small you want the various frames to be, and about how you want them laid out on the page: would they be best all roughly the same size and placed in neat rows, or should one be far bigger than the others, dominating the page? Bear in mind that your page layout sets the tone of the story. Should the reader be allowed to follow a simple ordering of the frames, or should there be a more complicated pattern of visual events? Remember you must give the reader enough information that he or she can follow the story.

Look out for the story elements–the crucial scenes, the significant characters, the relevant hardware. Imagine the script was for not a comic strip, but a movie: what would that movie look like? Try to visualize everything in motion.

MOVEMENT THROUGH THE STORY Manipulate the speed with which the reader moves through the story by attending to the composition of each succeeding frame. Rightward-directed composition speeds the reader up; leftward-directed composition slows

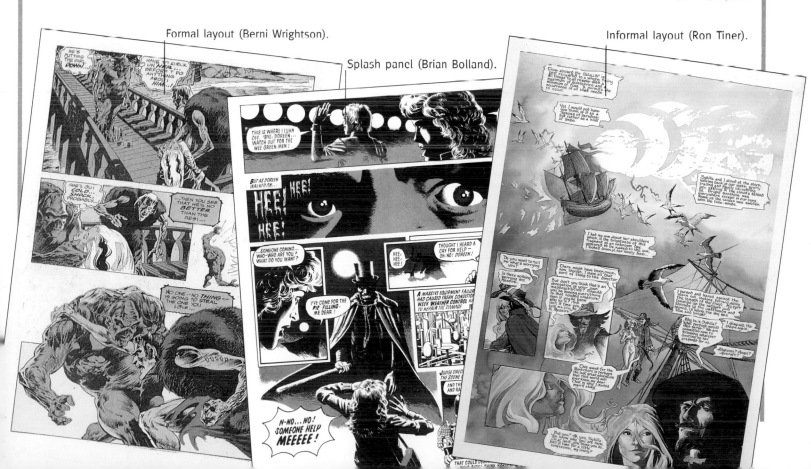

Formal layout (Berni Wrightson).

Splash panel (Brian Bolland).

Informal layout (Ron Tiner).

ARTWORK STAGES In doing the rough layout you are deciding how much space to give each picture, how the pictures fit together, and the relative prominence each should have. The shapes in the page's composition must lead the eye, linking one piece of lettering with the next.

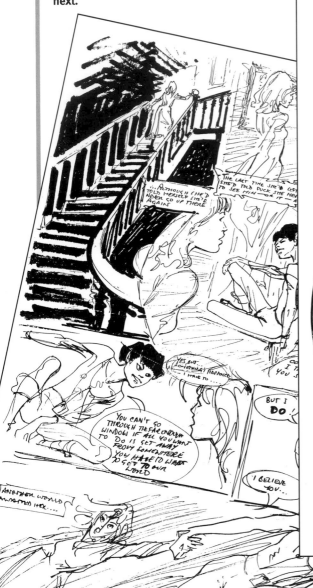

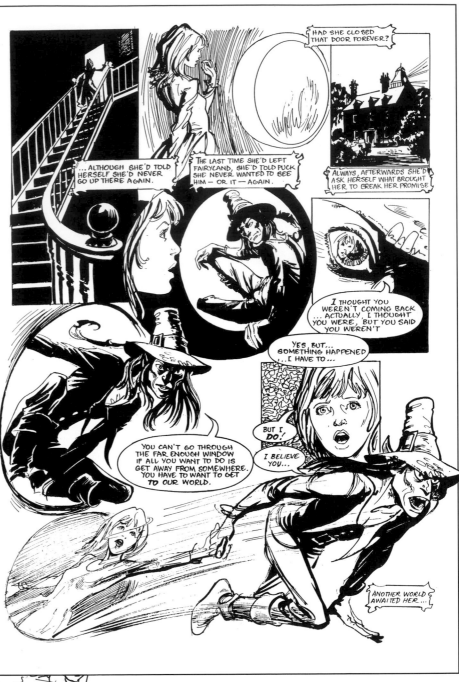

Left: The rough developed by Ron Tiner from the script shown on page 57.

Above: Finished black and white artwork. Don't start it until you have solved all the problems.

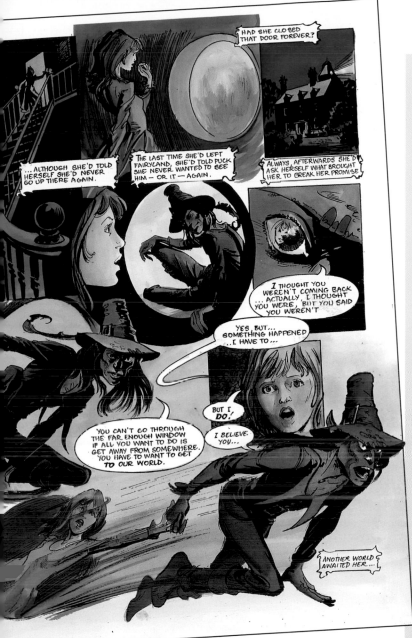

ABOVE: Your use of color need not—and likely will not—be naturalistic. Here Ron Tiner has chosen the colors for the emotional punch they can deliver. This page is doing a lot of work, setting one scene and then launching the characters toward another. This transition is important— hence, the great force and movement given to the final picture.

EXERCISES

You are asked to render in comic-strip form a scene in J. R. R. Tolkien's *The Lord of the Rings* (1954–55). Gandalf the Wizard, the two Hobbits Frodo and Sam, Gimli the Dwarf, Legolas the Elf, and the two men Aragorn and Boromir are passing through the caverns of Moria. They arrive at a vast chasm, at the bottom of which a hellish fire burns. The chasm is spanned by a single bridge of rock, and on the other side of the bridge they see a shadowy horde of orcs and the terrifying, batwinged balrog. Gandalf and the balrog meet in the middle of the bridge, Gandalf breaks the bridge with his staff, and the two fall into the fiery pit. Our heroes are safely separated from the orcs, but must now fend for themselves without Gandalf's powerful magic.

● You could draw the story from timid Sam's point of view. Begin the scene with an establishing shot showing the vast cave and the fiery chasm with our small group approaching it. Frame two shows a close-up of Sam's frightened face. Then show his view, past Gandalf and Boromir, of the shadowy orcs and, in their midst, the huge shape of the balrog. Next show a frontal view of Gandalf marching onto the bridge and issuing his challenge; behind him Sam clings to Frodo. The next frames should show Gandalf facing up to the balrog, then striking the rock bridge with his staff, all viewed from Sam's position. Then the two fall headlong, and last we see Sam as he realizes they have lost Gandalf's protection.

● Alternatively, you could ask your reader to identify with Gandalf. Start with a close-up of a stern, determined Gandalf standing protectively in front of his little group. The second frame needs to show a general view of the fiery chasm, followed by a distant shot of the orcs and balrog on the far side. Then a frame showing Gandalf setting out to cross the bridge, followed by a front view as he raises his staff and issues his challenge. A medium close-up from his viewpoint of the balrog strengthens the feeling of identification with Gandalf, before another general view of the pair falling into the fire.

● Or you might make the reader experience events from the balrog's viewpoint. First draw a close-up of the balrog among his cronies. Our establishing shot could show, from his viewpoint, the chasm and the distant group with the wizard at its head. A shot in medium close-up of the balrog moving forward toward the bridge is followed by its view of Gandalf setting out from the other side. Now show Gandalf looking small but dangerous.

COMPUTER ENHANCEMENT

It is a cliché that computer-derived art can never have the same warmth as art produced by "human" means, using a paintbrush or a palette knife or a pen or any other hand-wielded tool.

Like most clichés, this one is untrue, because a computer is a tool just like any other you might use. You can use computers to create pieces of art immediately identifiable as machine-produced artifacts, but you don't have to.

An obvious example of an area in which you often don't want your audience to be conscious of the fact that computers have been used is animation. For example, in the 1988 feature *Oliver & Company*, Disney made some use of computer animation. Critics objected to a few sequences in which computers had been used: they noticed that some New York cabs had clean lines rather than bumps and dents (as in reality –and as traditional animators would have rendered them). Disney took care in later features to make sure that audiences were conscious of the use of computers only when Disney wanted them to be.

You should follow the same principle. Feel free to produce structures that obviously could not be created by any means other than computers, but regard it as only a part of what you use computers for. In general, your audience should be wowing the artwork, not wondering how it was done.

In these pages we can show only some basics. Exactly what you do will depend finally on the software you choose to buy; the industry standard is currently Photoshop, for use with the Apple Macintosh. Any firm advice we gave on software would of course, be likely be out of date by the time this book was printed, so ask around to find out what other people think is the best–and the best-priced–presently on the market.

Further Information
☞
Distortion of form;
page 72
Lighting; page 100

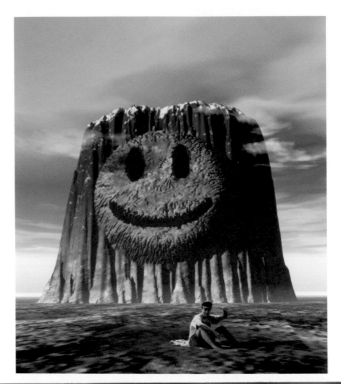

ABOVE: For these illustrations by Malcolm Tween 3D models of the scenes were constructed on computer, all its different parts –even some of the clouds– being created as wireframes. Textures were then wrapped around each other. The image can be viewed from any angle, or even animated.

LEFT: **The base file** This photograph was scanned to render it as a file. Copies were viewed on screen, and the various enhancements performed. Each enhanced version was saved as a separate file, and supplied to the printer on disk. In reality, you would probably want to perform a combination of enhancements, not just one. Images (not necessarily photographs) with sharp edges and clear definition are likely to give the best results.

LEFT: **Emboss** This is a striking effect. What the software does is render the image as a grayscale (the black stays black and the white stays white, with everything else being rendered in shades of gray—as on a black-and-white TV set), and then to optically "sink" the dark areas and "raise" the light ones.

RIGHT: **Color balance** You can adjust individually the amounts of red, green, and blue in the picture; the technique is commonly used not for the purposes of fantasy, but for "color correction"–to improve flesh tones. In the example shown here, the red has been doubled, the blue halved, and the green left the same.

RIGHT: **Rise** Similar to emboss, but all the color information is retained. The effect increases the apparent detail of the image, texturing areas that might have looked fairly smoothly shaded in the original. Rise can be used to produce, among other things, interesting backgrounds: compare the one here with that in the unmolested original. This enhancement has the effect of artificially aging organic subjects.

LEFT: **Line art** Also known as edge detection, this enhancement finds boundaries between areas and outlines them, removing the colored areas themselves; the result is a sort of lattice. You often find you get interesting textural effects in areas that were made up of small splodges of color.

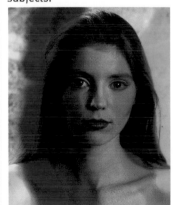

LEFT: **Tinting** This is the easiest form of manipulating the colors of the picture. You simply "paint" fresh colors onto the image using the software's mouse-controlled "airbrush." As with all the other techniques described on these pages, you'd usually use this only on a part of the image, not all over it, as here.

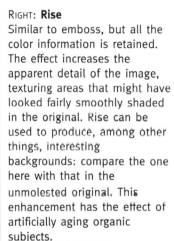

Hardware: Amiga 4000/030; Software: Photogenics, from Almathera; Model: Sadie Rule; Artist: Paul Hamilton

LEFT: **False color**
The original picture is unaltered, but all the colors have been changed – usually into "impossible" ones. You achieve this by first selecting colors, in order, from the palette the computer offers. The computer then substitutes the colors into a grayscale version of the image, using the first color for the darkest areas and so on through to the last color for the lightest areas.

LEFT: **Posterizing** In this enhancement, the software greatly reduces the number of colors in which the image is rendered–in this instance to the lowest possible number (the computer's six "video primary" colors–red, green, blue, yellow, magenta, and cyan–plus black and white). The visual image simulates a screen print. The more colors you add, the more closely the image approaches true color.

RIGHT: **Saturation** This allows you to adjust the saturation level (color strength) of the image. The software looks at each dot of color (pixel) in the original and pushes it toward the purest form of that color. The overall effect is to make the image very brash–almost offensively so, if that's what you want!–and, incidentally, to brighten the image up. Here the saturation has been increased by 200%.

RIGHT: **Randomizing** The software scatters individual pixels, moving them in a random direction to a new location within a prescribed radius of their original position; the result is reminiscent of seeing the original through frosted glass. The radius defined to produce this example was quite small; the larger the radius, the less recognizable the image will be.

LEFT: **Solarization** The software emulates the photographic technique whereby undeveloped film is deliberately exposed to light. Experiment with differing amounts of false solarization until you get what you want–indeed, experiment could be regarded as the key to all computer enhancement: unlike the case with orthodox techniques, you're never committed to an effect until you decide you like it.

LEFT: **Motion blur** The software here simulates the photographer's (deliberate) camera shake in order to blur the picture in a straight line. You control the angle of that straight line–in this case, it is vertically upward–and the degree ("distance") of the blur. Obviously this is an enhancement you can exploit to create speed effects, but there's no need to feel that's its only use: play with the software until something interesting appears.

ABOVE AND BELOW: **Displacement mapping** The easiest way to think about what the software is doing is to imagine you are looking at the original through an uneven pane of glass. You control the precise shape of the "glass"–selecting a map, like that shown above, onto which the elements of the original will be plotted by the software in order to produce the result shown below. One use would be creating an image of something reflected in rippling water.

Combining techniques This picture–*Desire*, by Paul Hamilton–has been created from the original photograph using a broad spectrum of computer-enhancement techniques, including several that are not discussed here (you will discover them for yourself when you start using the particular software you have purchased). The most significant of these is the facility offered by the software to compose pictures using elements taken from several originals. Here a new background has been added and the considerably enhanced image of the model overlaid onto it; equally, you could take a background from a different source and use it similarly. You might create a picture like this if you were asked to produce the cover artwork for a new printing of Colin Wilson's classic novel *The Space Vampires* (1976).

CREATURES

Paradoxically, if you want to depict alien or fantasticated creatures, the first thing you must know is how everyday creatures are put together.

If you are to show a unicorn, you must first be able to draw a horse. Always think about the function of a creature's body. Physical forms evolve as a response to the way a particular organism can best function in its environment. Fantasy environments may be bizarrely different from those on Earth –for example, you might want to paint a creature that lives in the atmosphere of Jupiter, and so must operate normally in three dimensions of movement rather than two. But most often the environments won't be that different. To take the example of the unicorn again, this creature is likely to spend its time galloping across plains or roistering along river banks: the grass may be blue and the sky red, but essentially the animal is operating in an Earth-type environment.

Get hold of some books on animal anatomy–biology textbooks are as good as any. Don't just stick to the mammals: look for diagrams of reptiles, insects, and marine lifeforms as well. Once you see how the bones of an animal's skeleton fit together, and how the muscles overlay that skeleton, you are well on the way to being able to portray the animal in motion.

COMBINATIONS OF ATTRIBUTES Many of your fantasy creatures will not be so simply related to real animals. They are likely to combine attributes drawn from two or more creatures. Legendary monsters are often like this. The centaur is a mixture of man and horse. The gryphon has a lion's body but an eagle's beak and wings. The creatures you create are likely to display similar combinations. The creature devised by H.R. Giger for the *Alien* movies, even though made as otherworldly as possible, has attributes of humans, insects, crustaceans, and deep-sea creatures. Play around with elements of various different living animals and see how bizarre you can make the combinations. Never forget that the creature has to look as if it might function in some environment or another.

ABOVE: *Capricorn* by Sue Ellen Brown. The fish-tail of the goat refers to the association between Capricorn and the Babylonian sea-god Ea, known also as the "fish-ram."

BELOW: To create this picture, Terry Oakes obviously studied real marine creatures; the beast looks as if it would function in its habitat.

ONE FOOT IN REALITY The most convincing art is made by grounding the creatures with which you populate your fantasy landscape in reality– that is, making sure that, however fantastic in appearance, they are functional in their own terms.

RIGHT: In these sketches Ron Tiner has made preliminary studies of an ordinary horse before making the fantastications necessary to produce images of mythological creatures.

BELOW RIGHT: That functionality is a key is demonstrated by this sheet of improvizations by Henry Flint–you only realize after a few seconds that a couple of the insects are jokes.

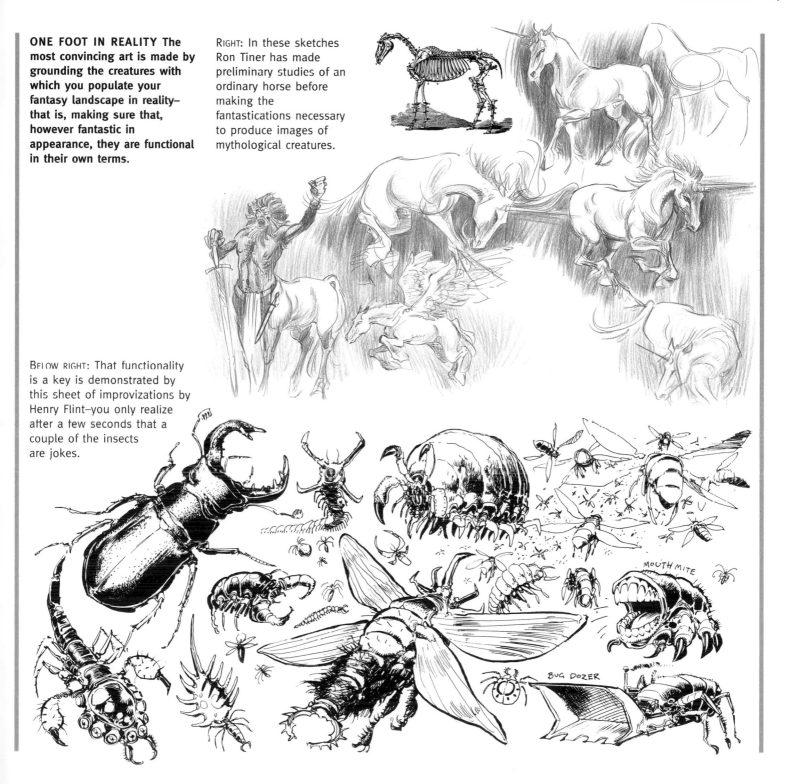

MOUTH MITE

BUG DOZER

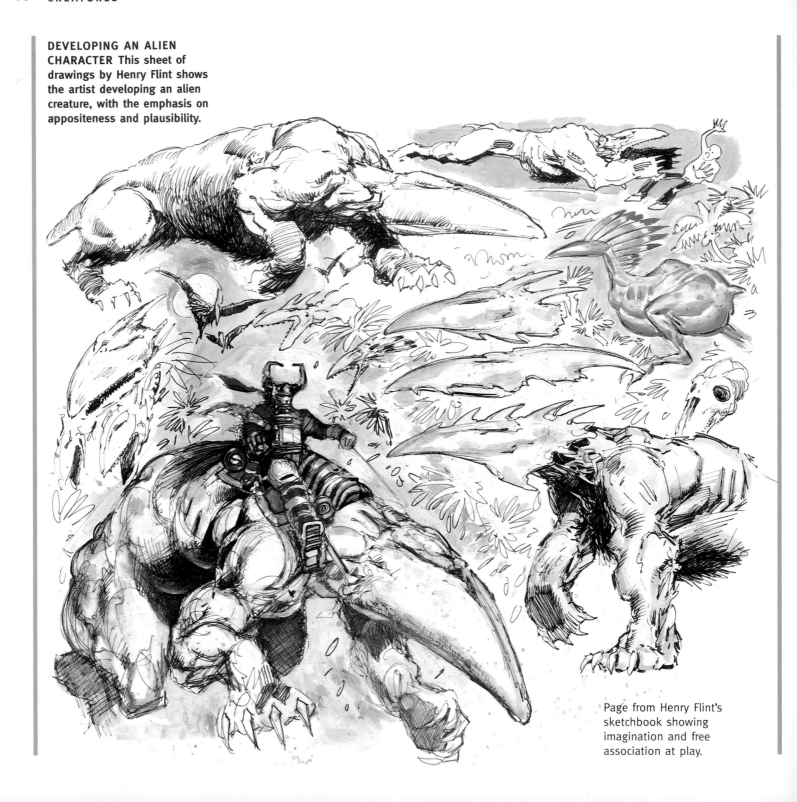

DEVELOPING AN ALIEN CHARACTER This sheet of drawings by Henry Flint shows the artist developing an alien creature, with the emphasis on appositeness and plausibility.

Page from Henry Flint's sketchbook showing imagination and free association at play.

PLAYING WITH IDEAS This process can take you a long way from your original scheme for a fantasy creature, but the overall process has to be kept under control. As you sketch, let your imagination roam freely, but every now and then pause, have a look at what you've got, and rein in your sillier ideas.

ABOVE: Elements of insects and reptiles combine in this drawing by Paul Campion.

RIGHT: Another sketched idea by Paul Campion—the jellyfish from Hell!

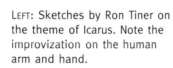

LEFT: Sketches by Ron Tiner on the theme of Icarus. Note the improvization on the human arm and hand.

EXERCISES

You have been asked to produce a set of illustrations of the types of extraterrestrials that might exist on other planets in the solar system. Have a look at the environments these creatures are supposed to inhabit.

● On Venus the surface temperature is about 830°F. This is well above the boiling point of water, and well above any temperature to which you'd normally set your oven, so there is no possibility that any lifeform like ourselves could exist. It is possible that lifeforms could be based on the element silicon—they would be very rock-like creatures, and they would move very slowly.

Because the temperature on Venus is so high, the surface rocks glow red. Also, the thick atmosphere causes a high degree of refraction.

● On Mars there is almost no free surface water, but much may exist below the surface, frozen. Any Martian creature would have to be ground-hugging and small. But a single individual could extend over a huge area of the ground. Imagine yourself into the mind of such a creature.

● Jupiter is a huge planet, but most of it is either gas or liquid. A creature in this environment would have to be able to move up and down with the same ease that it moved from side to side. A likely creature is one whose thin-skinned body contained lots of air-sacs, so that it could, in effect, burp its way from one place to another.

DISPLACEMENT

The object of much fantasy art is to "displace" viewers from the mundane world by giving them clear signals that what they are looking at is in some way definitely *other*.

You are aiming to lift the viewer from the ordinary into the extraordinary. Often this is no particular problem: if you're showing a scene full of dragons, the viewer needs no further clue that this is not something taken from the real world!

The technique of displacement, however, is much more subtle than that. You present the viewer with a picture that seems, on the surface, completely mundane, and yet the viewer is aware from the outset that there is something wrong with it –something other. One or more elements of the picture have been displaced away from the mundane. M.C. Escher was a master of displacement: many of his pictures seem perfectly normal at first sight, but a few seconds later you realize that the structures or events they portray are completely impossible.

Try doing some sketches from life and introducing to them some out-of-place element. If you're waiting for a train, do a quick drawing of the other people standing on the platform, but add something of your own invention to make the scene bizarre. Be as subtle as you like: a line or two may be enough to create the sense of unease, of oddness, that you're trying to capture.

Further Information
☞
Alternate realities; page 42
False perspective; page 78
Lighting; page 100

LEFT: This illustration by Russell Morgan deploys distortion of scale and plays with the rules of perspective to achieve a result that on first sight seems perfectly logical. Only after a few seconds does the viewer get the sudden feeling of displacement.

BELOW: This picture by John Holmes could serve in itself as a perfect definition of our use of the term "displacement."

NOT QUITE NORMAL One way of achieving displacement is to present a mundane scene in which the viewer notices something distinctly wrong after a while. On this page, three artists approach this notion from the same starting-point–a rail station–and offer three very different displacements.

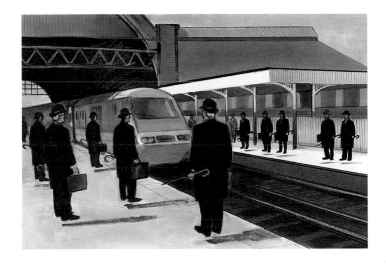

LEFT: In this Ron Tiner sketch, all seems normal until you spot that the commuters are floating a few inches off the ground.

BELOW CENTER: A line of predatory-looking slot machines lurk along Paul Bartlett's station platform.

BOTTOM LEFT: Henry Flint has reversed the situation – showing trains standing on the platform waiting for a human to clatter in.

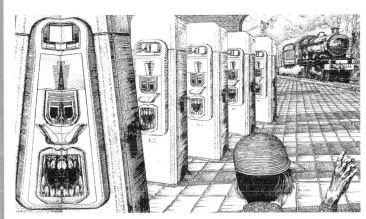

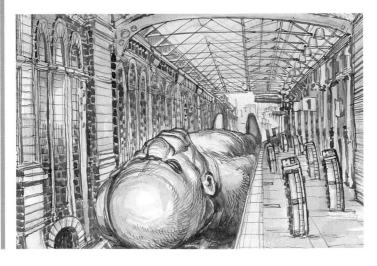

EXERCISES

You have been asked to produce a set of pictures for the Gene Wolfe novel *There Are Doors* (1988). This is set in two different realities, one being our own. The other is a sort of tinpot-dictatorship version of the United States. This second reality seems perfectly plausible to the narrator, but to us it becomes progressively more fanciful. The setting itself is not impossible, and each scenario, seen in isolation, seems reasonable, yet by the end we realize that we have been seduced into very bizarre territory.

● You could show scenes in that other world as completely mundane except for an occasional billboard saying something strange like "Death is Life," showing that this is a society whose public precepts differ from those of our own.

● The secondary world could be somewhere the narrator has created out of his desire to escape from our world. To illustrate this interpretation, you could show normal-seeming scenes containing fantastic elements. A line of people waiting at a checkout might each have some fantasticated attribute, like wings or a third eye. You could thus convey that there is much in the scene to be observed which the narrator himself *is not observing*.

● You could turn the events described by the narrator completely on their head, showing the secondary world as completely bizarre, but with the narrator seeing nothing but the normality he wants to perceive. That checkout line might be made up of unicorns and dragons.

DISTORTION OF FORM

One of the standard techniques of fantasy art is to turn something mundane into something otherworldly by using an odd angle of observation.

Curious and intriguing foreshortening effects are created by rendering scenes from odd angles. People standing in a line in a store would look really weird if you were lying on the floor and looking up at them from there–hugely enlarged legs, tiny heads, and so on.

The idea of distorting form is related to this, but with a major difference. Instead of looking at something (say, a person) from an unorthodox angle, you create an even greater oddity because there is no visual cue to the viewer as to why some parts of the subject are grossly deformed by comparison with others.

MORPHING One of the most popular current special-effect movie techniques is morphing, which involves using computer-animation techniques to give objects (usually people) impossible shapes. Part of the excitement of movie morphing is that the images are in motion, but a static form of morphing–really an imitation of morphing–is an integral part of much fantasy art. Some of the effects you can achieve by distorting forms are very obvious, like the ones mentioned above, but others can be much more subtle, and convey an otherworldly feel precisely because the viewer does not consciously realize you are using them.

For example, the legs of an elemental creature in flight might be such that it would be impossible for it to actually stand up. The viewer does not consciously realize this, but nevertheless gets the subconscious input of otherworldliness. Some classical painters, notably Titian, used this idea when depicting mythological or biblical subjects.

Further Information
☞
Computer enhancement;
page 62
Exaggeration; page 76

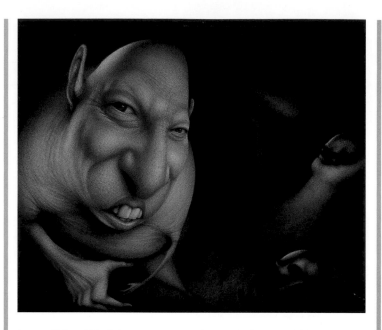

ABOVE: Brian O'Dell has colossally distorted the human form in order to produce an extremely unsettling monstrous creature.

BELOW: A forest of distorted human forms occupies this illustration, *Loaded*, by Michael Helme.

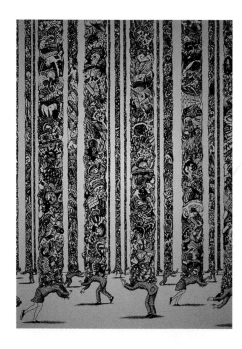

DISTORTING ON A GRID
When distorting a form, it is best to do so in a consistent fashion. One way to do this is to place a rectilinear grid over an undistorted version of the picture, then twist or bend the grid.

A pair of examples by Ron Tiner of how distortion of a grid can generate weird deformations.

BIZARRE FORESHORTENING
Drawings by Ron Tiner showing how you can create strange, even unsettling, distortions of perception by exaggerating the effects of perspective.

EXERCISES
You have been asked to produce some visuals for a new CD/ROM game. Currently even the least efficient CDs have a hugely greater number of accessible bytes than the largest hard disk you are likely to have on your PC. But even on a hard disk, you can have a lot of fun distorting forms, assuming you have a scanner (even a cheap, hand-held scanner will do). Scan in a suitable image to work with—initially in black and white rather than color, as otherwise your experiments will become prohibitively expensive in terms of bytage—and start fooling around with it. If the image is that of a human (or humanoid) try:
● Pulling one half of the face out to one side, leaving the other looking normal. You could even think of turning the drawn out half of the face into a smear running right out of the frame.
● Making the person enormously top- or bottom-heavy.
● Putting in some completely random factors—just play with the various controls without even looking at them, and enjoy the effects of serendipity.
● Play with the angles from which you are viewing the character. Once you find one you like, exaggerate the foreshortening to a ridiculous degree. Or try reversing the foreshortening: if you are looking up from ground level at the character, make the upper part of the body much larger than the nearest parts.
● Once you have achieved an image that pleases you, use a printout as the basis for your painting.

Erotica and Exotica

Erotic fantasy art has been in existence for at least a century—just take a look at some of the paintings by Sir Lawrence Alma-Tadema (1836–1912).

In the past couple of decades, it has become ever more popular. This aspect of fantasy art crosses over rather too easily into pornography, but it cannot be ignored: you will probably be asked to produce erotic fantasy art during your career. The usual features are underclad women and, less frequently, underclad men. Often these are accompanied by a piece of hardware (like a motorbike) or an exotic animal (like a leopard).

The basic skill is to portray the figures as smooth—as if they had been coated in oil. The odd thing is that, if you met people like these in real life, you would probably turn and run. Most of the artists who work in this subgenre use models or (more often) photographs of models as direct reference. This gives them all the visual information they need and allows them to concentrate on those sleek, sexy qualities.

If you wish, you can use an airbrush to create that effect of ultrasmooth skin texture. Alternatively, you could try successive layers of transparent washes of watercolor.

WARNING All published photographs are the copyright property of the photographer. If you do not own the copyright to a photograph, do not base artwork on it.

CLOTHES If your subjects are clothed—and most often they won't be—aim for clothing that decorates and reveals, caressing the body lines. Most modern clothing hides or supports the body, which is exactly the opposite of the effect you want to create.

ANIMALS Black panthers and leopards are suitable accompaniments to an erotic fantasy picture. Fantasy creatures are other likely elements: a unicorn, in juxtaposition with a suitably virginal-looking woman, can bear a tremendous erotic charge.

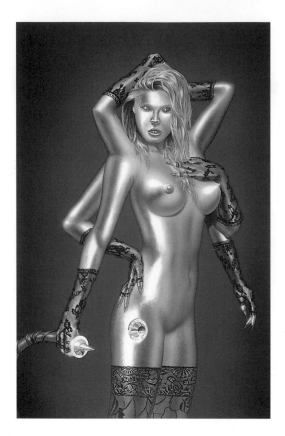

ABOVE: *Dear Santa: Please Can I Have ...?* by Paul Campion. Enough said!

BELOW: *Chain of Fools* by Chris Achilleos. One way of making exotic humans look convincing is to make them compatible with creatures sharing the picture.

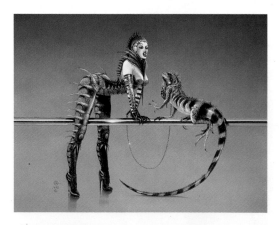

BUILDING UP A FANTASY To paint *The Young Dragon Trainer* Chris Achilleos used a fairly ordinary-looking person as a basis upon which to build a highly fantasticated figure.

RIGHT: The artist embellished and enhanced the first image – a touched-up photograph – until he effected an almost complete transformation from domesticity to erotic otherworldliness.

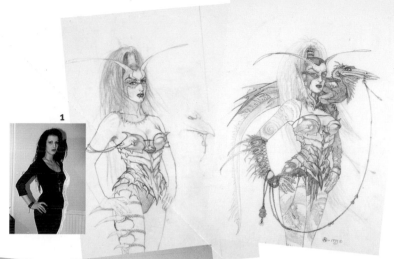

1 The image is worked up in pencil on tracing paper, with overlays of tracing paper being added each time an alteration is made. Once Achilleos is satisfied he creates a master-copy on the topmost sheet. Using a 9H pencil and rouge paper, the artist transfers the master-copy onto the artwork surface.

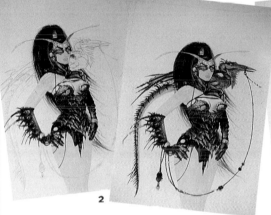

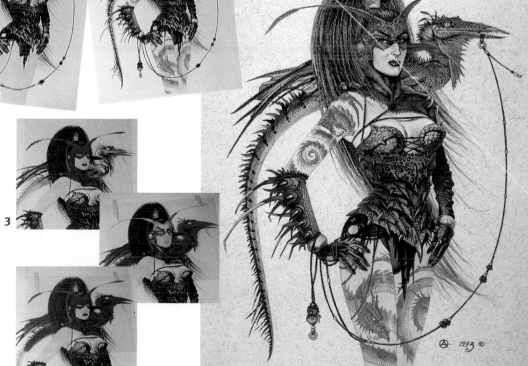

2 The artist works further on the image in pencil before beginning to lay in the flesh tones. Unusually, each element of the picture is worked up separately to a highly finished state. Here the tattoos were added at a late stage to give surface form to the limbs.

3 By painting on acetate overlays, Achilleos is able to experiment with the colors of different elements of the picture.

EXAGGERATION

In creating pictures that surprise, intrigue, and delight the fantasy reader—pictures that set the imagination afire—fantasy artists are constantly pushing out the barriers of the "normal."

One technique we can legitimately use to do this is exaggeration. Some of the most effective fantasy art veers close to caricature–it becomes something almost parodic. But, if it stops just short of that, the exaggeration can convey to the viewer a lovely "feel" of fantasy. The exaggerated muscles on almost anyone's depiction of Conan the Barbarian might be physiological impediments were he to be a mundane man, but in the context of a sword & sorcery scenario they seem plausible. Similarly, Tom Abba, depicting the parodic barbarian Thog the Mighty, has set around Thog's belt such a weight of edged weaponry that the character would, in reality, be barely able to stand, yet the arrangement is perfectly acceptable within its own context.

DON'T BE FRIGHTENED TO EXAGGERATE! You could draw a Rambo-style, muscle-bound hero as small and wimpish, but is that really the image you want to convey? Much better, surely, to make him huge and covered with weapons! Make his muscles vast (especially those of the shoulders and arms); give him so many weapons he could hardly stand up if he were to be carrying them in the real world. While working up the preliminary stages of a character in your sketchbook, you can give him all the crazy attributes you want: later on, you can tone them down a bit, but for the moment enjoy the exaggeration.

> **Further Information** ☞
> Body language; page 50
> Characterization;
> page 52

ABOVE: By taking an up-shot and making sure the character more than fills the space, the artist has given the figure of The Beast tremendous force.

BELOW: Henry Flint creates his effect by exaggeration of complexity. (The picture also shows the progression from sketch to final artwork.)

RIGHT: Steve Crisp grossly exaggerates the weapons hardware to be carried by a warrior of the future.

BELOW: Henry Flint creates his effect by exaggeration of complexity. (The picture also shows the progression from sketch to final artwork.)

EXERCISES

In Bernard King's novel *The Destroying Angel* (1987), there is a library containing all the books ever written on the subject of lost worlds such as Atlantis and –most important in terms of the novel–Ultima Thule. You have been asked to produce a line drawing depicting that library.

● The subject of the library is one that stretches on into infinity, so you could portray the physical library as doing likewise, with shelves of books, stairs, and ladders stretching upward far beyond the boundaries of your picture.

● Since the subjects of the books are so huge, why not show a reader in the library surrounded by vast, floating letterings of the titles?

● Or why not imagine the books themselves as being more real than reality? In the 1991 movie *The Addams Family*, for example, a character opens a copy of Margaret Mitchell's *Gone With the Wind* (1936) and is thrown over by the gale that roars out of the pages. You could show a person opening one of the books and being knocked over backward by its contents.

● Among the books in the library are some showing the glacial cold of Ultima Thule. You could show some of the books on the shelves covered in icicles.

FALSE PERSPECTIVE

There are various ways in which you can play with the natural perspective of a picture to create a puzzling or intriguing effect—to give the viewer a *displaced* feeling.

In order to give apparent depth to a picture, we normally use the convention of linear perspective. The farther away from us an object is, the smaller it appears. The apparent diminution is linear: it can be formalized and made plain using the conventions relating to positioning and to the vanishing point on the horizon to which all the perspective lines point. But you can use this perspective the other way around to show that a scene is something other than what it seems.

Use curving lines rather than straight ones to establish positions and forms within your picture. Remember to be consistent when playing with perspective: conventional linear perspective, the form normally used in illustration, is designed to fool the viewer into believing that the flat, two-dimensional page shows a three-dimensional scene. In effect, when using conventional perspective, you are asking the viewer to enter into a contract with you—he or she will accept the perspective you use as a fair description of the reality. As soon as you start fooling around with that convention, you are asking your viewer to take a further step. Unless you can convince them, your viewers may decline to take that step.

ABOVE: Dan Seagrave deftly uses three-point perspective in order to create a delicious vertiginous feel.

LEFT: An *Alice* illustration by Brian Partridge likewise generates a vertiginous feel, this time by warping the perspective in such a way that straight edges become curved. By the same means, we are able to look both upward and downward simultaneously.

Further Information
☞
Comic strips; page 56
Human and humanoid;
page 88
Illusion of space and
depth; page 92

CONVENTIONAL PERSPECTIVE

In order to manipulate false perspective, you need a full understanding of the rules of conventional perspective. This is a good idea anyway, because in many of your fantasy paintings these are the rules you will be wishing to follow.

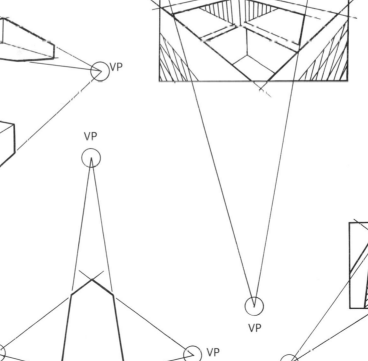

ABOVE: *Empty Words in an Empty Landscape* by Paul Bartlett, a pen-and-ink study for an etching, adroitly uses three-point perspective to make the maze seem of infinite extent.

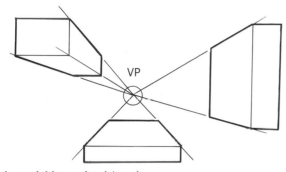

Single vanishing-point (above) perspective deals with only one set of planes, thus giving the two-dimensional picture depth in only one direction.

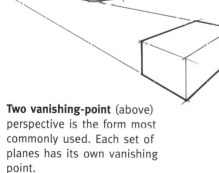

Two vanishing-point (above) perspective is the form most commonly used. Each set of planes has its own vanishing point.

Three vanishing-point (right) perspective is used when you want to create the illusion that something is of great depth or height. The verticals slope to meet at a high vanishing point.

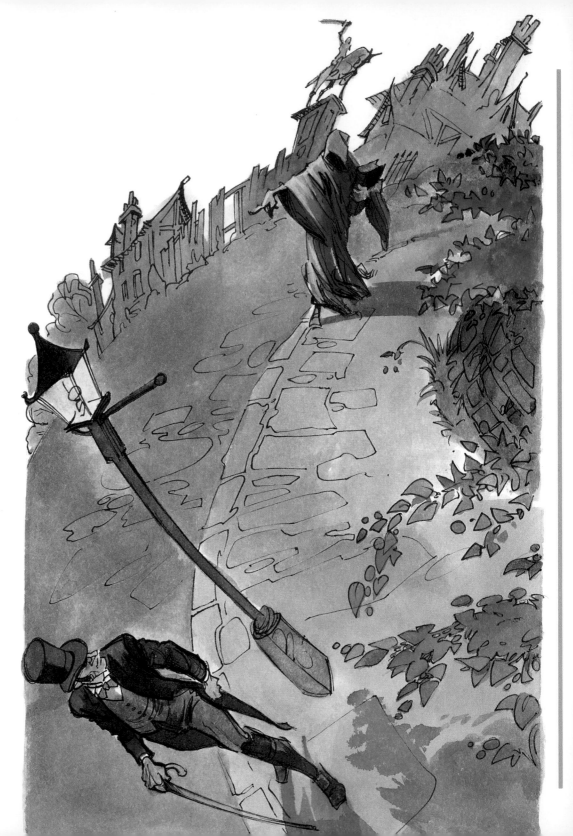

PLAYING WITH PERSPECTIVE

This is a means of disorienting the viewer, giving a sudden jolt of "otherness," so that even mundane scenes can become indefinably strange. The thing to remember is that conventional perspective is itself a trick, a mere illusion, yet we accept it unquestioningly as if it were providing a true portrayal of depth. Any distortion of it is likely to disorient the viewer.

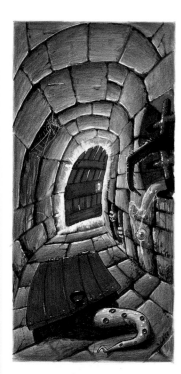

ABOVE: In this piece by Paul Campion, we get a slight "double perception" effect because it is impossible to work out the orientation of the door.

RIGHT: This colored drawing by Ron Tiner was a deliberate attempt to disorient the viewer by adhering to the rules of conventional perspective, yet replacing all the straight lines with arcs of a circle.

The curvilinear perspective employed in this drawing by David A. Hardy cleverly creates the illusion that we are looking at the scene through the visor of our space-helmet.

HARDWARE

If you are to imagine and draw the products of future technology, you need to have some awareness of where technology is now.

By "hardware" we mean hard-technology art–the depiction of the hi-tech. This is the kind of art usually associated with science fiction and technofantasy: it is characterized by clean edges, the appearance of huge sculpted areas of metal, the right-seeming "aerodynamics" for spaceships, and so on.

Think about the functions your pieces of hardware have to perform. In Arthur C. Clarke's book *The Snows of Olympus* (1995), there are two pictures of future farms on Mars: one was drawn in the 1960s and the other in the 1990s, but there are more similarities than differences between the two pictures. The reason is that the two artists thought about the same problems and "solved" them in similar ways.

YOU–THE INVENTOR In hardware art you, the fantasy artist, become something more than an illustrator: you become an inventor. Hardware creations arise through a lot of drawing, redrawing, enhancing, adding, adapting . . . Fool around in your sketchbook until you feel you've invented something good. Hardware surfaces can be gleaming, smooth, and machined, or they can have a patina, be weathered or decayed. Experiment with hardware surfaces until you feel happy with them. To give them shape, you could use surface markings like letters and/or alien glyphs. This is the approach the French artist Moebius used in his initial sketches of the colossal derelict spaceship that is encountered early in the movie *Alien* (1979).

FRAMES AND VIEWPOINTS In *Terminator 2: Judgment Day* (1991) the good robot, Arnold Schwarzenegger, retains a basically human form almost throughout. There are two ways we are constantly reminded that his character is a machine. One is the machine-like delivery of his lines. The other is a visual trick. On occasion we see events through his machine vision, with items of data scrolling rapidly on the screen and, *Continued on page 86*

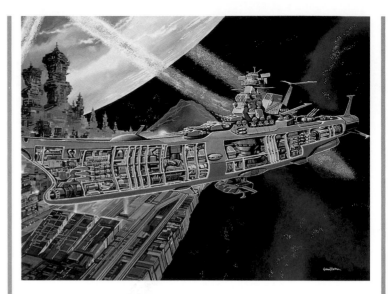

ABOVE: Cutaway painting by Graham Bleathman of the space cruiser *Yamato*. In order to make this sort of picture convincing, pay particular attention to detail and to the accuracy of your line.

BELOW: An important point to remember about hardware art is that it is not new. Here the 19th-century French illustrator Albert Robida jauntily anticipates TV with his "telephonoscope."

DEVELOPING A DESIGN

If you want your hardware art to be convincing, it's often a good idea to work out first how the machine or device involved would actually function. In these technical drawings, David A. Hardy plays with the notion of floating cities before settling for a segmentary structure that can link up with five others to create a ring-shaped aerial megalopolis. The idea is further developed on pages 84–5.

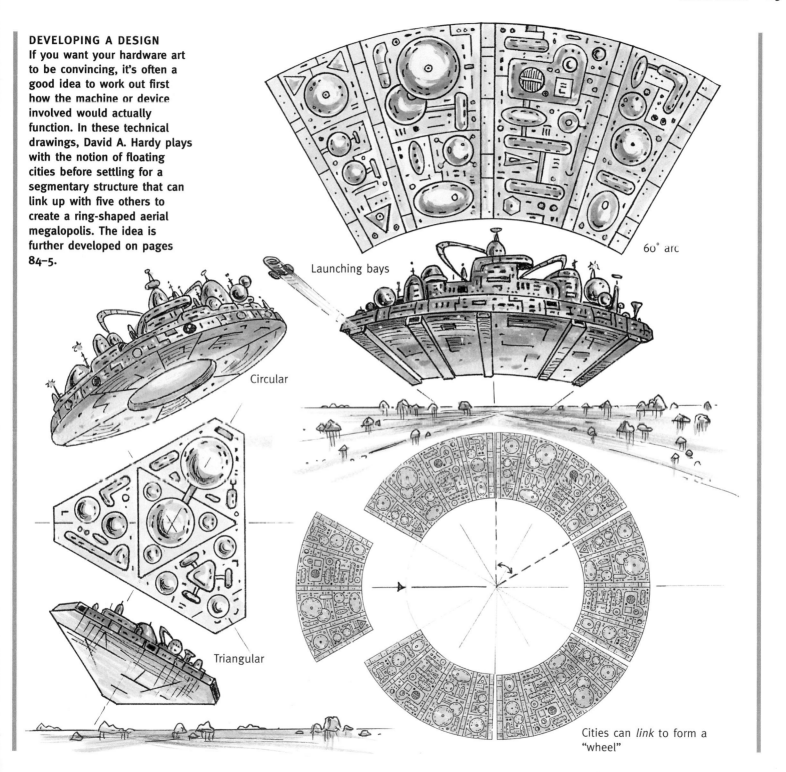

60° arc

Launching bays

Circular

Triangular

Cities can *link* to form a "wheel"

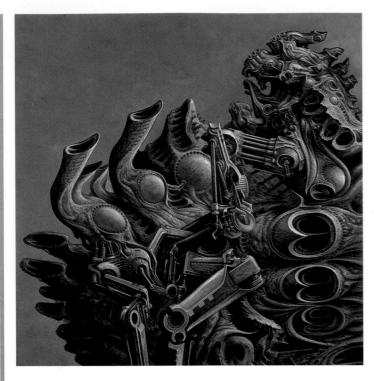

ABOVE: Hardware can be inorganic but have an organic semblance, as in this piece by Dan Seagrave, or it can actually *be* partially or entirely organic.

RENDERING IN VARIOUS MEDIA Before tackling the final artwork, you need to think about which materials you will use to create the surface effect you want, and probably try a few experiments. In this image David A. Hardy plays with (from left to right) pen-and-ink stipple, gouache applied with a brush, and airbrush with additional application of gouache by brush for the linework.

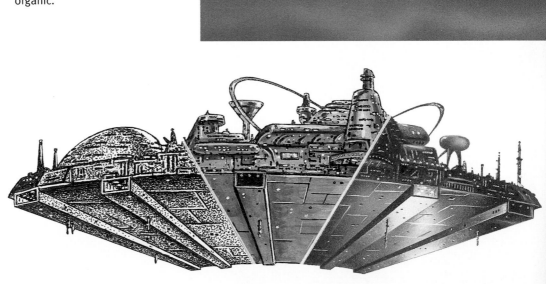

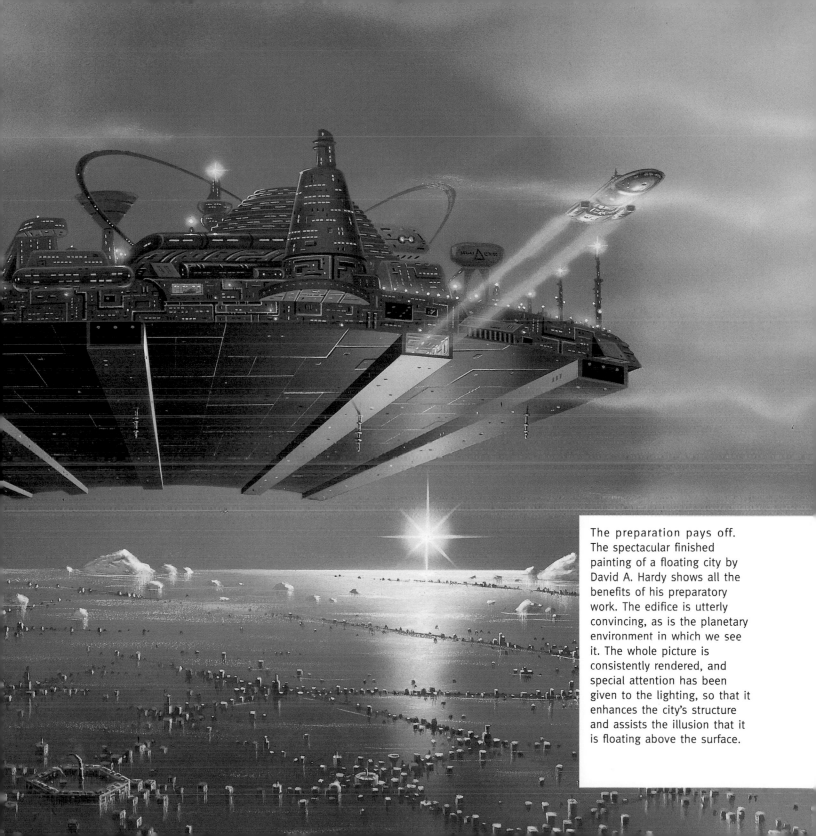

The preparation pays off. The spectacular finished painting of a floating city by David A. Hardy shows all the benefits of his preparatory work. The edifice is utterly convincing, as is the planetary environment in which we see it. The whole picture is consistently rendered, and special attention has been given to the lighting, so that it enhances the city's structure and assists the illusion that it is floating above the surface.

as significantly, with scenes being shown in leached colors and with the focus swooping dramatically to and fro. The impression of hardware is excellently conveyed by this quite simple stratagem.

You can catch an analogous hardware "feel" by reverting to a style that has much in common with engineering drawing, where some of your lines are drawn the way they should be rather than to represent what the scene would actually look like. Allied with this, you can use odd frames and viewpoints, again taking your inspiration less from conventional art than from scientific diagrammatization.

PERSONAL HARDWARE Given the broad commission to show a fully armed warrior of the future, Henry Flint made copious preliminary sketches and doodles of plausible or not-so-plausible items of lethal-looking gadgetry.

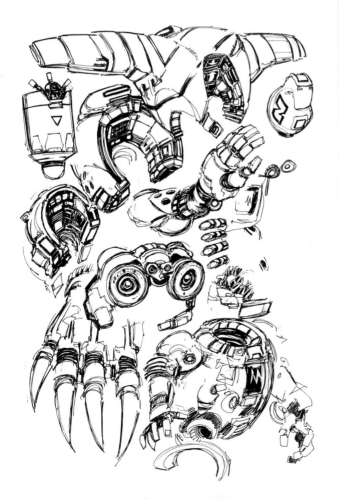

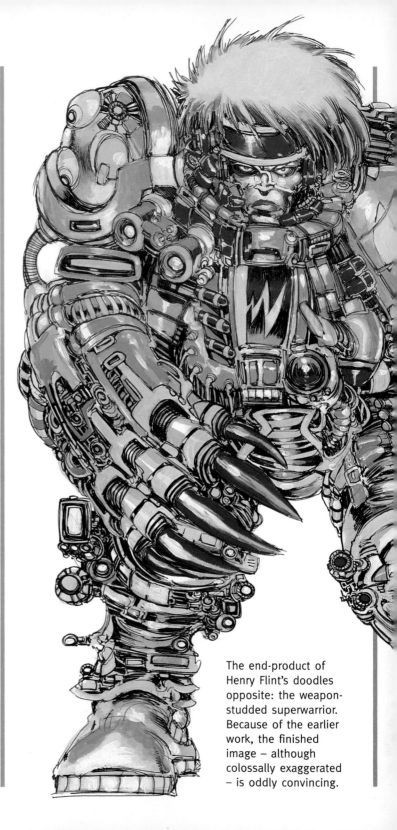

The end-product of Henry Flint's doodles opposite: the weapon-studded superwarrior. Because of the earlier work, the finished image – although colossally exaggerated – is oddly convincing.

FUTURISTIC CAR (right) Paul Campion combines real-world items to produce a futuristic car. It's basically a 1937 Ford–plus supercharger, steel-plated wheels, roof-mounted M60 machine-gun, wing-mounted L7A1 GPMGs, and chrome spikes..

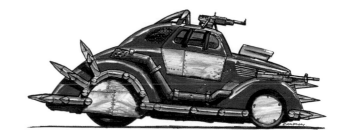

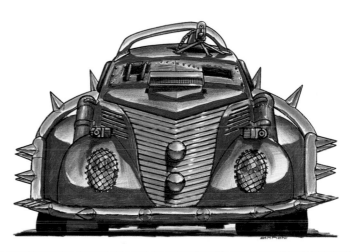

EXERCISES

The 19th-century French satirist and artist Albert Robida produced a number of books from the 1880s onward that both parodied the predictions of Jules Verne and depicted, in ingenious but impractical fashion, the technological developments of the future. Among the various devices he sketched were space rockets and the "telephonoscope," a sort of large-scale videophone that was in its way a prediction of television. You have been asked to produce a modern-day, hardware version of Robida's original vision.

• You could decide to keep the ambience of the original picture, with the corpulent roué watching, in the privacy of his own home, the scantily clad dancing girls performing in a distant theater. However, you could give the gadgetry itself a gloriously incongruous high-tech feel, with gleaming mountains of hardware, wires trailing everywhere, and flashing laser beams.

• You could leave the general form of the hardware much as it is, but apply a hi-tech finish to it. In this way you would retain the quaintness of Robida's vision while exploiting modern tools–such as the airbrush, with its ability to add a hi-tech sheen–and the sophisticated reproduction processes that can be used to capture that metallic look.

• You could go the whole hog, making the screen of your 51st-century telephonoscope a vast wraparound affair showing some colossal space-battle in progress, with arcing energy beams, and perhaps even the occasional disintegrating planet. This could juxtapose wittily with the figure of the reclining roué, still watching the proceedings with a certain jaded air. This might be the approach most in the spirit of Robida's original wry comment.

HUMAN AND HUMANOID

Almost all fantasy illustrations, no matter how otherworldly their settings, contain human figures–if not human beings *per se* then fairies, giants, dwarves, superheroes . . .

To draw any of these distorted versions of the human form, you must make yourself familiar with the normal human form. These creatures may look weird, but their bodies will still work in roughly the same way as a human one. There are various books on human anatomy for the artist: ask at your local bookstore. Take every opportunity to study the nude human figure, either through life-drawing classes or by asking friends to pose–or simply study yourself naked in the mirror.

DRAWING FROM LIFE When drawing a model, pay special attention to the body's proportions. Try to see how the important joints work. Study the bone and muscle organization, and look at the distribution of mass around the body–the way the various masses respond to gravity in different poses. Think always about how the parts of the body work, and how all those bits function together so that the body as a whole works. Get it right: don't be tempted to produce an idealized portrait that won't help advance your understanding.

Carry a sketchbook everywhere. Watch how people move and behave when they're performing different actions or when their minds are engaged in various activities. Don't be frightened of concentrating on a particular area to the exclusion of all else until you know how it functions.

EXAGGERATION Once you're completely familiar with how normal human bodies work, you can start to experiment with abnormal ones. Here you're likely to be performing a con trick on the viewer. That superhero with muscles bulging in more directions than you knew you had muscles might well be unable, in real life, to walk around without pulling himself to pieces, but your fundamental knowledge of the human body will enable the illustration to look convincing.

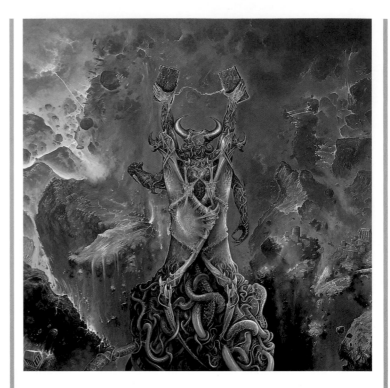

ABOVE: This painting by Dan Seagrave is not only visually strong, but expertly lures the viewer into inventing the story that lies behind the picture.

BELOW: *Sand Gorgon* by Steve Firchow is notable for its lighting. There are two sources, one high and distant, one low and from the front.

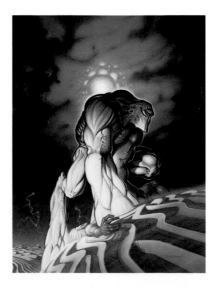

ANATOMY OF A FANTASY FIGURE In order to make the proportions of a fantasy humanoid look plausible, use the head as a unit of measure. The body of a normal human is six to eight heads in height, and as Ron Tiner's drawings demonstrate, you can increase or decrease this ratio to create particular impressions about the type of human/humanoid you are illustrating. Remember to study the real before going on to depict the unreal.

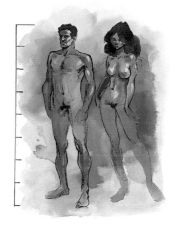

ABOVE: A height of eight heads is at the top of the range for normally proportioned human figures.

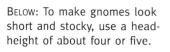

BELOW: To make gnomes look short and stocky, use a head-height of about four or five.

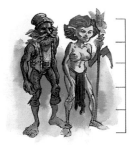

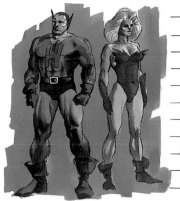

ABOVE: Conversely, a superhero's head-height could be nine, ten, or even more.

CONVINCING POSTURE Your humanoid will look convincing only if you have correctly planned the posture and distribution of the bodily masses. Sketch a simplified version of the skeleton (not just a slick figure) first to make sure you have these points right. These two examples by Ron Tiner show the sort of thing you should be doing.

HEAVY OR LIGHT It is evident in this color drawing by Ron Tiner that two of the characters are bulky while the dancing quartet are ethereal. Line, color, coarseness of feature, bodily shape, and even facial expression combine to create the required impression.

Massive limbs and a small head make the figure seen bulky and earth-bound.

Delicate hands, feet, and limbs impart a quality of lightness.

RETAINING HUMAN ATTRIBUTES How much in the way of recognizably human features does your humanoid require for the viewer still to be able to maintain some measure of identification with it? Often very little; an expression in the eyes may be sufficient. The artists whose drawings are shown here were asked to let their fancies roam from the human toward a specific other form. To perform this sort of mutation, you must know as much about the form toward which you are distorting the human as you do about the human form itself.

RIGHT: Here David A. Hardy tries to produce not just a humanoid robot, but one that possesses the qualities of human-ness. The humanoid is certainly made of hard materials, but its form is everywhere curved.

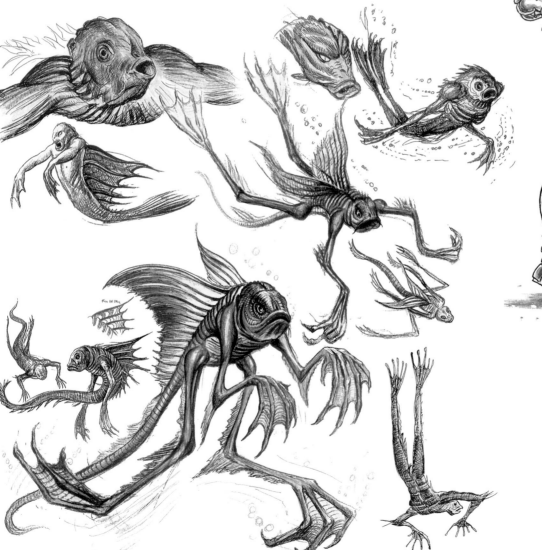

LEFT: In this page of developmental sketches, Steve Crisp has explored several avenues toward creating a humanoid marine creature. His general approach has been to retain at least vestiges of human limbs, and sometimes also a torso. The color choice plays some additional part.

BELOW: Fantasy ideas are infectious. Ron Tiner picked up a notion from the sketches on the opposite page and doodled an amphibian version.

ABOVE: Paul Campion's insectile humanoid uses posture–that of a person crouching–in order to retain a sense of underlying human-ness, however chitinous the exterior.

RIGHT: Henry Flint's humanoid has humanish limbs with a reptilian torso and head. The overall reptilian nature is enhanced by the coloring.

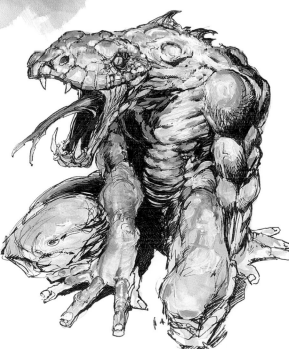

EXERCISES

A movie company is planning to make an animated version of Shakespeare's *A Midsummer Night's Dream*. You must produce character sheets for Act II Scene 1, in which Oberon and Titania, King and Queen of the fairies, are introduced, along with Puck, a wood sprite, and other magical denizens of the forest.

● Oberon can appear as a huge giant, tall as a forest oak, or as a human-sized ethereal woodland spirit. Even when he appears in human size, he needs to cut an impressive figure, so give him the physical proportions of a superhero – eight or nine heads high. To make him look regal, give him flowing robes and some kind of crown. He is *not* human, however, so work some magic on the details of the head for an otherworldly effect.

● You must create a regal figure also for Titania, his queen. She can be portrayed as a huge, shimmering tree spirit or as human-sized, but must always be impressive and commanding, so her proportions will be similar to those of Oberon.

● Puck is usually seen as a naked, mischievous small boy with pointed ears. Once again, aim for a not-quite-human appearance.

● The other fairies each have distinctive characters within the play and so need to be individually "designed." They have names like Peaseblossom, Moth (an ideal opportunity to try your hand at a hybrid), Cobweb, and Mustardseed. Make them delicate, ethereal creatures, capable of flight.

ILLUSION OF SPACE AND DEPTH

Some of the tricks you use to create an illusion of depth and space involve those of conveying massiveness, but most of the others are concerned with one form or other of perspective.

A typical fantasy-novel cover–almost a cliché of the genre–shows one or more tiny figures in the foreground and, behind them, a landscape that seems to recede into infinity, with huge mountains reaching up to almost touch the sky, or vast plains that look as if they might go on forever. The overall impression is that the background is built on some scale vastly more huge than the human.

AERIAL PERSPECTIVE When we look at a real scene, our perception of it is affected by the color values of the various elements. Refraction in the atmosphere causes changes so that more distant objects–the classic example being faraway hills and mountains–look blue or purple even though they are really just as green as nearby ones. The focus is less sharp than on foreground features, so that you can see little details and tonal contrasts become more muted, so that there is little apparent difference between light and dark colors. This is known as aerial perspective.

As an exercise, try doing a quick color sketch in which you reverse this process, with objects in the foreground being bluer and "fuzzier" and those in the background being redder and sharper. The effect can be very surreal, because you are sending the viewer's brain all the wrong messages.

By exaggerating aerial perspective, you can make distant objects seem almost impossibly far away.

LINEAR PERSPECTIVE The basic law of linear perspective is that things appear smaller the farther away they are. Spaces between objects become smaller, too, so that lines (i.e. adjacent features) on distant objects tend to run together, becoming too small for you to be able to discern them as

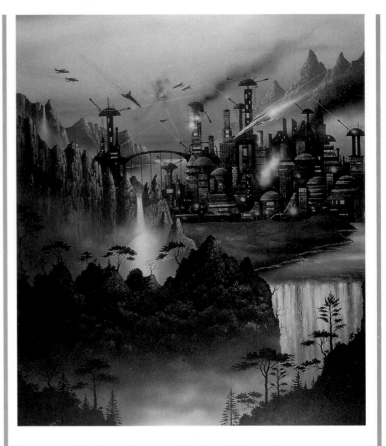

ABOVE: *Utopia I* by Danny Flynn uses the overlapping of receding planes to give a sense of depth and draws the eye toward its distant focal point by strategically placed spaceships.

separate. Thus you should both use fewer lines for more distant objects and also make those lines finer.

The law of diminishing size sounds simple–and indeed is–but often you are drawing objects that in reality are not all the same size. If you have two asteroids, one ten times the size of the other but twice as far away, the more distant one would still look bigger than the closer one.

So you may have to combine elements of both kinds of perspective–aerial and linear. Or you can perform another kind of "con trick." If you were showing a receding trail of asteroids, you could start by pretending they were all roughly the same size, so that distant ones look naturally smaller than near ones. Once you have created this general illusion, you can make a few of the more distant ones a bit bigger.

PERSPECTIVE IN SPACE Of course there's no aerial perspective in space, but you can still use the trick of muting the tone and color contrasts. More distant objects (like spacecraft) can be indicated this way, with all their colors tending toward the background color–black in reality, but often you depict space some other color.

ABOVE: This drawing by David A. Hardy creates the illusion of vastness through linear perspective and the positioning of the looming craft above more human-scale objects.

BELOW: Often you depict space as colored–green in this picture by Ron Tiner. Thus distant objects appear greener (i.e., closer to the background color).

ABOVE: You can show that objects in space are closer to the viewer by depicting them– as in this Ron Tiner sketch–in bolder lines and with coarser hatching than you give to more distant ones.

ALIEN PERSPECTIVES On Earth the atmosphere is fairly transparent, but this need not be so on other planets. Venus' atmosphere has such a high refractive index that the horizon in fact curves toward the sky. The gases in the Jovian atmosphere are colored, lit in part by the planet's own energies, and unimaginably turbulent. Try playing with the aerial-perspective effects you'd experience in such situations.

LEFT: To show objects receding into the distance, establish a general trend of their getting smaller the farther they are away from you.

RIGHT: Once this trend has been established, use overlapping and differences in line thickness to enhance the effect.

IMPOSSIBLE STRUCTURES

One of the great joys of fantasy art is that it frees you from the constraints of reality, but this does not mean that you can discard all the rules.

Most of us will have seen the structures created by the Dutch artist M. C. Escher. A channel of water runs uphill to a waterfall that feeds the bottom of the channel; a stairway looks superficially normal but is in fact never-ending, leading nowhere except back to itself. Such structures are impossible; nothing like them could exist in the real world, but they create, at least temporarily, an illusion of reality.

However bizarre the edifices you create, they must still look convincing at some level. Escher's never-ending stairway is effective just because the stairs themselves look so real.

But, while tipping your hat to structure, you can safely abandon the practical rules of architecture, depicting, for example, towers several miles high, but only a few tens of yards wide at their base; edifices that float in midair; large decorations embellishing relatively small buildings; remote extensions that could be reached only by flying creatures; or castles the size of mountains. You could also experiment with architectures based on living organisms like trees which would need to be in a constant state of flux because the trees would be continuing to grow, or buildings constructed on the back of a creature, or on the head of a giant.

REALITY CORNER But there must always be an element of the structure that keys in to the viewer's knowledge. One way of achieving this is by introducing bits and pieces of known architectural styles, or architectural elements we commonly see in everyday structures. The Gothic style is the one that fantasy artists most frequently call on–it is immediately recognizable as well as having an inbuilt fantasy feel.

A useful structural element to keep in mind is the flying buttress. Patch a few of those onto your edifice, plus the occasional Gothic arch and you will convey the

Further Information
☞
Exaggeration; page 76

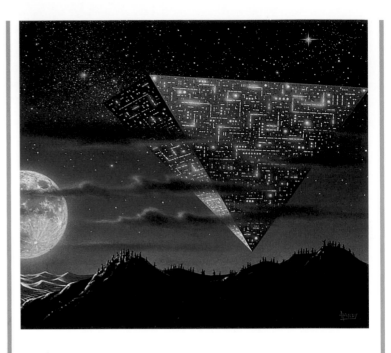

ABOVE: *Pyramids* by David A. Hardy. "Traveling in an inverted pyramid, an advanced technology visits (or revisits?) the relics of a civilization on Earth."

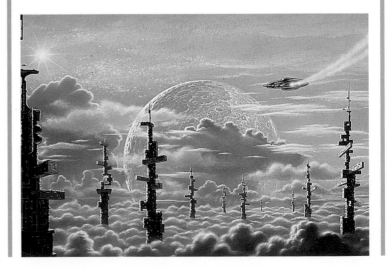

BELOW: *Towers of Taban* by David A. Hardy. "The inhabitants of this imaginary planet of a far-off star build their skyscrapers to a grand scale."

FANTASY ARCHITECTURE

Creating implausible and impossible structures is a kind of conjuring trick – the viewers realize that the structure could never exist, yet can imagine dwelling inside it. One way of doing this is, as displayed in the pictures on the opposite page, to give surfaces, lighting, etc., a super-realistic treatment. For this page three artists were asked to let their imaginations roam into areas unknown to architectural science.

RIGHT: Paul Bartlett's organic city seems to take fungi and gourds as its inspiration. Lots of little details combine to make the image convincing; the use of perspective tricks (notably curved lines in place of straight ones) increases both the fantastication and, paradoxically, the plausibility.

BELOW LEFT: In David A. Hardy's tree cities, anthill-type dwellings top plateaux formed by the branches.

BELOW RIGHT: Subtle hints tell us of the colossal height of the buildings in Paul Campion's turreted city.

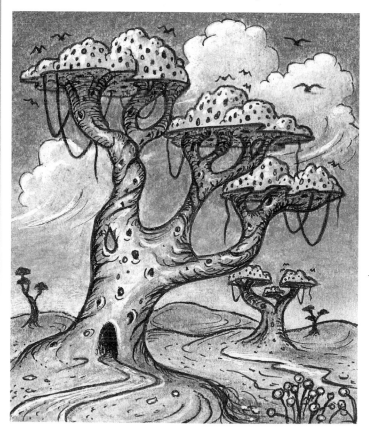

impression that this building just might be structurally sound, while also giving your viewers a reference point whereby they can interpret the thing you have painted.

Another stratagem is to introduce human (or at least humanoid) figures to your painting. This has the added advantage in helping to convey a sense of scale. However fantasticated the place they live in, people have certain basic needs. You have to have windows so that light can enter the building; people require running water–and, of course, toilets–so think about tacking on a few elements that would seem to cope with these requirements. You can make these additions as baroque as you like; they need not be truly functional or even specific as long as they create the impression that they are there for some function or other.

HEIGHT AND VASTNESS
These are often the keys to the implausibility of an architectural structure. Don't be afraid to make your buildings miles high or so vast that they would require a good internal public transportation system. David A. Hardy has used linear and aerial perspective to convey the colossal heights of the skyscrapers in his futuristic city.

EXERCISES
Perhaps the most famous implausible structure in all fantasy is Mervyn Peake's castle of Gormenghast–impossibly huge, impossibly sprawling, impossibly decaying, and aged. You have been asked to paint the cover for a reprint of *The Gormenghast Trilogy*, and obviously the subject must be the castle itself.
• You could imagine that you were standing somewhere in front of the castle, so that you saw the whole of its frontage, spreading and sprawling out in every direction. Give the castle an appearance of great age both by making it look pitted and rotten and by giving it a sort of mushroomy, fungal color, as if those stones have been growing under the stairs. One of the important features of Gormenghast is its appalling

state of repair, but don't be tempted to show any bits actually falling off, as that would negate the very sense of timelessness you are after.
• Alternatively, you could imagine yourself inside the castle, viewing an endless vista of unnecessary corridors and antechambers with cobwebs everywhere. The predominant color should be gray. You might think of having, as an effect, watery sunlight coming in through a window, but the light and color should fade very swiftly, as if something in the very air were leaching them of their vitality.

The corridor down which you are looking is, of course, many miles long. Use both aerial and linear perspective (see pages 78–9) to make it look even longer than that.

• But you might take a much more original viewpoint. Imagine yourself leaning out of one of the windows of Gormenghast and looking along the length of the wall beside you. You would see it stretching away toward infinity –a horrible, crumbling, vast surface that reached to the horizon and beyond. You might have the sense that the ground was somewhere visible below you, but know that the castle's vast frontage extended an impossible distance above your viewing point, making the lighting gray, oppressive, pressing down claustrophobically on you from above. Capture just a small part of this, and your portrait of Gormenghast will be a classic.

JUXTAPOSITION

The juxtaposition of diverse objects is one of the fundamentals of art, the basic principle of both the still life and collage.

In fantasy art, outrageous juxtaposition is an important tool you can use to create a true effect of otherworldliness: the items you choose to juxtapose are taken from such wildly divergent sources that there is no possibility of their ever being found together in the real world. The overall effect is one of surrealism, which can be either comic or sinister.

Unfamiliar juxtapositions have the effect of jolting the viewer's expectations and imagination. The surroundings in which we normally live are very predictable. A main purpose in fantasy art is to haul the viewer out of this mundane world into another–where the only thing predictable is the presence of the unpredictable! A way of attaining this "feel" is to put together the sorts of things you might well encounter in everyday life but would never see together, or at least not related to each other in any meaningful way.

A CHICKEN ON A BICYCLE Anyone can throw together a collection of disparate objects: the result may convey that true fantasy "feel," but more often it will not. The trick is to make your portrayal of this bizarre scene as naturalistic as possible.

Taking the effect further is a matter of technique–pure and simple. All the techniques you would normally use to convince a viewer he or she were looking at a completely naturalistic scene–uniformity of lighting, correctness of perspective, shadows, and so on–must be brought to bear to create the illusion that your picture is of a real situation, even though it might be of a chicken riding a bicycle! Paint the chicken as though it belongs on the bicycle and the bicycle as though it belongs under the chicken–and both of them as though they belong in an average city street.

Never forget, though, that there are two components to an effective piece of bizarre juxtaposition. One is visual:

Further Information
☞
Alternate realities; page 46

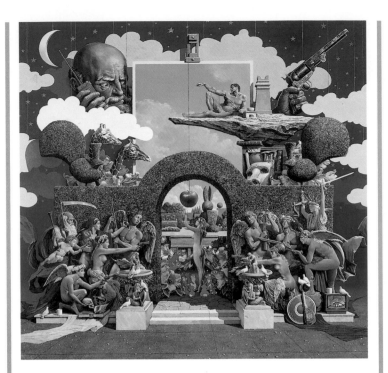

ABOVE: *God, Man and the Price of Apples* by Chris Brown contains so many bizarre juxtapositions that the picture gains a strange unity.

BELOW: *Lost Angeles* by Maxine Miller achieves juxtaposition through superimposition to create an eerie and affecting ethereality.

you are putting together objects or people who could never be seen in such proximity. But the other component, and the more surreal one, is conceptual: you are throwing together ideas that in the normal way should be totally unrelated. This is what a lot of the best written fantasy is about, and there is no reason why you should not attempt to emulate that conceptual inventiveness in your art.

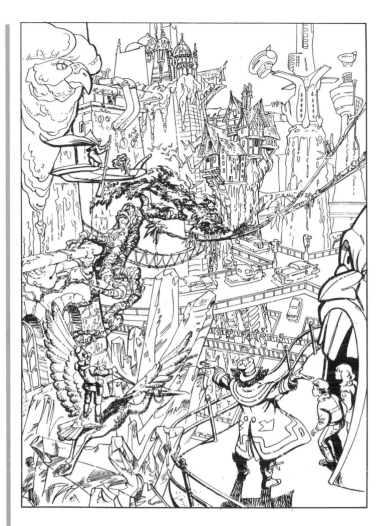

ABOVE: *City of Paradox* by Ron Tiner contains countless juxtapositions of genres and historical periods. The grouping at bottom right, where the children are being welcomed to this weird place, both gives the picture reality and emphasizes the overall fantastication.

RIGHT: The secrets of David A. Hardy's dirty laundry exposed!

EXERCISES

In the 1988 movie *Who Framed Roger Rabbit?*, the central idea is that animated-movie characters ("Toons") can move around in the real world, interacting with the human beings living in it. Clearly the opportunities for juxtapositions are enormous, and few of them were left unexploited by the movie.

Your local cinema has decided to show a revival run of the movie and has asked you to produce a poster. Unfortunately, the cinema has very little money, so the poster must be in black and white only—you cannot take advantage of the sort of explosion of color which the movie so very effectively deploys. In order to convey the feel of the movie, you must rely entirely on weird juxtaposition.

● You could show a naturalistic view of the foyer (an interesting way of doing this would be to take a photograph and enlarge it massively on a photocopier, thereby achieving a pleasing, quasi-solarization effect) with a cartoon-style Roger Rabbit standing among the customers at the box office.

● You could compose the poster out of a set of (say) nine frames, each showing an instantly recognizable work of art such as Leonardo's *Mona Lisa*, with the figure of Roger Rabbit intruding into it in some very obtrusive fashion.

● You could take a stock scene from some other well-known movie, like the scene in *King Kong* (1933) where Kong is clinging to the top of the Empire State Building. Instead of Fay Wray writhing in his hand, put Roger in the place of Kong—and possibly Jessica Rabbit in the place of Fay Wray.

● You could abandon any of the above ideas and instead show a picture of a dead rabbit with a picture-frame placed around it on the butcher's counter. A sick notion, perhaps, but it could be a very effective one. Here the juxtaposition would be not a visual but a conceptual one – a clash of ideas being used to create something unexpected.

LIGHTING

You can add both visual and emotional impact to your work by inventive use of lighting, but first you must be aware of the conventions whereby lighting is used in orthodox art.

Light normally comes from a single source. The position of that source in relation to the various elements of the picture determines, for example, how shadows will fall and how facial features will be illuminated. Unless the light source is placed somewhere unusual (say, directly overhead or directly underfoot), everything in the picture will be more brightly illuminated on one side than on the other. There are various other rules of a similar sort, but for the purposes of the ensuing discussion, we will assume that you are familiar with them.

SILHOUETTES An object lit entirely from behind will appear as a totally flat shape, so if you want to use this form of lighting you must make sure that the silhouetted object has an interesting outline. Think about the angle from which you want to show the object; the same spaceship can look like a meaningless blob from one angle, but take on an impressively threatening, massive form if seen from another.

Silhouetting can be immensely exciting, giving objects more "presence" than other, more orthodox means of portrayal.

EDGE-LIGHTING You can convey the same sense of drama and forcefulness–and often with greater subtlety–by edge-lighting the central images. Here you are assuming that your source of illumination is positioned so that the salient edges of the object are picked out with light, with the rest of the object being mysteriously murky.

EXPLORING EDGE-LIGHTING As an exercise, lightly sketch a huge alien spaceship and put the image into a rectangular frame. Color in all of the rest of the frame except, say, the upper surface of the spaceship, which you leave glowing

BELOW: *When the Cat's Away* by John Hoad. Were it not for the lighting, this image might seem to be rather fey and romantic; instead, it has a definite touch of mischievous, possibly malign, strangeness.

LIGHT SOURCES The way that lighting falls across a face can determine the way we perceive personality and expression. You are making your viewers alter their reading of mood and temperament.

From above sinisterly deepens shadows around the eyes.

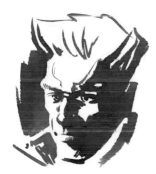

From the side delineates features to emphasize character.

From the near side gives a starker portrayal.

Two light sources gives the face a more sensitive look.

Uplighting can be relied upon to produce a sinister look.

Edge-lighting can be used to emphasize dramatic effect.

RIGHT: Color sketch by Ron Tiner. If using silhouette, make sure that the outline tells the viewer everything.

EDGELIGHTING Much of the viewer's response to this depends on the colors of the lighting and background.

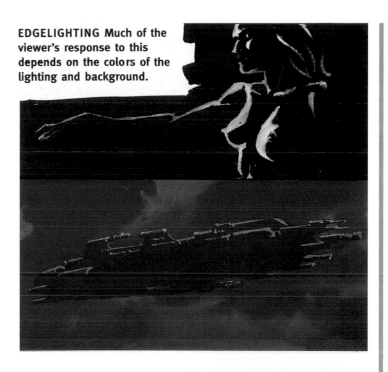

ABOVE: In these two examples of edge-lighting by Ron Tiner, the use of color is emotionally derived rather than naturalistic, to give the desired effect.

RIGHT: In this Tiner picture, too, the color use determines our emotional response.

whitely. You can still detect the rest of the spaceship's form, but so slightly that the effect is almost subliminal. Now perform exactly the same exercise a few more times using different colors for the shading, and decide whether green, purple, red or some other color makes the spaceship look most threatening, massive, or high-tech.

ARTIFICIAL LIGHTING In silhouetting and edge-lighting, it is assumed there is just one source of light. For maximum contrast and dramatic punch, single-source lighting is the option to choose, but you should play around with your lighting effects, and bear in mind that the kind of lighting you choose has a profound effect on the emotional response the image generates.

Normally, of course, the single light source is the sun—or, more accurately, the illuminated sky. Natural light is not always the best for fantasy art, as it gives a more diffuse effect than you would normally want. Most often the lighting purports to be natural but is in fact artificial, creating dramatic effects of light and shade.

EXPLORING ARTIFICIAL LIGHT As an exercise, set up an object in a darkened room, preferably one with lots of texture and an interior—a sheep's skull would be ideal. Light the object with a single spotlight and do a quick sketch, then move the spotlight in a different direction and do another. Repeat this process several times and see the different emotional charges your various sketches convey.

Never forget that light and shade are tools you can use, so place your patterns of light and shade wherever you think they will best enhance your picture idea and give it emotional undertone or dramatic impact.

LIGHT AND COLOR If you take the exercise described above one step further, putting different-colored bulbs into your spotlight (and using appropriately colored pencils for your quick sketches), you will find that your response to the subject differs dramatically according to the colors in which you view it. The sheep's skull becomes almost satanic when seen under a red light, but that may not be nearly as frightening as the effect of lighting it in blue or green. By contrast, if you put a pale pink bulb into the spotlight, the skull may look almost pathetically ineffectual.

Altering the color in which you ask your viewer to see your images is a fundamental way of playing with their emotions. And so is the strength of line you use. Add a few defining black lines to some of your sketches and see how that affects your emotional interpretation of the skull.

ALIEN LIGHT The lighting on different planets on which humans could live cannot actually vary very much, but viewers will expect scenes set on distant planets—or on fantasy worlds—to *look* different, however much the shapes in the picture might be the same.

Crisp hard edges indicate lack of atmosphere.

Two light sources create a complex pattern of shadows.

Clarity of distant objects indicates atmosphere is thin.

Overall color values show this is an alien world.

Pattern of light across surface shows there is no atmosphere.

Shadows are pitch black because no atmospheric refraction.

ALIEN LIGHT In order to convey this effect, we use the deployment of subtly "wrong" color schemes. You can, of course, use completely false coloring–green skies and so on –but, to give a scene alien light, it is generally more effective to add subtle extra hues into the ones the viewer would normally expect to see.

An even subtler way of attaining such effects is to play around with the shadows. Giving everything two shadows would convey that there were two suns and hence a dual light source. Or try making all the shadows glow in an unfamiliar way–so that they look neither gray nor blue-black but instead some other color, possibly quite a bright one. Alternatively, you could make them completely black and very sharply delineated, conveying that there is something very peculiar and otherworldly about the lighting here.

One (rather expensive) way of playing around with alien-light effects is to use the inadequacies of the color-photocopying process. Draw/paint a scene in normal lighting and then have a color photocopy made of your picture. The new appearance–usually more garish–of the lighting is almost certain to give you a fresh insight into ways that you could add that touch of unearthly light into your picture.

EXERCISES

You are commissioned to paint the cover for a new edition of H. Rider Haggard's famous novel *She* (1886). The scene you choose to illustrate is the one where Ayesha (She) steps into the Flame of Eternal Youth.

● You could look from the outside through the flames to see Ayesha's face, perhaps at the very moment when she realizes everything is going wrong. The colors of the flames– blues and greens, perhaps– overlay the flesh tones of her face, but also are reflected in them, giving her skin bizarre hues and making unexpected shadow-shapes around her features.

● Or you could show the scene from Ayesha's viewpoint–looking out through the flames at the chamber where the horrified Holly and Leo are watching the terrible transformation. The Flame of Eternal Youth will be creating unusual lighting effects on their faces, and also illuminating the walls of the chamber– which you can make as oddly formed as your imagination desires. Here is a good opportunity to practice all sorts of unorthodox lighting and coloring effects. And don't forget the use you can make of shadows on the chamber walls.

SWORD AND SORCERY

The good sword & sorcery artist has the power to make us start believing again in things that we stopped giving credence to in childhood.

Often described by its aficionados using more "respectable-seeming" terms like "high fantasy" and "heroic fantasy," sword & sorcery is the branch of the genre in which, typically, mighty-thewed, sword-wielding barbarians, aided often by Junoesque princesses, do battle with the forces of darkness, which are reified in the form of vile villains (often supernaturally assisted or endowed) and hideous monsters; wizards of various stripes are likely to take part on both sides in these titanic struggles, while the swords themselves may be possessed of magical powers of some kind.

WRITTEN SWORD & SORCERY To understand sword & sorcery art, you really need some kind of feel for the written genre, so read some. All sword & sorcery stories tend to be set in what is, despite variations in nomenclature and other ancillary details, recognizably the same "fantasyland." The vast majority of these tales are–paradoxically within what is billed as a literature of the imagination–fairly unimaginative, being founded on well-recognized precepts and following established rules. Yet the subgenre has a certain kitsch appeal.

The founding fathers of sword & sorcery were Robert E. Howard, with many novels based on the exploits of barbarians like the famous Conan; Edgar Rice Burroughs, who set his sword & sorcery in strange locales (on other planets, as in the *John Carter* stories, or even in the interior of the supposedly hollow Earth); J.R.R. Tolkien, who created a vastly intricate fantasyland that was, pleasingly, not just another Middle-Ages-That-Never-Was; James Branch Cabell, who with his *Poictesme* series of novels was subverting the subgenre

Further Information ☞

Exaggeration; page 76
Human and humanoid; page 88
Impossible structures; page 94

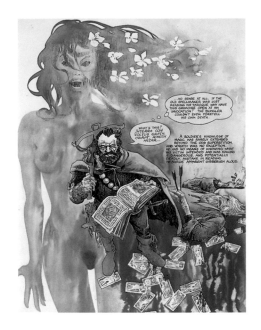

ABOVE: A page by Ron Tiner from the graphic novel *Thera*. The solid, earthbound figure of the soldier contrasts with the transparent treatment of the female spirit.

BELOW: *The Sorcerer's Apprentice*, by Steve Firchow, an interpretation of the old story of the doomed young man experimenting with magic he does not fully understand.

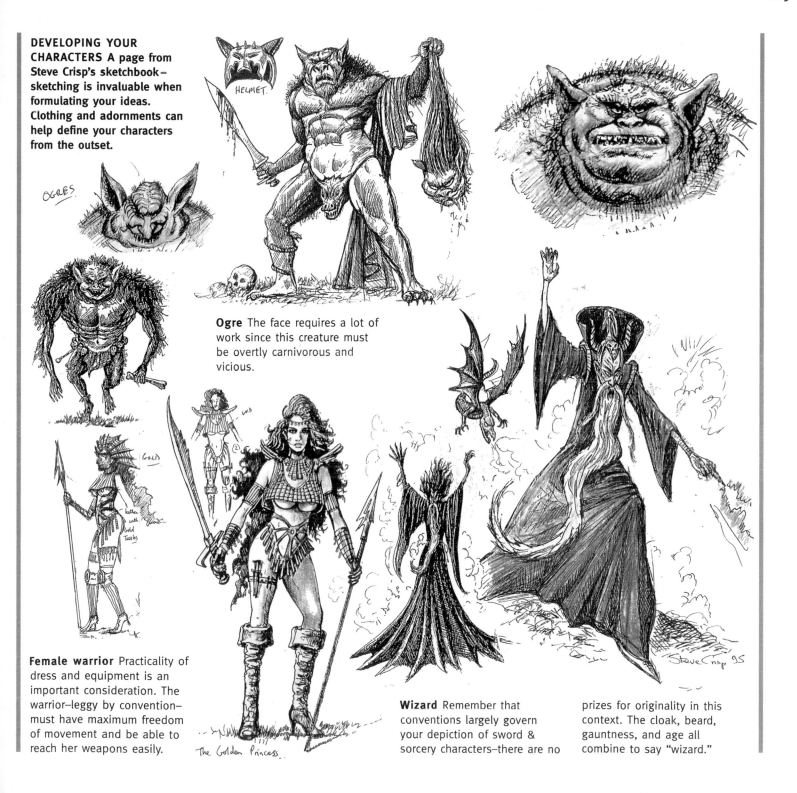

DEVELOPING YOUR CHARACTERS A page from Steve Crisp's sketchbook – sketching is invaluable when formulating your ideas. Clothing and adornments can help define your characters from the outset.

OGRES.

HELMET.

Ogre The face requires a lot of work since this creature must be overtly carnivorous and vicious.

Female warrior Practicality of dress and equipment is an important consideration. The warrior–leggy by convention–must have maximum freedom of movement and be able to reach her weapons easily.

The Golden Princess.

Steve Crisp 95

Wizard Remember that conventions largely govern your depiction of sword & sorcery characters–there are no prizes for originality in this context. The cloak, beard, gauntness, and age all combine to say "wizard."

almost before it was there to be subverted; Fritz Leiber, who coined the term; and, in the modern era, Stephen R. Donaldson, whose interminable *Chronicles of Thomas Covenant the Unbeliever*, starting with *Lord Foul's Bane* in 1977, set the sub-Tolkien style for generic sword & sorcery novels to be issued in a very long series of dauntingly fat books.

PARODY The subgenre, with its exaggerated characters and situations and its simplistic views of Good and Evil (note the capitals), is obviously open to parody, and many modern sword & sorcery works contain elements of arch self-parody (which is certainly an element you should think of incorporating in your art).

A CLOSE RELATIONSHIP Written and illustrated sword & sorcery are closely, almost inextricably intertwined: they draw on the same conventions and use the same visual imagery–even the same color schemes! History, myth, and legend are all brought together to create worlds in which all the characters are larger than life.

The role of the sword & sorcery artist is a particularly challenging one because the underlying tenets of the subgenre are so patently ridiculous–so wildly exaggerated–that the viewer's first reaction on encountering them is almost certainly going to be that this is nonsense. While one approach is to exaggerate even the fact that it *is* nonsense (to revel in the kitsch, as artists like Frank Frazetta so gloriously do), the true challenge is to endeavour to make these scenes, and the characters populating them, seem–against all the odds–*real*.

ABOVE: Steve Cusp here rallies many sword & sorcery clichés –notably the mounds of skulls and the composition, with the dragon's evident distance enhancing the sensation of its vastness.

RIGHT: Ron Tiner here adapts sword & sorcery for comic-strip purposes. The overall coloration conveys one of the subgenre's preoccupation–gore. See working sketch on page 13.

EXERCISES Jean M. Auel's phenomenally successful *Earth's Children* series, begun with *The Clan of the Cave Bear* (1980), is set in prehistory and concerns the adventures of orphaned Cro-Magnon lass Ayla, who is adopted into the Neanderthal clan of the first book's title. She is physically and mentally their superior, yet must conform to their rules—particularly difficult since those rules regard women as, by definition, inferior. The movie *The Clan of the Cave Bear* (1985) was widely disliked as being too much of a feminist tract. A more serious criticism concerns its stereotyping: Ayla, played by Daryl Hannah, is blonde, leggy, and fair-skinned, while just about everyone else is squat and swarthy.

Prehistory is a valid setting for sword & sorcery art, and you've been asked to use this approach for the cover painting of a new reissue of Auel's book.

● You could take your inspiration from the movie, and show Ayla as ... well, as near to Daryl Hannah as the publisher's lawyers would allow! A pivotal notion in the book is that, although women in the Clan of the Cave Bear are not allowed to touch weapons, Ayla teaches herself to use a sling – so clearly you want to show her in action with this weapon: blonde hair flying everywhere; the musculature of her legs well displayed as she holds her balance, and her outflung arm (and its shoulder) showing the tension of the movement. In the background you could have, of course, a magnificent panoply of mountains, their lower slopes decked with huge, primordial-seeming trees. You would probably want to use quite a lot of airbrush in this picture so that you could give (for example) Ayla's arms and forehead a convincing sheen of sweat.

● You could turn your viewer's preconceptions around. It is possible that, in fact, the Cro-Magnons were black and dark-haired rather than white and blonde-haired. Also, rather than have Ayla lithe and skinny, you could make her a real athlete–get hold of magazine photographs of some of the great black female athletes there have been in recent years, and study the way that the light falls on their limbs when their muscles are working at full stretch.

● Instead of showing an action scene, why not set Ayla and a few clansmen in a more formalized pose: she in the foreground, dominating the picture, with one triumphant arm (perhaps clutching a long bone) pointing to a storm-laden sky; the clansmen grouped behind her, looking on in awe.

THROUGH THE LOOKING GLASS

Mirrors and reflections are primary tools you can use to enhance the fantasy "feel" of a picture.

More than that, mirrors, reflections, and shadows can be used to extend the range of ideas in the picture, or even to become the central idea.

FUNDAMENTALS OF REFLECTION The image in a mirror is the same distance behind the surface as the object is in front of it. Remember that this applies not just to flat objects, but to the different parts of three-dimensional objects (such as people).

Think about viewpoint when drawing reflections. Imagine you're looking from an angle at someone regarding his face in a mirror. As a start, think of there being two identical people, the second of whom is in the position of the reflection; then sketch the reflected face accordingly. However, this doesn't quite work, unless the person has a perfectly symmetrical face. Still thinking of there being two people, remember that if the real one has an eye patch on his right eye, that will appear to be on the reflection's left eye; the same goes for all the asymmetries of the face.

The angle between the mirror's surface and your line of sight determines the total amount you will see (with contributions from both images) of the person's head. If your line of sight were at 90 degrees to the surface, so that you were effectively looking over the person's shoulder, you could see virtually the entirety of their head.

The point here, obviously, is that you can exploit mirrors to show much more–in three dimensions–of an object than would be visible in any other way. You can use this variously to reveal things about people (or other objects) that would not normally be visible: the smile of someone facing you can take on a whole new meaning if you see in the mirror behind him what he has behind his back.

The perspective of a reflected image is not the same as that of the original–you can't simply think of one being a reversed tracing of the other. This is because you are looking at the two images from different angles. Try drawing someone standing

ABOVE: The central panel of a triptych by John Holmes captures elements of Carroll's *Through the Looking Glass* and gives them a '90s riff, contrasting dramatically with the more conventional picture on the left.

LEFT: Illustration by Charles Robinson, dating from 1908, of *Alice in the Pool of Tears.* Both this and the picture above make adroit use of reflections.

THE RULES OF DRAWING REFLECTIONS Before you can think of playing around with fantasticated reflection effects, you should make sure that you have mastered more orthodox ones. Even using orthodox reflections–and perhaps cheating a bit–you can often generate a subtle feeling of fantasy in your pictures. (Color sketches on this page are by Ron Tiner.)

ABOVE: The distance of the image behind the mirror's surface is the same as the distance the object is in front of it.

Getting the linear perspective of reflections right is important. If you're worried that you haven't got the knack of it, do lots of rough sketches, drawing in the construction lines until you feel more confident.

LEFT: You can play with reflected images to create special effects and enhance the atmosphere of your picture.

ABOVE: An uneven surface breaks up the reflected image, causing it to shimmer intriguingly.

in still water, with his reflection showing beneath him. Quickly sketch in the vanishing point for the original figure–as defined by, say, the line through his shoulders, the line across his pelvic bones and the line between his ankles where they break the surface of the water. The vanishing point defined by the same three lines drawn through the reflected image is the same as the "real" one.

WHAT YOU SEE MAY NOT BE WHAT YOU GET

Mirrors have (generally) smooth, unruffled surfaces. The same is not true of that other medium in which we generally see identifiable reflections: water. Ripples and currents distort the reflected image, and you can exploit this in all sorts of ways. (Remember to mute the color values of any image reflected in water.) One thing you can do is make the ruffled reflected image seem like a rather different sort of object from the original. A gnarled old treetrunk on a riverbank can seem, in its reflection, to be some kind of a grasping monster.

Don't forget distorting mirrors are an important part of much fantasy. The carnival "Hall of Mirrors" may be a cliché, but it's one you can use to devastating effect!

And, finally, remember that one of the most important uses of mirrors in traditional fantasies was for the purposes of gazing, as in "Mirror, mirror, on the wall . . .". Through peering into a mirror, people possessed of magical powers were able to see distant scenes or future events. In such instances, the mirror could be anything reflective, like the surface of water in a bowl. You might think of showing someone in a darkened room leaning eagerly over a dish of water, their face illuminated by a golden radiance rising up from the water–indicating that they are looking at somewhere far away.

THE LOOKING GLASS OTHERWORLD

But the great joy a fantasy artist can have with mirrors and other reflecting surfaces is the notion that lay at the heart of Lewis Carroll's *Through the Looking Glass* (1871): on the other side of that surface, there lies another world. Normally the bits of it that we see look just like straightforward reflections of our own world, but what *would* we see if we could look around the edges of the mirror frame? And can the looking-glass world always be relied upon to provide us with merely an accurate reflection of ourselves? Could that reflection be really another person, with an unknown agenda of his or her own? Is it possible that we could step through the surface of the mirror and discover ourselves in that otherworld? Or could the denizens of that otherworld reach through the mirror's surface to grab us?

FANTASTICATED REFLECTIONS Whatever we know intellectually, it can be difficult to *believe* that the world on the other side of the mirror is just a two-dimensional reflection of ours. Artists (and moviemakers) have widely exploited this emotional misperception. Working with reflections is not always easy, but is worth the effort.

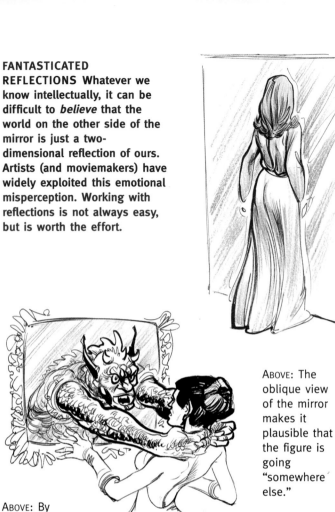

ABOVE: The oblique view of the mirror makes it plausible that the figure is going "somewhere else."

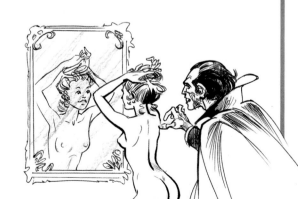

ABOVE: By giving the mirror a surface through which the monster grasps, the illusion is retained of another world.

RIGHT: The convention that vampires have no reflections.

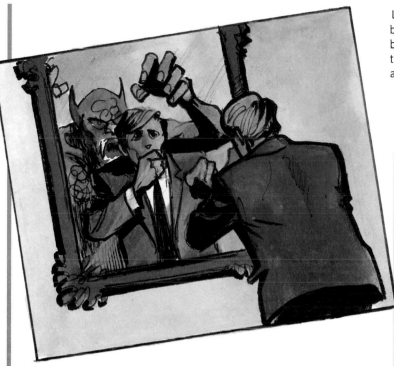

LEFT: The reflection need not be of an otherworld; but it can be symbolic, as here, where the "monster" is the man's anxiety.

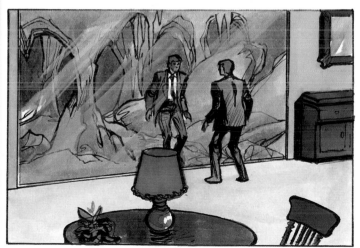

ABOVE: Again, Ron Tiner uses reflection symbolically to show the romantic yearnings of the world-bound character.

EXERCISES

A publisher has asked you to execute a set of illustrations for a new edition of Lewis Carroll's *Through the Looking Glass* (1871). Obviously you have a hard act to follow—the original Tenniel illustrations for this book are part of everybody's childhood memories of it—but a commission is a commission. One of the pictures you want to draw is of Alice stepping through the lookingglass. You could:

● Take the straightforward option, which is to show Alice up on the mantelpiece, with her grossly distorted reflection behind her.

● Try showing Alice from the otherworld point of view—from the looking-glass world. Imagine that you were looking up at a mirror and you saw a Victorian child, her features pressed against the glass, preparing to climb into *your* world.

● Imagine the mirror's surface as cobwebby, so that as Alice comes through she has to brush away the clinging filaments of mirror surface. You could think of her as temporarily blinded by the strands; or perhaps you—as a looking-glass creature—are very small and so Alice seems huge.

● If the publisher has allowed you to use color, you could—again observing from the lookingglass-world —show Alice bursting through the mirror in the midst of a snowstorm of flying, kaleidoscopic mirror shards. As a first experiment, you might try getting hold of sheets of aluminized paper in various colors, cutting them into angular scraps, and then collaging them down onto your initial sketch. But use whatever technique you feel most comfortable with.

THEMES

One of the most effective ways of working toward success in your creation of fantasy art is to pay constant attention to what other artists are doing–to discover how they are approaching problems that you may find yourself confronting in a few months' or years' time, or possibly even tomorrow. Drop frequently into your local book store, record store, poster store . . . anywhere that has plentiful fantasy art through which you can browse undisturbed. Make a point of seeing the best fantasy movies, especially if they are animated or contain spectacular special effects. And read a lot of fantasy. As we have maintained throughout this book, fantasy is a single spectrum of creativity, with no hard borderlines between its various manifestations. This is not to say you

should simply copy other people's ideas–that's the last thing you want to do. It is the quality of your own ideas that will determine whether or not you are a good fantasy artist or a journeyman. But, at the same time, finding out what other artists are up to will expose you to a wealth of knowledge about fantasy that no single teacher–or book–could hope to convey.

In this major section of this book, we offer you a gallery of pictures by some of the world's finest current practitioners of fantasy art. Your best plan is first merely to wander through them, enjoying them, then to come back and look at each one carefully: every picture here has something to tell you.

LEFT: Cover by Jim Burns for the anthology *Other Edens*.

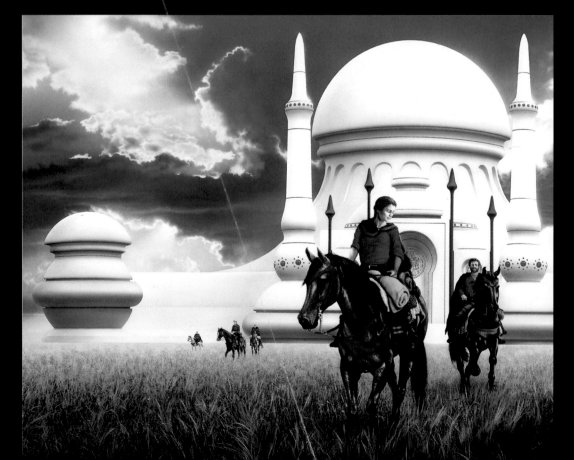

RIGHT: Untitled piece by Dan Seagrave.

HIGH FANTASY

For high fantasy, even if you decide to focus on a small group, you want to think *big*–to exaggerate in some way or another. The characters in heroic fantasy are larger than life.

Cover illustration in gouache by Geoff Taylor for *A Time of Justice* by Katherine Kerr. Because the composition was designed to suit a wraparound paperback cover, the artist had to consider where the lettering will fall on front, back and–notably–spine.

Rhodry, his new dragon ally Arzosah, and the dwarven axemen are rushing to aid the besieged town of Cengarn.

Meanwhile, within the town walls, the Princess Carra – and her precious unborn child – is under the protection of the sorcerers Jill and Dallandra who eagerly await the arrival of their allies.

Only by destroying Alshandra can there ever be peace between Horsekin and humankind. But it seems an impossible task...

With a *Time of Justice*, Katharine Kerr concludes her epic Westlands cycle and creates a new masterpiece of fantasy fiction.

'This grand saga is by a wide margin the best Celtic fantasy around' *Chicago Sun-Times*

KATHARINE KERR

A TIME OF JUSTICE

KATHARINE KERR

A TIME OF JUSTICE

DAYS OF AIR AND DARKNESS

'ONE OF THE TOP FANTASISTS OF HER GENERATION' *Interzone*

SCIENCE FICTION FANTASY

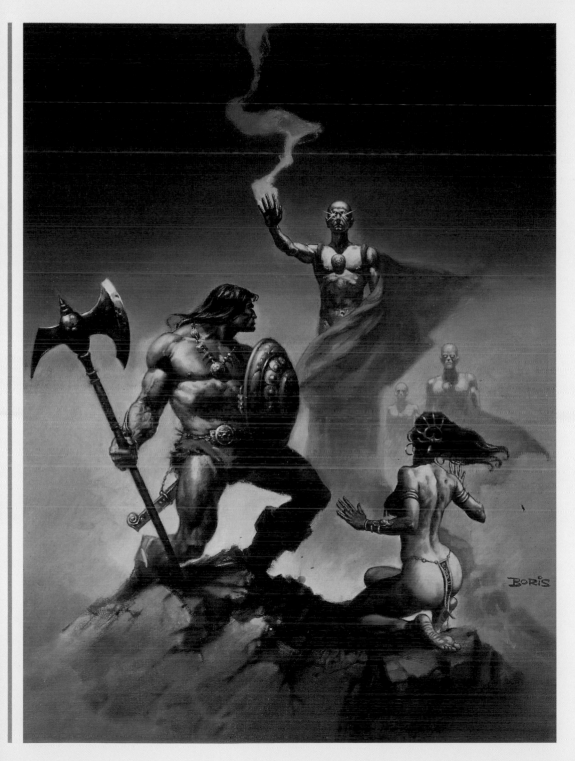

Comic-book cover by Boris
Vallejo, depicting Conan. Note
the convention of treating the
subject as a tableau rather
than a scene of action, or one
from which action could
logically develop.

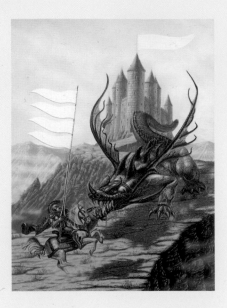

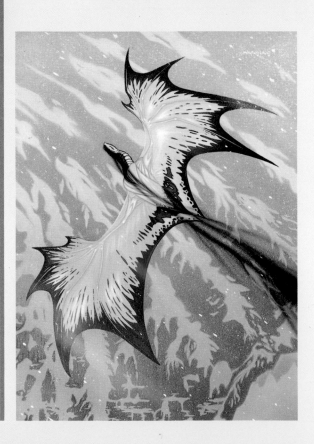

LEFT: *Knight and the Dragon* by Terry Oakes, a fairly conventional treatment of a fairly conventional subject. Notice the tightness of the grouping, with the placement of the castle behind the dragon giving a combination of shapes that neatly pulls the whole picture together.

BELOW LEFT: *Scatha* by Steve Firchow. The artist has captured the feeling of a headlong rush through a cold mountain snowstorm. The limited palette–gray and green–helps to create the illusion of bleakness and cold.

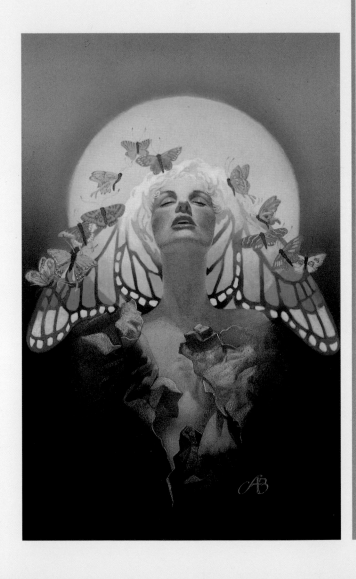

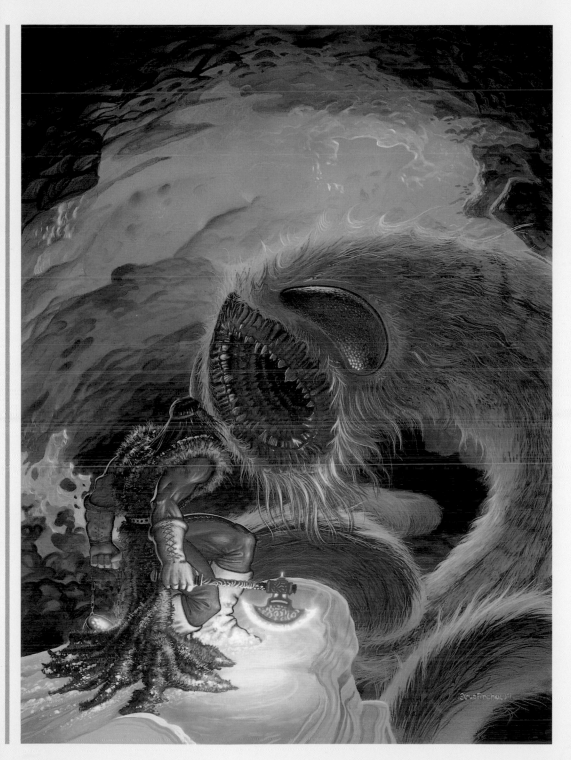

OPPOSITE, LOWER RIGHT: *Metamorphosis* by Ami Blackshear, a beautiful, delicate fantasy with subtle, sophisticated use of color. The picture repays prolonged viewing, as many of its elements are deliberately ambiguous, permitting two or more different perceptions. Superficially, this is a fairly intimate study, but it nevertheless conveys the impression of immense scale.

LEFT: *Conan and the Ice Worm* by Steve Firchow. The use of color is particularly interesting. Firchow has used blues to create the sense of icy chill, but has created a contrasting area of warm colors to draw the eye to the figure of Conan.

Comic book cover by Bill
Sienkiewicz depicting Conan.
The use of light is interesting
here, appearing both to
radiate from the figures and to
focus on them so that the
whole picture seems to glow
with its own life. Note also the
shapes: around the figure of
Conan, they are almost
exclusively geometric, while
curves are used around the
recumbent woman.

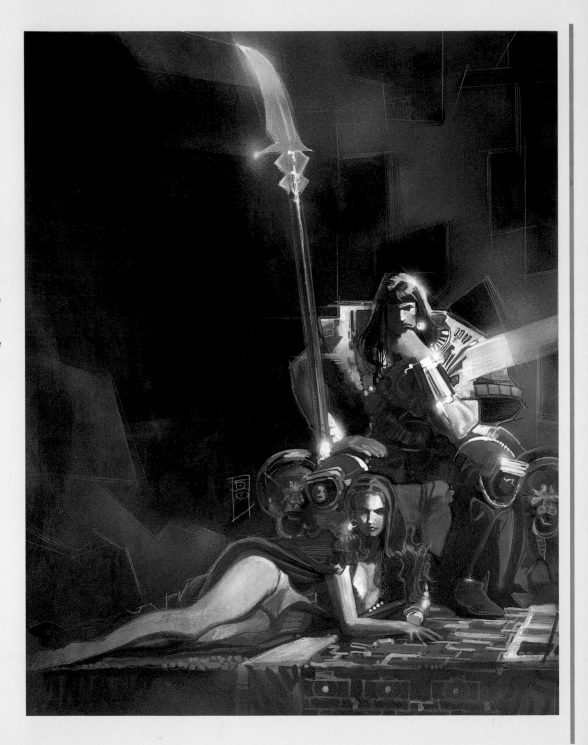

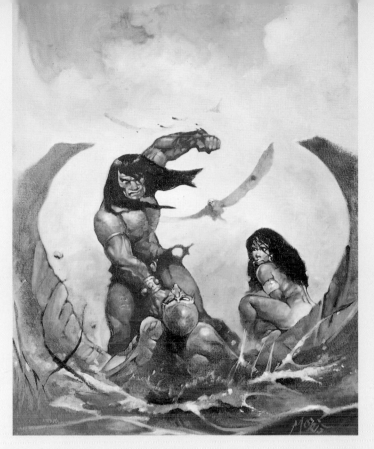

Conan again, in the comic-book cover *Wings of Death* by Kenneth Morris. The curved wings are the important element in this picture's composition. Not only do they serve to hold the picture together; they also mimic the movement that Conan's fist is about to make, thus enhancing the picture's dynamic.

Steve Firchow's *Morning Flight*, in ink, acrylic, and colored pencil, is based on a passage from J.R.R. Tolkien's *The Hobbit*. The soft edges on the background mountains were created using an airbrush and thick, moveable cardboard masks.

LEFT: Illustration by Sachiko Kamimura for *The Heroic Legend of Ariskau*. This is an example of the Japanese *manga* artwork that has become so popular in recent years in both comics and the animated movies–*anime*–derived from them.

RIGHT: Cover by Boris Vallejo for the comic-book *Savage Sword of Conan the Barbarian*. This picture makes use of a fairly common device, that of having a background figure much bigger than the foreground characters and leaning heavily forward over them to create the feeling of power and menace.

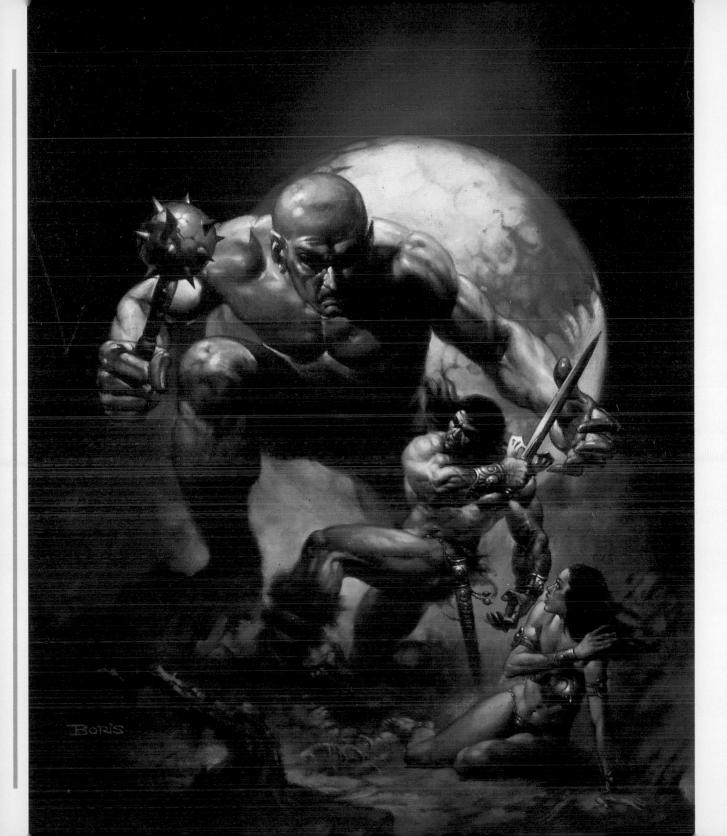

ALIEN LANDSCAPES

Most fantasy takes place in worlds utterly different from our own, or a fantasticated version of our own world. Either way, put yourself into the frame of mind where the world you are depicting is an *other* place, somewhere different, somewhere where all may not be quite what it seems . . .

Tree-Girl by Danny Flynn, done in gouache and ink. The idea for this picture came from a real tree whose shape bore a passing resemblance to a young woman, yet Flynn has not only wholly fantasticated the shape, but also the venue (perhaps underwater, perhaps not). A surreal feeling is created by the inclusion of the highly realistic dog, seemingly unconcerned by the weirdness of its surroundings.

Cover illustration for Arthur C. Clarke's *Against the Fall of Night* by David Farren, done in acrylics applied half by airbrush and half by paintbrush. "In trying to show four worlds, I saw a chance to illustrate an ocean transcience transforming into a desert. Top right of the illustration shows a planet described in the book as like 'a rotten orange being devoured by giant maggots'! Once I had masked it out, I textured the planet, then airbrushed the shadow color at a very low angle to the board."

Cover done in gouache by
Geoff Taylor for *The Wizard
and the War Machine*. The
cover was created for a series
of books. In creating covers
for a series or otherwise
related books, the task of the
artist is to make the pictures
individual while maintaining
consistency.

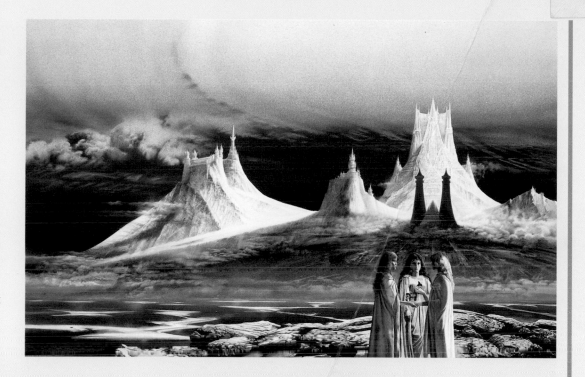

BELOW AND LEFT: Covers done in gouache by Geoff Taylor for *Black Trillium* and its sequel *Blood Trillium.* Again Taylor has used the technique of maintaining series consistency through related compositions. These differ more from each other than those on the opposite page, but the balance of shapes is the same in both. Also, both back covers show a distant bulk, and both front covers a distant mass – this time offsetting a more intimate, human portrayal in the foreground.

ABOVE: Wrapround cover illustration by Chris Brown for Mary Gentle's *Rats and Gargoyles*, done in acrylics on board. Although the overt fantasy element is the giant bird breaking free of the building on the front, what is of most interest to us is the fantasticated cityscape, showing architectural elements drawn from several cultures, as well as various follies and impossible structures.

RIGHT: Wraparound cover illustration by Geoff Taylor for *Merlin's Wood* by Robert Holdstock, done in acrylics. An evocative recreation of the legendary forest where Merlin came to dream his magic. Note the juxtaposition of the huge, ancient-seeming fallen form in the foreground with the naturalism of the rest of the scene.

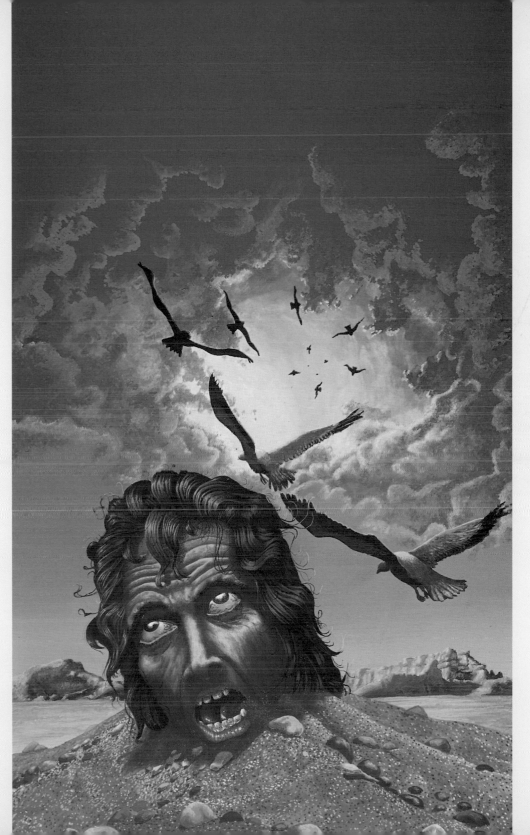

To Spec 5 by Terry Oakes. The great depth of the picture is achieved by the central area, which is almost like a hole punched into the sky. The "hole's" depth is itself created by using white at the very core and then a warm color framed by and juxtaposed with colder colors. The retreating spiral of birds enhances the illusion of depth. The landscape is rendered otherworldly by the bizarre foreground.

ABOVE: Cover of *Reunion* by David Farren, done in acrylics, "A fairly specific brief as regards elements to be shown. The elongated Moon Lady's face intrigued me. The basis for this was a photocopy of a photograph of a model's face, condensed using the latest technology. The Moon mountains on the horizon have the same sharp detail as the foreground because there is no atmospheric perspective on the Moon."

ABOVE: Cover by Danny Flynn for George R.R. Martin's vampire novel *Fevre Dream*, done in gouache and ink. Flynn designed this illustration to be used as a horizontal strip on a black background (which also contained the lettering), and this design concept has since been widely used by horror publishers.

RIGHT: Cover for Robert A. Heinlein's *Red Planet*, by Danny Flynn, done in gouache and ink.

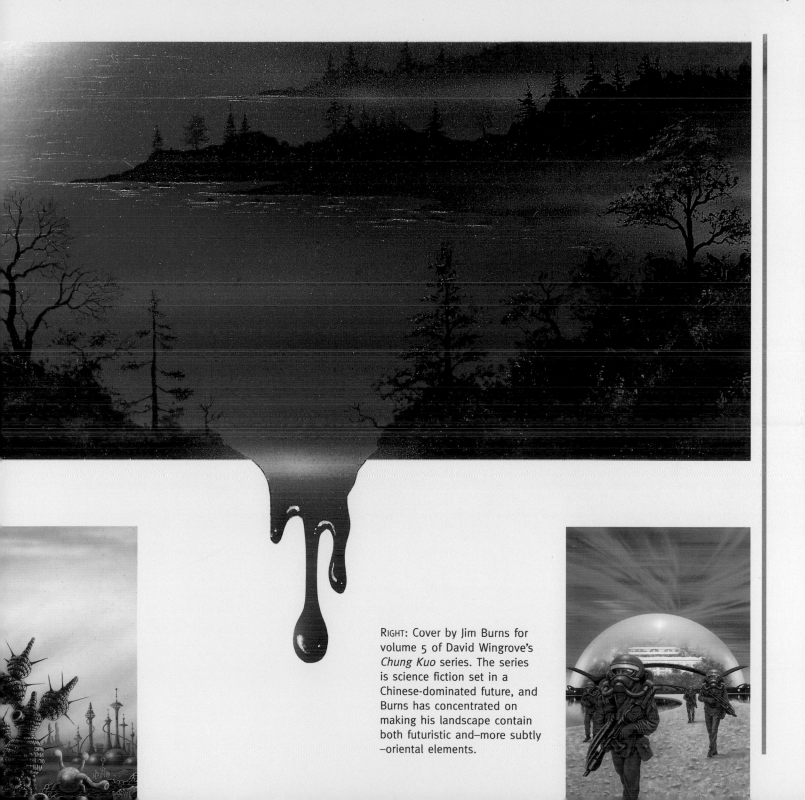

RIGHT: Cover by Jim Burns for volume 5 of David Wingrove's *Chung Kuo* series. The series is science fiction set in a Chinese-dominated future, and Burns has concentrated on making his landscape contain both futuristic and–more subtly –oriental elements.

FANTASIA

When dealing with the world of enchantments— the magical land—or the fanciful parallel reality that is fairyland, a delicate touch and sensitive approach is needed.

RIGHT: *Ribbon Woman* by Alan Baker, done in mixed media including watercolor, pen and ink, pencil, and airbrush. The delicacy of the touch matches the whimsicality of the notion.

BELOW: *Tranquillity* by Ami Blackshear, using watercolor and inlaid papers. The illustration was inspired by the Chinese proverb quoted at bottom right.

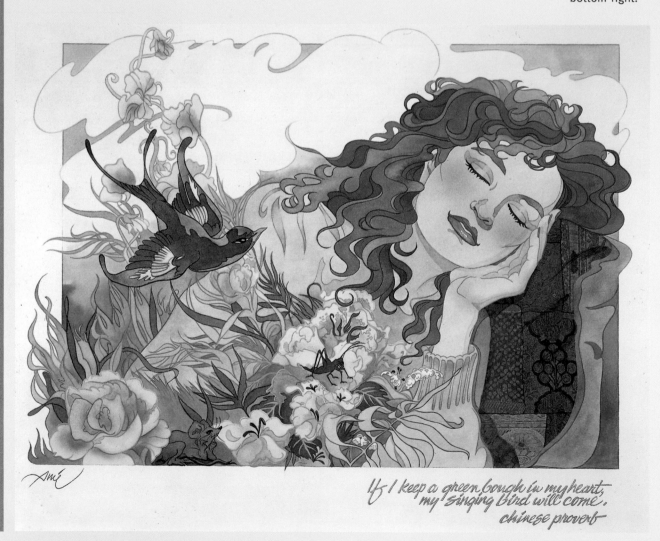

If I keep a green bough in my heart, my singing bird will come. chinese proverb

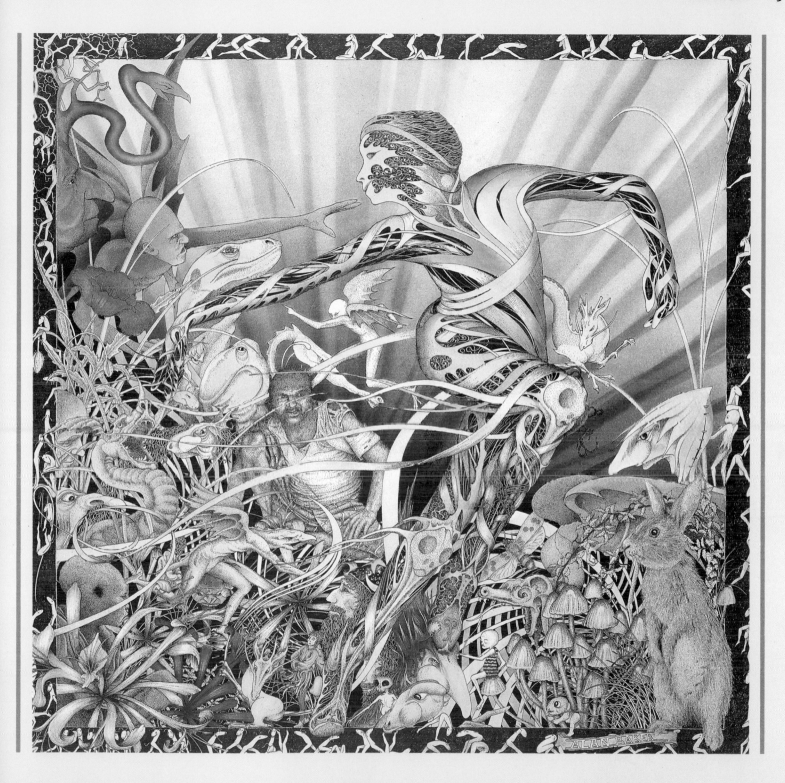

Cover by Terry Oakes for a collection of ghost stories. The picture offers us a choice of perceptions, since the two curving trees can also be seen as the outline of a skull, with other elements filling in its features. The space at the top has been left for the lettering.

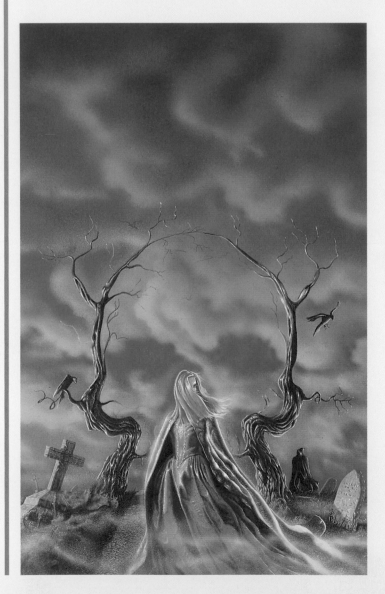

RIGHT: *Artificial Things* by Jim Burns brings an almost super-real approach to a subject matter that is itself fantasticated.

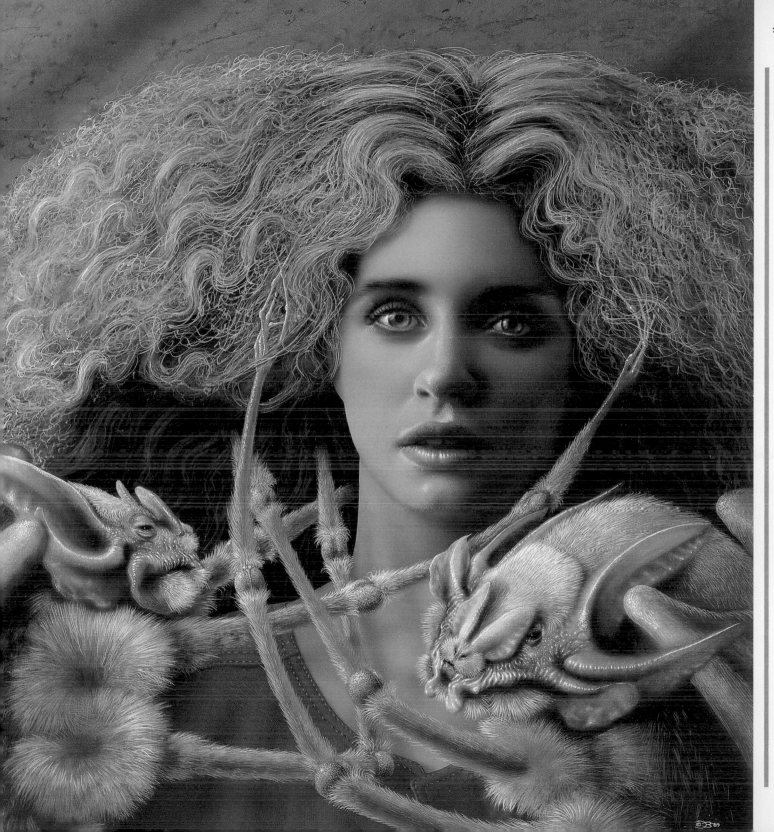

Melancholic Faery by Brian Froud, done in acrylic, colored pencil, and gouache on a smooth-surfaced line-and-wash board. This picture was produced for a book on bad fairies. In its delicacy and sensitive use of color, this epitomizes the best of the subgenre; what takes it beyond that is the considerable humanity of the depiction.

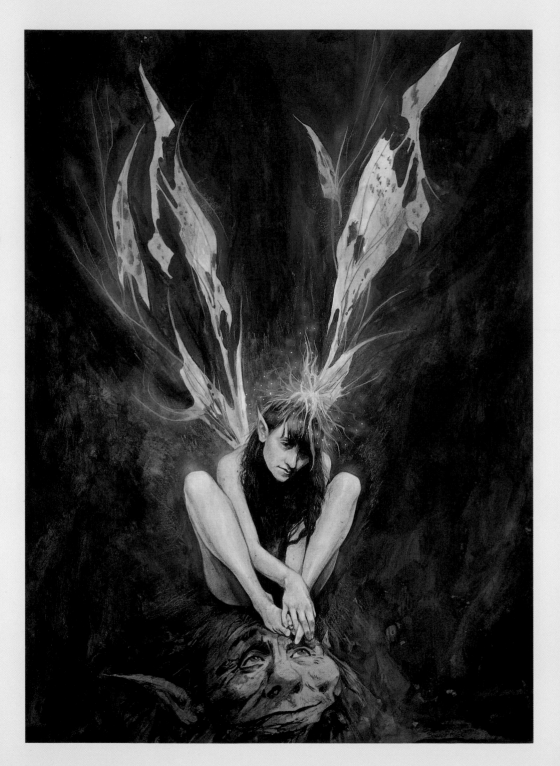

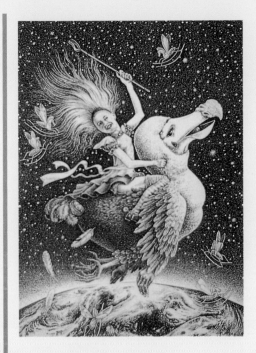

ABOVE: *Alice and the Dodo* by Brian Partridge. "The drawing is about inspiration and how the artist's/author's imagination is driven by it, reaching new heights and achieving undreamed-of-possibilities." This is the second version of the drawing; Partridge has a habit of returning to redraw pictures several times over a period of years.

BELOW: *Sylvan Fantasy* by Steve Firchow, done in ink and acrylic. "I was trying to capture the stillness and quiet of a Japanese garden. Odd formats are wonderful to look at but *hell* to frame!" Yet worth it, because in this instance the format certainly has an effect on the way we respond emotionally to the picture.

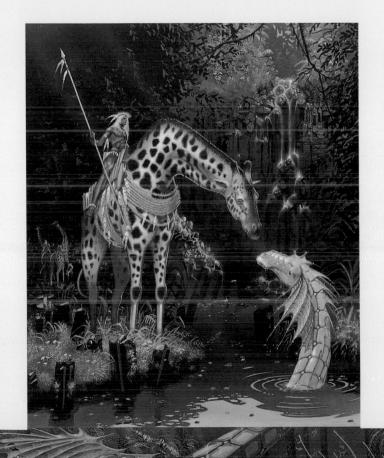

LEFT: *Wynken, Blynken and Nod* by Sue Ellen Brown, done in acrylics, airbrush, and mixed media. "It's a portrait of my friend Nancy and her son Alex. I really was inspired by the imagery of the poem."

RIGHT: *Goblins* by Alan Baker, done in mixed media including watercolor, pen and ink, crayon, bleach, pencil, and airbrush, and inspired by a scene in J.R.R. Tolkien's *The Hobbit.* What is impressive here is not just the strength of the drawing, but also the composition and lighting, acting in combination to draw the whole picture together.

The Lady of the Lake by Harvey G. Parker, done in oils and obviously strongly influenced by the Pre-Raphaelites. Parker's normal practice is to pose models and photograph them for reference. The suit of armor in this picture was designed by Terry English for the John Boorman movie *Excalibur*.

Right: An excellent example of displacement, by Alan Baker.

Left: *Gator* by Julian Haigh. This is 18 inches long, done in hand-modeled clay, bisque-fired and painted using dry brushing with acrylics.

Below: *Fairies* by Ami Blackshear, done in watercolor. "This is only a portion of the whole illustration, and was used as a greeting card."

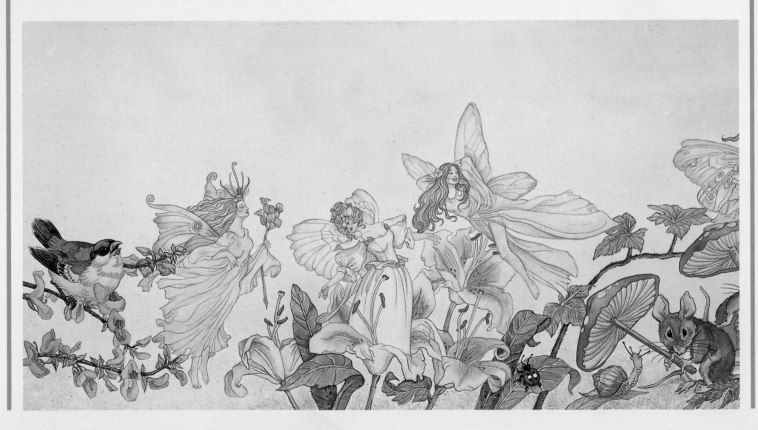

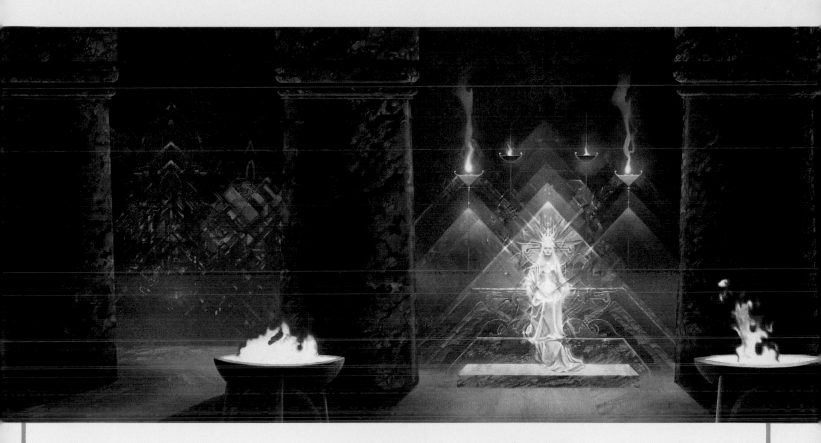

ABOVE: Cover for David Eddings's *The Diamond Throne*, done in gouache by Geoff Taylor. Taylor has cleverly made the central figure not only the focus of interest, but also the light source. The picture as a whole has a lovely sparkly feel.

LEFT: *Alice Dreaming* by Brian Partridge. "Many people I have met—especially women—remember the fear that they felt when they first read *Alice in Wonderland* as a child. It is this 'black' quality I wanted to include in this drawing, where objects or tokens from the story are caught, entangled in Alice's hair, just as they are caught in her—and our—imagination."

SPACE OPERA

Space opera tends to be at the more lighthearted end of the science fiction spectrum, containing action adventures and casual galaxy hopping. Much of the art follows this same route, depicting impossibly huge spaceships or implausible conjunctions of astronomical bodies. This cavalier approach can give such artworks a considerable charm, generating that "sense of wonder" which is what the best of fantasy is about.

Cover by Jim Burns for Kate Elliott's *Jaran 3: His Conquering Sword*. This interestingly juxtaposes typical–almost clichéd–fantasy characters with the hugely threatening and very hi-tech spaceship. The alien feel of the spaceship is emphasized through the color. It is depicted in very cool blues whereas the rest of the picture is rendered in extremely warm colors.

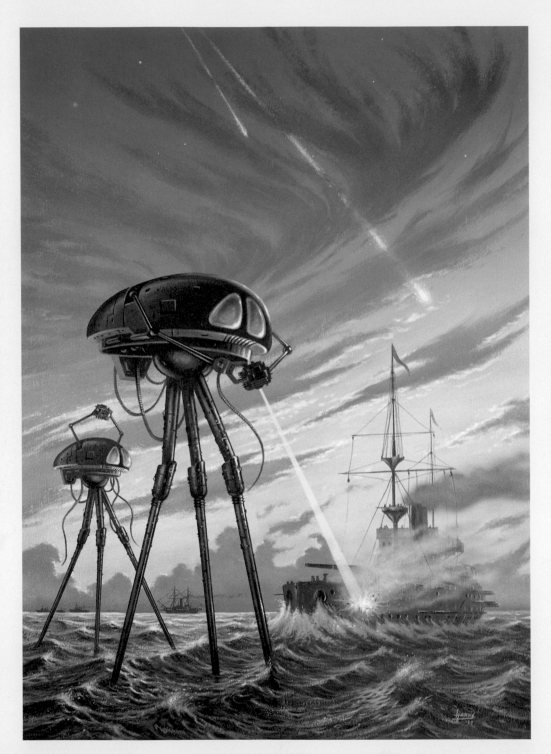

War of the Worlds, by David A. Hardy, done in acrylics. "This was a private commission. Inspired by Wells's book, it shows a fighting machine using a heat ray on the ironclad *Thunderchild*." It is interesting to compare this image with Les Edwards's interpretation on page 147.

RIGHT: *Comet*, by David A. Hardy. "This 'painting' was produced entirely on-screen using the software Painter 3. The photo-realistic whorls in the cometary tail would be very difficult and time-consuming to accomplish by conventional painting methods, even using 'wet in wet,' marbling techniques, and airbrush."

ABOVE: *Homeward Bound* by Alan Jefferson, done in gouache and watercolor, applied with brush and airbrush. "Spaceship design reminded me of a fish, so I painted it returning home old, battered, and falling apart after its long journey–similar to the salmon fish."

Aftermath by David A. Hardy is one of his illustrations for the book *Challenge of the Stars* (1972) by Patrick Moore—done using traditional airbrush methods. It shows the outermost planet of another solar system, whose sun has gone nova. "Once-tall mountains have been melted like candle-wax, and the surface is cracked and barren. The sky is enriched by an aurora-like display as the shell of gases released by the star fluoresces in the ultraviolet. The star is a binary, the red giant looking ghostly behind the bright blue star."

Bright Shiny Car, a computer-generated image (1560 x 1602 pixels) by Malcolm Tween. This displays the fascination with vastness and mass that lies at the heart of much of the best space-opera art.

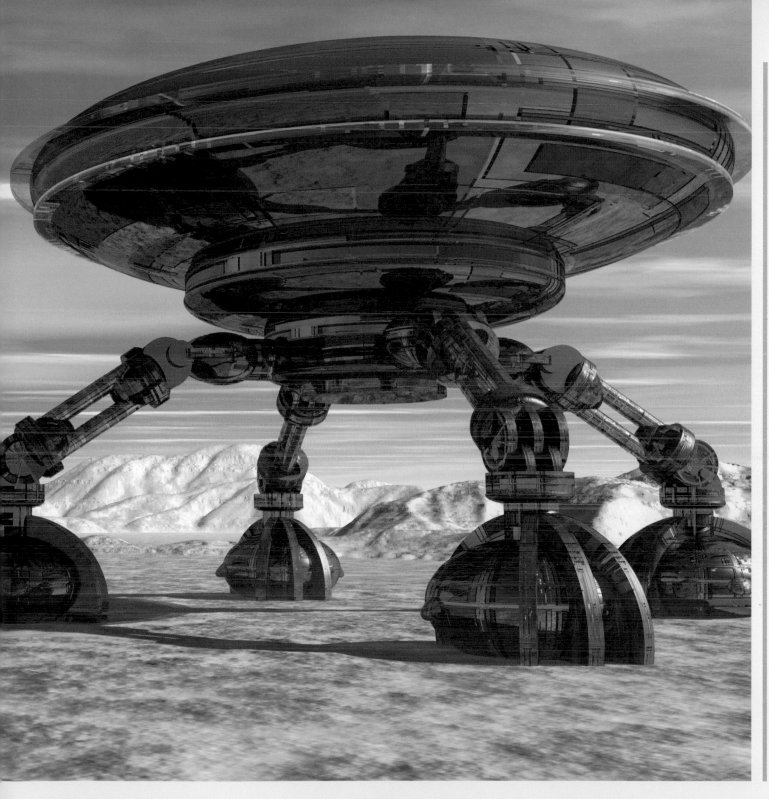

An LP/CD cover by Alan Jefferson, done using gouache and watercolor applied with brush and airbrush and "designed to show elements from *Galactic Nightmare*, a science-fantasy musical."

Starstruck by Alan Jefferson, done using gouache and watercolor applied with brush and airbrush, a well-executed example of one of the core images of space-opera art.

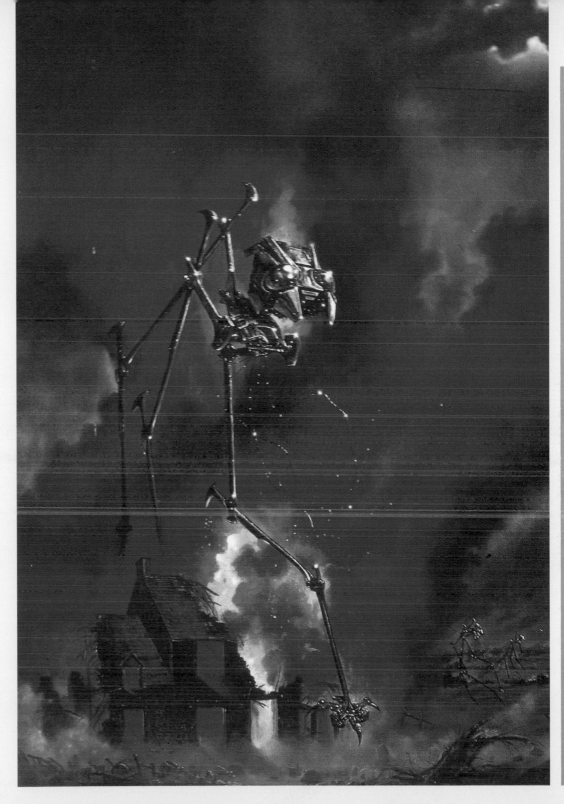

Cover by Les Edwards for an H.G. Wells anthology, depicting a scene from *The War of the Worlds*. It is interesting to compare this image with David A. Hardy's interpretation on page 142.

Splatter

Art in the fields of dark fantasy and horror can aim either to disturb or to nauseate, or both. When creating illustrations based on a text, you will obviously follow the tack taken by that text. In other instances, however, the scope is there for you to exploit the darker regions of your imagination.

RIGHT: An extremely disturbing and unsettling picture by John Holmes, done in gouache and airbrush, represents the subtler approach to horror illustration. There is violence here, but it is all latent.

OPPOSITE: Again, John Holmes ventures into the darker reaches of the subconscious. This time, a bizarre juxtaposition contributes to the picture's emotionally perturbing effect.

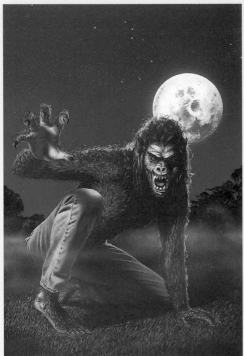

Portrait of the Artist with his Eye in his Mouth by Paul Campion, done in acrylics applied with both brush and airbrush. "Inspired by a picture of a dissected eye-socket from a medical textbook, and yes, I do sleep OK at nights."

Above: Cover by Paul Campion for Thomas M. Disch's anthology *Bad Moon Rising* done in acrylics applied with both brush and airbrush. The artist used himself as a model in order to get the pose and the wrinkles in the jeans correct.

Shelob by Steve Firchow, done in inks, acrylics, and colored pencils. "I was trying to realize visually the horror of Shelob from *Lord of the Rings*. I did this piece very quickly in order to keep the horrific impression fresh and not overworked."

The viewpoint angle of this picture by John Holmes, done in gouache and airbrush, contributes much of the creepiness: we are looking up from the slug-infested sewer. The fact that the little girl is wearing a dress rather than jeans, establishes her vulnerability. This picture also draws on the horror motif whereby denizens of a dark underworld burst uninvited into our sunlit mundane reality.

Far From the North by Alan Baker, inspired by Nordic myths and legends and done in mixed media, including watercolor, pen and ink, crayon, bleach, pencil, and airbrush.

BELOW: Another meticulous piece in gouache and airbrush by John Holmes. This is one of those illustrations where obviously much has happened before the moment portrayed in this picture; the image demands that the viewer use imagination to fill in the story. The last part of the victim that the slugs will devour is his scream.

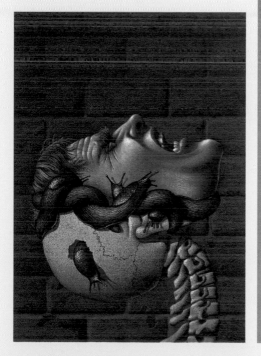

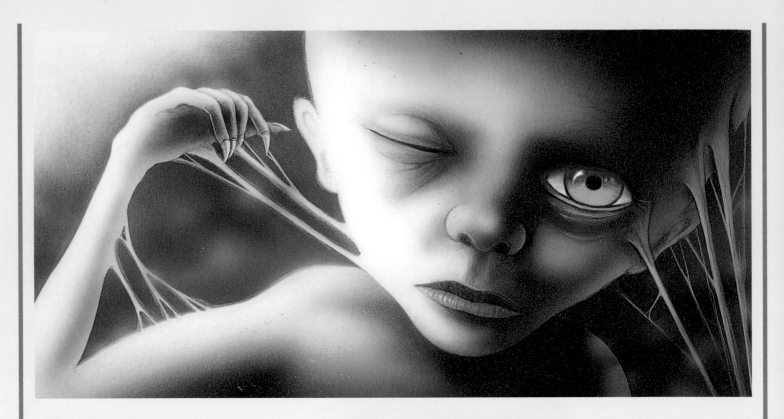

Cover for Octavia Butler's
Clay's Ark, done by Danny
Flynn in gouache and ink.

Nightmare by Jael, done in
acrylics and oils applied with
airbrush and brush. "Inspired
by the neuroses (darknesses)
lurking beneath our civilized
exteriors."

Director Says Cut by Robin Grenville Evans wittily captures the ethos and standards of B-grade exploitation/sexploitation movies.

THE STRANGE

The quest for the unsettling offers one approach to fantastic art –the search for that sudden shock of displacement which the viewer experiences on encountering the image. Although the subject-matter of the pictures on the next few pages varies widely, all have this quality in common.

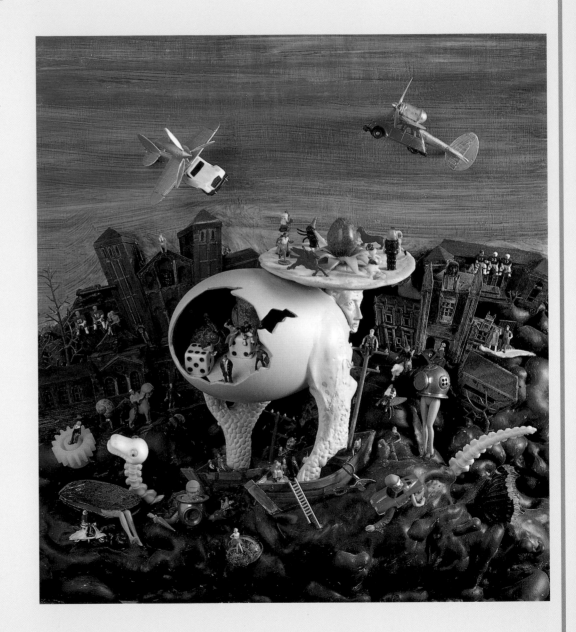

Untitled artwork by John Ottinger, based–obviously–on Hieronymus Bosch's 15th-century *The Garden of Earthly Delights*, perhaps the single most important painting in the history of fantastic art. Ottinger's 3-D homage is done in plastic, clay, and egg.

Serving by Paul Hamilton, a computer-generated image done using Photogenics (from Almathera) on an Amiga 4000/030 and displaying a nice displacement effect between the underlying commonplace nature of the subject matter and the bizarreness of the actual objects.

Another untitled 3-D image by John Ottinger, done in plastic, clay, and egg. The strength of this unusual piece is that it kicks the viewer's imagination into action. The figure of the baby robot emerging from the egg conjures up notions of an organic origin for something that is wholly inorganic in nature. It also plants the idea that the robot "race" might become our replacement as Earth's dominant species.

LEFT: *Breakdown* by Paul Bartlett, done in oils on wood, one of a series of artworks he produced using a lay figure (a jointed dummy). This picture's unsettling effect is probably caused by the fact that we respond to the pitifully bandaged figure as if it were human, although we can see that it is only a wooden effigy.

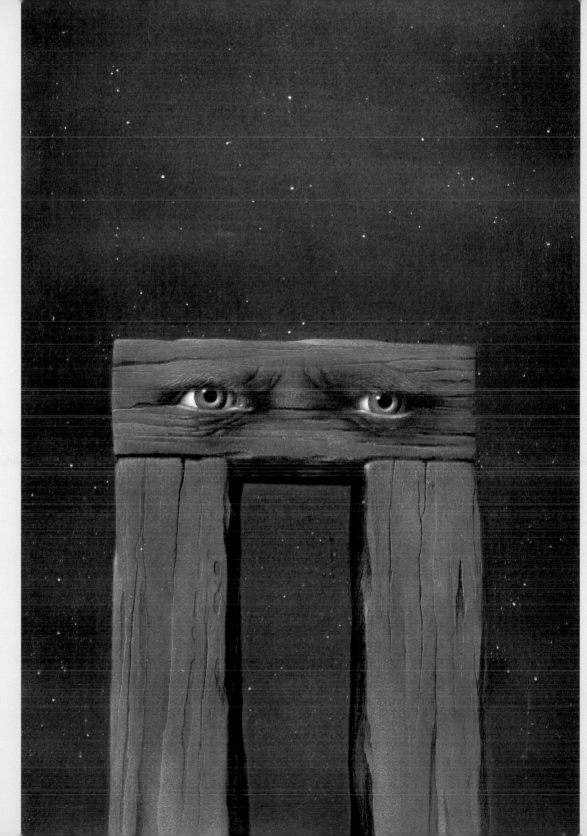

RIGHT: This gloomy, disturbing
illustration by John Holmes,
done in gouache with airbrush,
speaks for itself.

LEFT: *Winter* by Ian Miller, done in drawing inks and pan watercolors. This was commissioned for a calender that was never published. Among the other images, those of the prowling trees are perhaps particularly unsettling.

RIGHT: *White Rider/Hollywood Gothic* by Ian Miller, done in drawing inks–using Rotring technical pens–and pencil. Part of the design/storyboard for a projected movie.

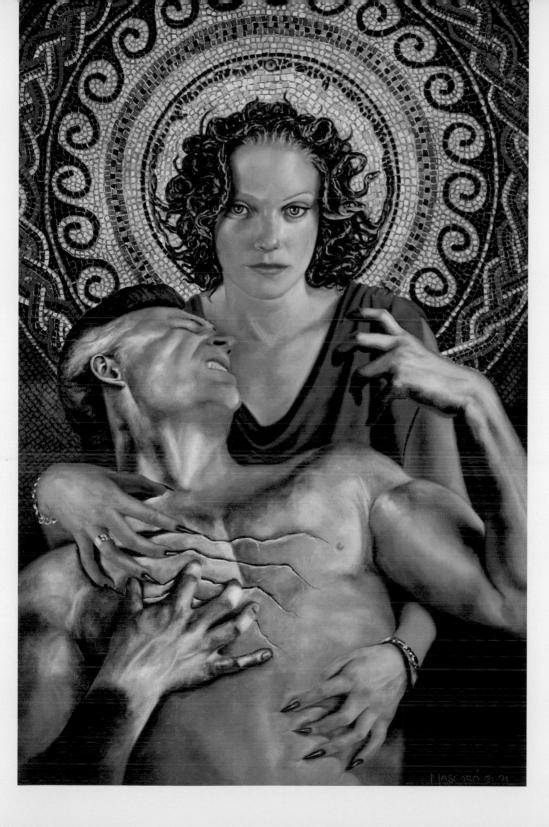

LEFT: Untitled piece by Michael Mascaro. A neat dislocation of our perceptions is achieved through ambiguity; we are uncertain whether both figures are of stone, or one, or neither.

BELOW: *Footpads of Darwin* by Judith Clute, done in oils on linen. This surreal work can be read as almost a portrait of crosshatch fantasy (the breed of fantasy in which widely disparate elements, both old and new, are woven together to create something entirely fresh). "I wanted to do a sort of time travel: characters such as I see in London . . . move into a Quattrocento scene (Uccello's *Rout of San Romano*). The only way I could make it work was to set in irrational elements."

Venus de Credit by Chris Brown, a diptych done in acrylic on canvas. This somewhat disrespectful parody of Michelangelo's famous image on the Sistine Chapel ceiling casts new light through an old window.

Impossible Ivory Tower by Paul Bartlett, done in oils on a panel, can be read as a comment on the imaginative artist's predicament.

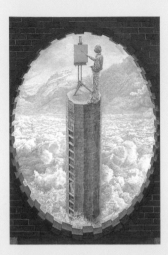

BELOW: *Cabral* by Michael Helme, done in wax and pencil crayons, acrylics, and inks. Inspired by the Surrealist/automatic paintings of Roberto Matta, who attempted to portray the contents of the unconscious, this uses linear perspective (free form) to achieve a sense of great depth.

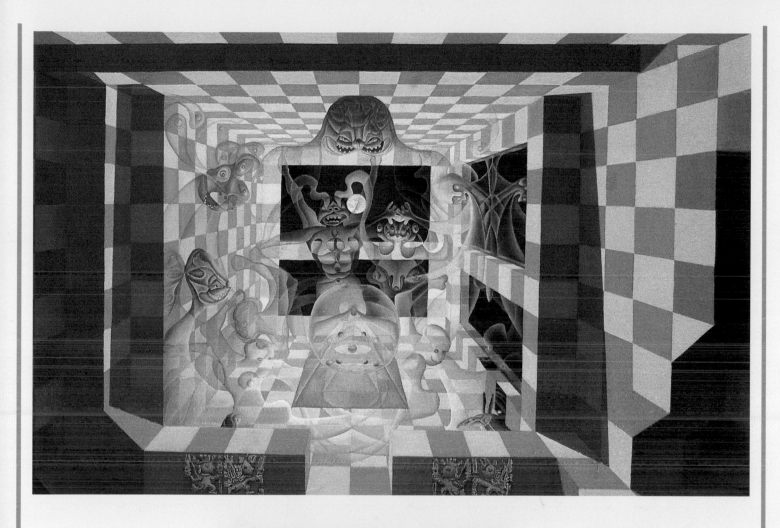

RIGHT: *Homage to a Tulip* (detail) by Paul Bartlett, done in colored pencils, uses an ultra-realist approach to create a sinister and dreamlike effect —notably through the use of vibrant color for the main subject and cold, dead, almost inorganic blues for the surrounding vegetation.

ABOVE: *The Past It Never Leaves Us and the Future is Already Here . . .* (detail) by Paul Bartlett, done in oils on canvas, plays games with perspective in order to disorient the viewer.

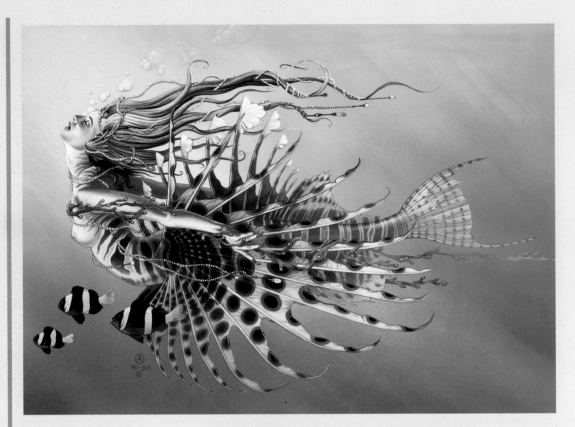

Fish Girl by Chris Achilleos, done on watercolor board in waterproof inks and gouache, with some airbrushing. This interestingly merges the warm, soft fleshiness of the human image with the hard, cold spikiness of the piscine form, so that the two widely divergent sets of elements seem to exist perfectly naturally together.

RIGHT: *The Sun and the Moon* by James Bentley, done in airbrush over a marker base– and showing an exceptional skill in the handling of surfaces–links several notions about time.

RIGHT: *Revenge of the Medicine Man* by Terry Oakes. The eeriness of this exotic piece, with its meticulously painted foliage, is enhanced by its unusual, imbalanced composition – presumably chosen to leave room for lettering.

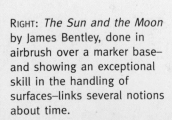

BELOW: *A Phoenix* by David Scott Meier is a vigorous, semi-abstract piece, its color values amply conveying the fire involved in the phoenix's endless cycle of rebirth.

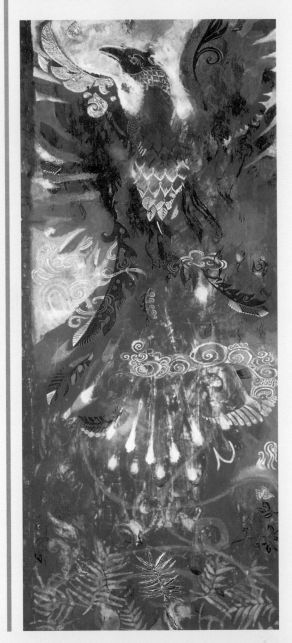

ABOVE: Portrait by Simon Bisley of the Marvel Comics character Daredevil in action.

Beauty in Space, by Jael, has highly romanticized fantasy blending imperceptibly, as one's eye travels down the image, into science fiction hardware and astronomical art.

GETTING PUBLISHED

Maybe you just want to paint for yourself, but we assume one of your aims is to see your work published—even to make a career as a fantasy artist.

The first thing you need to do is some research, to find out where the kind of work you're interested in is usually published. Go through all the relevant magazines you can find and check out the fantasy covers in your local book store. Find out what kind of work each editor and publisher uses; look closely to ascertain what kind of media their illustrators usually work in. All this will help you make sure you do not waste your time and money offering work to people who want something quite different.

As a first step, you might offer some of your work to a fanzine (amateur magazine for science fiction/fantasy fans) or small-circulation magazine (you can often find details of these in the classified ads of the main professional magazines). Since these publications do not normally pay a fee, they are often quite keen to see material from newcomers, and they give you the opportunity to have your work published. Few of them can afford color printing, so your best bet is to offer line work.

Get to know magazines that might be interested in publishing your work.

YOUR PORTFOLIO Approaching potential professional clients requires intelligent preparation and planning. Before making contact with any editor or publisher, cast a critical eye over the samples of your work that you plan to show.

The first rule is, of course, that each piece must be original. Copying another artist's work is legitimate if you are doing so as an exercise to learn something about techniques, but the result must never be offered either as an example of your own work or for publication. Art editors have very good visual memories and will quickly recognize nonoriginal work. Either they will have glimpsed it in the publication from which you copied it, or they will notice inconsistencies of competence – these are painfully obvious to the experienced eye. Besides, there's the ethical question: trying to gain work by using a copy of someone else's picture is in effect stealing from them. Art editors often exchange information with their counterparts in other companies, and you will soon be known as a plagiarist.

The second rule is to have a wide range of examples in your portfolio. Your own natural style and way of working will, of course, be consistent through all your work, but make an effort to vary your subject matter and approach as much as you comfortably can. Make sure, too, that all your samples show you at your best; it is much preferable to offer a portfolio of ten consistently good examples than one containing twelve pieces, two of which are not up to standard.

If you haven't got ten really good ones, you almost certainly don't have enough to stand any reasonable chance of success. When you approach a publisher, you are competing with many seasoned professionals. Art editors know that the more work you have done, the more competent you will be, and thus the more capable of undertaking a commission if they decide they like your work.

CONTACTING A PUBLISHER Once you are confident your portfolio stands comparison with the work of the professionals, you can start considering the best way to present yourself to a publisher. Either telephone or write (enclosing a stamped, self-addressed envelope) to the art editor of the magazine or book publisher concerned to ask how they prefer dealing with new artists. Some may tell you immediately that they're not interested, but most will either ask you to send copies of your work or more rarely, arrange an appointment for you to come into the office and show your portfolio.

You can make copies of your work using a color photocopier. The results are perfectly adequate to give the art editor an idea of whether or not you can offer the kind of illustration he or she wants. Be sure to mark clearly on the

back of each sheet your name, address, and telephone number, and pack the copies in a stiffened envelope. Include a cover letter introducing yourself briefly (and/or reminding the art editor of your earlier contact) and stating the kind of work you are competent to undertake on a commission basis. If the art editor likes your work, the copies and your details will be filed for future reference and you will be contacted if and when the publisher needs you. Very occasionally, if you've been lucky with your timing, the art editor may ring you up immediately to offer a commission.

Work in the science fiction/fantasy illustration field is most often individually commissioned. The artist is given the dimensions of the printed artwork and told whether it is to be in line, halftone, two (sometimes three) colors, or full color. You are also told the fee–and this is almost never open to discussion or bartering; you just accept it or decline to undertake the job. Only top-line artists can negotiate–and in any case it is usually their agent who is doing the negotiating, not the artists themselves.

DEADLINES All commissions carry a deadline; i.e., there is a specified date by which the finished artwork must be delivered. Since there is always a schedule for the production of any publication, it can be very expensive for the publisher if any part of the projected book or magazine is not available

To see work in print is the ambition of most fantasy artists.

Your portfolio should contain at least ten really good pieces.

on time. Printers, binders, and distributors will be kept waiting if you take too long over a job, so publishers will rarely give you a second chance if you miss your deadline–or if you meet it, but with something that is not good enough for them to use.

AGENTS Illustration agencies act for artists, in terms of both securing work and negotiating payment. For this service, they usually require an established percentage of the fee for each job for which they are responsible–normally 30 to 35%–plus, any relevant city or state sales tax. Since percentage plus tax can total an amount approaching half the fee the publisher has paid, they deal in the main with the most sought-after professionals who can command reasonably substantial fees.

Approaching an agent for the first time is much like making first contact with a publisher, as outlined above.

THE CARDINAL RULES Never stop work. Never stop experimenting, and never stop refining and improving your techniques. Fantasy art is a very competitive field in which a great number of gifted, hard-working professionals operate. We believe this book could help you join their ranks.

Good luck!

INDEX

Note: Page numbers in *italics* refer to illustrations

A

Abba, Tom 76
 alternate reality piece *45*
 humanized house *47*
Achilleos, Chris:
 Chain of Fools 74
 Fish Girl 166
 The Young Dragon Trainer 75
acrylic inks 29
 surfaces suitable for 39
acrylics:
 surfaces suitable for 38
 techniques 33
Addams Family, The (film) 77
airbrush 10, 74
 techniques 32
Alien (film) 82
alien landscapes 122–29
Alma-Tadema, Lawrence 74
alternate realities 42–44, *42–45*
animals 66
 in erotic art 74
anthropomorphism 46–48,
 46–49
"arcadian" tradition 9
architecture, fantasy 94–96,
 95–97
Auel, Jean M., *The Clan of the
 Cave Bear* 107
automatic paintings, work
 inspired by *164*

B

Baker, Alan:
 alternate realities piece *42*
 displacement piece *139*
 Fairies on a Gourd 7

Far From the North 153
Goblins 136
Ribbon Woman 131
The Tree-Dwellers 46
ballpoint pen techniques 27
Barrie, J. M. 9
Bartlett, Paul:
 Breakdown 158
 displacement *71*
 *Empty Words in an Empty
 Landscape 79*
 fantasy architecture *95*
 The Game of Life, study for *14*
 Homage to a Tulip (detail)
 165
 Impossible Ivory Tower 164
 *Must Children Die and
 Mothers Plead in Vain?*
 poster *14*
 *The Past It Never Leaves Us
 and the Future is Already
 Here . . .* (detail) *165*
 sketchbooks *14, 20–21*
Baum, Frank L., *The Wonderful
 Wizard of Oz 93*
Bentley, James:
 The Sun and the Moon 166
Berkey, John 9
Bisley, Simon, Daredevil
 character *168*
Blackshear, Ami:
 Diamonds and Toads No.3 9
 Fairies 138
 Metamorphosis 117
 Tranquillity 130
Bleathman, Graham:
 Thunderbirds 1 and 2 4
 Yamato 82
body language 50, *50–1*
Boorman, John, *Excalibur* (film),
 armor from *137*
Bosch, Hieronymus:
 *The Garden of Earthly
 Delights 6*, 8
 work based on *156*
brachycephalic features 52, *53*
Brown, Chris:
 *God, Man and the Price of
 Apples 98*

Rats and Gargoyles cover *126*
Venus de Credit 162
Brown, Sue Ellen:
 Capricorn 66
 *Wynken, Blynken and Nod
 136*
Burns, Jim 9
 Artificial Things 133
 Chung Kuo (Volume 5) cover
 129
 Jaran 40
 *Jaran 3: His Conquering
 Sword* cover *140–41*
 Other Edens cover *112*
 A Quiet of Stone 11
 Triad 4
Burroughs, Edgar Rice 104
Burroughs, William 49
Butler, Octavia, *Clay's Ark* cover
 154

C

Cabell, James Branch,
 Poictesme novels 104–6
Campion, Paul:
 alien creatures *69*
 anthropomorphized cave
 mouths *48*
 Bad Moon Rising cover *150*
 *Dear Santa: Please Can I
 Have . . .? 74*
 fantasy architecture *95*
 futuristic car *87*
 humanoid *91*
 perspective *80*
 *Portrait of the Artist with his
 Eye in his Mouth 150*
Carroll, Lewis 9
 Alice illustrations 9, *108*
 *Through the Looking Glass 7,
 108*, 110, 111
cave paintings 8
caves and caverns,
 anthropomorphized *48*
Centola, Tom, *Unicorns 9*
chalk pastels 31

characterization 52–54, *52–55*
 in comic strips 57
childhood, inspiration from
 10–11
Chiodo, *Conan the Barbarian 8*
Clan of the Cave Bear, The
 (film) 107
Clarke, Arthur C.:
 Against the Fall of Night
 cover *123*
 The Snows of Olympus 82
clothing, characterization
 through 55
Clute, Judith, *Footpads of
 Darwin 163*
collage 10
 of shots 42–44, *42*
color:
 effect of perspective on 92,
 92, 93
 of light *101*, 102, *103*
comic books, covers *115, 118,
 119, 121*
comic strips 7, 8, 56–59, *56–61*
 artwork *60–61*
 brainstorming 61
 choice of shots *58*
 definitions 56
 movement through story 59
 page layout 58, *59*
 script 56, *57*
 storytelling 56
computer:
 distorting images by *73*
 images generated by 62,
 62–65, 143, 144–45
conceptualization 11, 12–23,
 40
cranial shapes 52, *53*
creatures 66, *66–69*
 brainstorming 69
Crisp, Steve:
 exaggeration *77*
 humanoid *90*
 Sword and Sorcery
 character sketches *105, 106*
Cronenburg, David, *Naked
 Lunch* (film) 49
crosshatching 27

D

Dadd, Richard 9
Dali, Salvador 8
dark fantasy 148–55
Davies, Paul, *The Demon Crown* 5
depth, creating illusion of 92
Disch, Thomas M., *Bad Moon Rising* cover 150
displacement 11, 70, 71–72, 139, 156–69
distortion of form 72, 72–73
 human 88, 89, 90
dolichocephalic features 53
Donaldson, Stephen R.:
 Chronicles of Thomas Covenant the Unbeliever 106
 Lord Foul's Bane 106
Doré, Gustave 9
Doyle, Richard 9
dreams 11
Dulac, Edmund 9

E

ectomorphs 53
Eddings, David, *The Diamond Throne* cover 139
edgelighting 100–102, 101
Edwards, Les:
 characterization 52
 Silver on the Tree 1
 War of the Worlds scene 147
Elliott, Kate, *Jaran 3: His Conquering Sword* cover 140–41
endomorphs 53
English, Terry 137
Ernst, Max 8
erotica 74

Escher, M. C. 9, 70, 94
Evans, Grenville, *Director Says Cut* 155
exaggeration 76, 76–77
 of human form 88
 of perspective 92
Excalibur (film), armor from 137
exotica 74, 74–75
extraterrestrials 20–21
eyes, in inanimate objects 48

F

facial types 52–54, 53, 54
fairies 91
fairyland 42
false perspective 78, 78–81
fantasia 130–39
Fantasia (film) 49
fantasy, spectrum of 7–8
fantasy art:
 sources of ideas 10 11
 themes 8–10
Farren, David:
 Against the Fall of Night cover 123
 characterization 52
 Reunion cover 128
felt-tip pen techniques 30
Firchow, Steve:
 Conan and the Ice Worm 117
 Morning Flight 119
 Sand Gorgon 88
 Scatha 116
 Shelob 151
 The Sorcerer's Apprentice 104
 Sylvan Fantasy 135
Flint, Henry:
 alien creature 68
 alternate reality pieces 43, 45
 "Chainsaw Biker" character sketches 15

displacement 71
exaggeration 76
hardware 86–87
"human tree" 47
humanoid 91
insects 67
"Metal Dreadlocks" character sketches 22–23
Offworld Cityscape 23
sketchbooks 15, 22–23
Flynn, Danny:
 Clay's Ark cover 154
 Fevre Dream cover 128
 Red Planet cover 129
 Tree-Girl 122
Forster, E. M. *The Machine Stops* illustration 13
Foss, Chris 9
Frazetta, Frank 9, 106
Froud, Brian, *Melancholic Faery* 134
Fuseli, Henry 9

G

Gahagan, Helen 52
Gascoigne, Phil, alternate reality piece 45
genre fantasy, alternate realities 45
Gentle, Mary, *Rats and Gargoyles* cover 126
geomorphology 49
Giger, H. R. 8
gouache 84
 in multimedia 37
 techniques 35
Grant, John, *The Far-Enough Window* character 57

H

Haggard, H. Rider, *She* 103
Haigh, Julian, *Gator* 138

displacement 71
exaggeration 76
hair, personality conveyed through 54
Hamilton, Paul:
 computer-generated illustration 62, 65
 Desire 65
 Serving 157
hardware 82, 82–87, 86
 anthropomorphized 47, 48, 48
 surface effects 84
Hardy, David A. 9
 Aftermath 144
 Comet 143
 fantasy architecture 95, 96–97
 floating city 83, 84–85
 humanoid 90
 juxtapositions 99
 perspective 81, 93, 96–97
 Pyramids 94
 spacecraft 47
 Terraforming Mars 100
 Towers of Taban 94
 War of the Worlds 142
Harris, John 9
hatching 27, 28, 30
 overlaid 26, 31
Heinlein, Robert A., *Red Planet* cover 129
Helme, Michael:
 Cabral 164
 distortion 72
heroic fantasy 104, 114
high fantasy 104, 114–21
Hoad, John, *When the Cat's Away* 100
Holdstock, Robert, *Merlin's Wood* cover 126
Holland, Brian, comic-strip layout 59
Holmes, John:
 displacement 70
 horror illustrations 148, 149, 152, 153
 looking-glass images 108
 untitled pieces 24, 50, 159
horror 148–55
Howard, Robert E. 104

human forms 88, *89, 90*
humanoids 88, *88–91*

imagination 10–11
impossible structures 94–96, *94–97*
ink techniques 28–29

Jael:
 Beauty in Space 169
 Letters to Jenny 42
 Nightmare 154
Japanese *manga* 10, *10*
Jefferson, Alan:
 Galactic Nightmare LP/CD cover *146*
 Homeward Bound 143
 Starstruck 146
juxtaposition 42, 98–99, *98–99*

Kamimura, Sachiko, *The Heroic Legend of Ariskau* illustration *120*
Kerr, Katherine, *A Time of Justice* cover *114*
King, Bernard, *The Destroying Angel 77*

landscape:
 alien *122–29*
 anthropomorphized 46, 48, *49*
Lang, Andrew 9

Leiber, Fritz 106
life, drawing from 88, *89*
light/lighting 100–103, *100–103*
 alien *102–103*, 103
 artificial 102
 color of *101*, 102, *103*
 sources 100–102, *101, 102*
line-hatching 27
looking-glass world *7, 108*, 110, 111

MacDonald, George 9
machinery, anthropomorphized *47, 48, 48*
McMahon, Michael, *Dr Who and the Cybermen* comic strip *56*
Magritte, René 8
Manga painting 10, *10, 120*
Martin, George R. R., *Fevre Dream* cover *128*
Martin, "Mad" John 8–9
 The Great Day of His Wrath 9
 Paradise Lost 9
Marvel Comics:
 Conan the Barbarian 4, 8
 Daredevil 168
Mascaro, Michael, untitled piece *161*
masking, for airbrush 32
materials 24–39
Matta, Roberto *164*
Meatloaf, *Bat Out of Hell II* illustrations *51*
Meier, David Scott, *A Phoenix 168*
mesocephalic features 52–54, *53*
mesomorphs *53*
Michelangelo, parody of *162*
Miller, Ian 9
 White Rider/Hollywood Gothic 160
 Winter 160
Miller, Maxine, *Lost Angeles 98*

mirrors, images in 108–10, *108–11*
Mitchell, Margaret, *Gone With the Wind 77*
Moebius 82
Moore, Patrick, *Challenge of the Stars* illustration *144*
Morgan, Russell, displacement *70*
morphing 72
Morris, Kenneth, *Wings of Death* cover *119*
mountains, anthropomorphized *49*
movies 7, 8
multimedia 10, 31
 techniques 37

Neverending Story, The (film) 46

Oakes, Terry:
 ghost-story cover *132*
 Knight and the Dragon 116
 marine creature *66*
 Revenge of the Medicine Man 167
 To Spec 5 127
 untitled piece *24*
O'Dell, Brian, distortion *72*
oil paints:
 surfaces suitable for 38–39
 techniques 34
oil pastels 31
Ottinger, John, untitled pieces *25, 156, 157*

Palmer, Thomas, *Dream Science 43*

Parker, Harvey G. *The Lady of the Lake 137*
parody 106
Parrish, Maxfield 9
Partridge, Brian:
 Alice and the Dodo 135
 Alice Dreaming 139
 perspective *78*
pastels:
 in multimedia 31, 37
 techniques 31
Peake, Mervyn, *The Gormenghast Trilogy 96*
pen-and-ink stipple *84*
pencil techniques 26
Pennington, Bruce 9
Pepper, Chris, *Let's Rock 41*
perspective:
 aerial 92, *92–93*
 false 78, *78–81*
 linear 92, *93*
 rules of *79*
photocopying, color 103
pornography 74
Pratchett, Terry 106
prehistoric paintings 8
psychedelia 10
Pyle, Howard 9

Rackham, Arthur 9, 46
realities, alternate 42–44, *42–45*
reflections 108–10, *108–11*
 distortions 110
 fantasticated *110*
 rules for 108–10, *109*
 symbolic use *111*
Robida, Albert 9, 87
 "telephonoscope" *82*, 87
Robinson, Charles 9
 Alice in the Pool of Tears illustration *108*
Robinson, William Heath 9
rocks, anthropomorphizing 46, 48, *49*

Savage Sword of Conan the Barbarian cover *121*
Schwarzenegger, Arnold 82
science fiction, alternate realities *45*
scumble *33*
Seagrave, Dan:
 hardware *84*
 humanoids *88*
 Nuclear Blast 46
 perspective *78*
 untitled piece *113*
shadows *102, 103*
Shakespeare, William, *A Midsummer Night's Dream* animation 91
She (film) 52
Shepard, E. H. 9
Shirow, Masamune, *New Dominion Tank Police, Manga* painting *10*
Sienkiewicz, Bill, comic-book cover *118*
silhouetting 100, *101, 102*
sketchbooks 12, *13–23*
somatotyping *53*
space, illusion of 92, *92–93*
space opera *140–47*
spacecraft, anthropomorphized *47, 48, 48*
spatter 29, *30*
stairway, neverending *94*
Steinman, Jim 51
stippling 27, 28, *84*
structures:
 impossible *94–96, 94–97*
 brainstorming 96
substrates *38–39*
surfaces *38–39*
Surrealism 10, *122, 164*
Sword and Sorcery art *104–46, 104–47*

Taylor, Geoff 9
 Black Trillium cover *124*
 Blood Trillium cover *124*
 The Diamond Throne cover *139*
 Merlin's Wood cover *126*
 A Time of Justice cover *114*
 The Wizard and the War Machine cover *125*
Tenniel, Sir John 9, 111
 White Knight from *Through the Looking Glass 7*
Terminator 2: Judgment Day (film) 82, 86
3-D images *156, 157*
 computer-generated *62*
Tiner, Ron:
 alternate reality pieces *43, 44*
 anthropomorphized rocks and tree *49*
 anthropomorphized spacecraft *48*
 body-language sketches *51*
 characterization *54*
 City of Paradox 99
 comic strip *59, 60–61*
 displacement *71*
 distortion *73*
 edgelighting *101*
 The Far-Enough Window character *57*
 humanoids *89–90*
 The Machine Stops sketch *13*
 mythological creatures *67, 69*
 One Thousand and One Nights comic strip *56*
 perspective *93*
 Procession 17
 reflections used symbolically *111*
 silhouette *101*
 sketches 13, *17–19*
 Sword and Sorcery *107*
 Thera illustrations *104*
Titian *72*
Tolkien, J. R. R. 104

The Hobbit 119, 136
The Lord of the Rings 46, 61
 rendering in comic-strip form 61
tools *24–39*
trees, anthropomorphizing *46–48, 46, 47*
Tween, Malcolm:
 Bright Shiny Car 144 45
 computer-generated illustration *62*
typewriter, anthropomorphized *49*
Tytla, Vladimir (Bill) *49*

Vallejo, Boris 9
 Conan (comic-book) cover *115*
 Savage Sword of Conan the Barbarian cover *121*
Verne, Jules 87

W

watercolor:
 in mixed media 31, 37
 techniques 36
watercolor pencil 26
wax-resist 28, 37
Wells, H. G. *War of the Worlds* scenes *142, 147*
Whelan, Michael 9, 51
White, Tim 9
Who Framed Roger Rabbit? (film) 99
Wilson, Colin, *The Space Vampires* 65
Wingrove, David, *Chung Kuo* (Volume 5) cover *129*
Wolfe, Gene, *There Are Doors* 71
Wood, Grant 9
Wrighteson, Berni, comic-strip layout 59

written word *7–8*
Wyeth, Andrew 9

CREDITS

Quarto would like to thank all the artists who have kindly allowed us to reproduce their work in this book. We are also indebted to the following artists' agents for their contribution: Valerie Paine at Arena, London (representing Jim Burns, Les Edwards and Terry Oakes); David Lewis, London (representing Chris Brown, John Holmes, Michael Mascaro and Dan Seagrave); and Jane Frank at Worlds of Wonder, McLean, Virginia, USA (representing Jael). Thanks also to our demo artists Tom Abba, Paul Bartlett, Paul Campion, Steve Crisp, Henry Flint, Phil Gascoigne, Paul Hamilton and David A. Hardy, Ron Tiner; and Mark Taylor who produced the artwork for the Tools and Materials section.

p6 Visual Arts Library, London; p10 New Dominion Tank Police © Manga Entertainment Ltd; p56 top Dr Who © Marvel Comics Ltd; p59 left Swamp Thing © DC Comics; p59 centre Judge Dredd/2000 AD © Fleetway Editions Ltd; p76 above The Beast © Marvel Comics Ltd; p82 above Space Cruiser Yamato by Graham Bleathman © ITC Entertainment Ltd; p82 below The Telephonoscope by Albert Robida is reproduced from his book Le Vingtième Siècle, from the collection of Chris Morgan; p98 God, Man and the Price of

Apples and p162 Venus de Credit appear by courtesy of the Nicholas Treadwell Gallery, Bradford, England; p120 Heroic Legend of Ariskau © Manga Entertainment Ltd; p126 Rats and Gargoyles by Chris Brown appears by courtesy of Transworld Publishers, London; p171 below left original paintings are by Paul B. Davies; p172 right book covers reproduced by courtesy of Hayakawa Publishing Inc, Japan, and include the work of Hitoshi Yoneda, Seika Nakayama, Yoshitaka Amano, and Jun'ichi Murayama.

The work of Geoff Taylor, pages 114, 124, 125, 126 below, 139 above, appears by courtesy of HarperCollins Publishers, London.

Finally, a special thank you to Chris McCormack at Marvel Entertainment Group Inc, who generously provided examples of work commissioned for Marvel Comics shown on pages 4, 8, 50, 115, 118, 119 above, 121, and 168 right.

Every effort has been made to credit all copyright owners, but Quarto would like to apologise should any omissions have been made.